CREATE YOUR OWN
GRAPHIC NOVEL

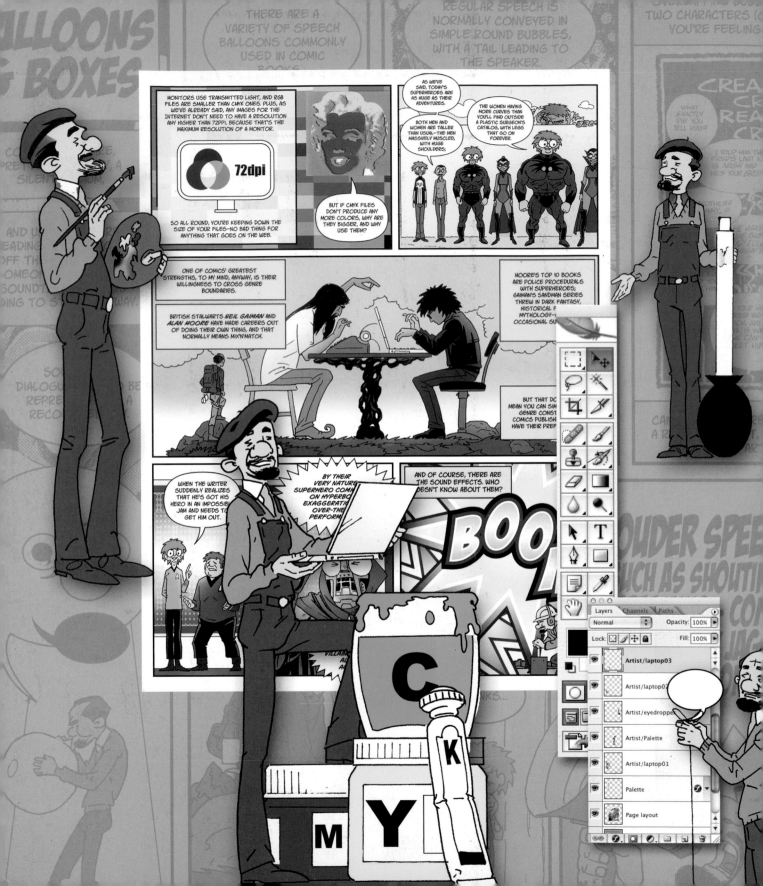

CREATE YOUR OWN GRAPHIC NOVEL

FROM INSPIRATION TO PUBLICATION – THE CREATIVE COMICS MASTERCLASS

MIKE CHINN AND CHRIS MCLOUGHLIN

ILEX

First published in the United Kingdom in 2007 by

ILEX
The Old Candlemakers
West Street, Lewes
East Sussex, BN7 2NZ

www.ilex-press.com

Copyright © The

This book was co
Ilex
Cambridge
England

Publisher Alastai
Creative Director
Editorial Director
Editor Ben Renov
Art Director Julie
Design Assistant
Consultant Editor

British Library Cataloguing-in-Publication Data
A catalogue record for this book is available from
the British Library

ISBN 10 – 1-904705-90-1
ISBN 13 – 978-1-904705-90-1

Printed and bound in China

For more information on this title please visit:
www.web-linked.com/grnouk

CONTENTS

HELLO AND WELCOME . 8
FROM PULPS TO E-ZINES10

1) SO WHAT IS A GRAPHIC NOVEL? 12

GRAPHIC NOVELS VERSUS COMIC BOOKS14
GENRES AND BEYOND .16
SCIENCE FICTION .18
HORROR . 20
FANTASY . 22
CRIME + ADULT . 24
MANGA . 26
IS THERE ANYTHING LEFT? 28
EXAMPLES IN PRINT . 30

2) STRUCTURES AND ELEMENTS 32

TERMINOLOGY . 34
FRAMES OR PANELS? . 36
CONSTRUCTING A STORYLINE 38
BALLOONS + BOXES . 40
CHARACTERIZATION . 42

3) COMPUTERS AS CREATORS 44

QUICK REFERENCE . 46
WORKING ONLINE . 48
WORD-CRUNCHING . 50
DRAWING WITH SOFTWARE 52
COLORING . 54
SAVING . 56
PUBLISHING: PRINT OR WEB? 58

4) IDEAS FIRST 60

INSPIRATION . 62
OBSERVING PEOPLE 64
KEEPING NOTES AND RECORDS 66
DIGITAL CAMERAS. 68

5) GETTING THE SCRIPT WRITTEN 70

WRITING STYLES . 72
FULL SCRIPT VERSUS PLOT METHODS. 74
ONLINE COLLABORATION 76
PACE . 78
CHARACTER DEVELOPMENT 80
SETTING. 82
USE OF MOVIE TECHNIQUES 84
RESEARCH . 86
WRITING A BRIEF AND SYNOPSIS 88

6) GETTING THE SCRIPT DRAWN 90

ARTISTIC STYLES . 92
ARTISTS' TECHNIQUES. 94
BITMAP AND VECTOR SOFTWARE. 96
MAC OR PC? . 98
WORKING FROM A BRIEF 100
WORKING FROM A SCRIPT102
MOOD . 104
STYLES OF ARTWORK.106
PANEL LAYOUTS. 108
FRAMING DEVICES AND CROPS. 110
SCANNING IN HAND-DRAWN ARTWORK. 112
USE OF LAYERS. 114
RGB OR CMYK? . 116
CREATING BALLOONS AND LETTERING 118
PLACING TYPOGRAPHY.120

7) 3D OR NOT 3D? 122

THE NEXT BIG THING?.124
SKETCHING IN 3D .126
CREATING SOLID BACKGROUNDS.128
REALISTIC CHARACTERS.130

8) PUBLISH AND BE DAZZLED 132

WEB COMICS .134
FLASH!. .136
SELF-PUBLISHING .138
PROMOTION AND MARKETING 140
THE INTERNET FOR SALES AND PROMOTION. . .142
BASIC NETWORKING144
PITCHING TO A PUBLISHER146

RESOURCES 148

BOOKS . 150
ORGANIZATIONS + JOURNALS.152
ONLINE RESOURCES154
GLOSSARY .156
INDEX .158
ACKNOWLEDGMENTS.160

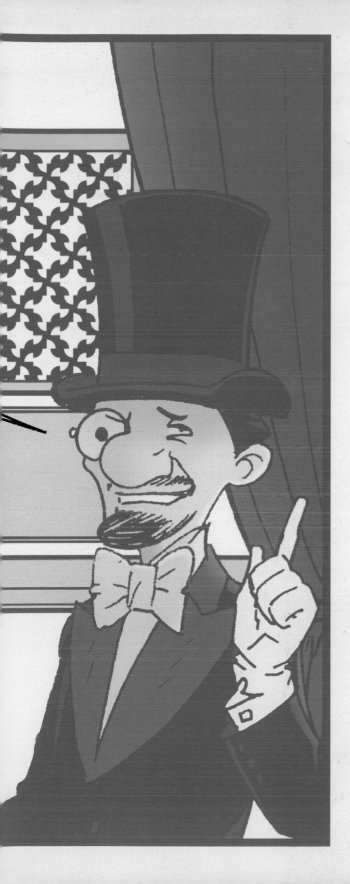

INTRODUCTION

HELLO AND WELCOME. 8
FROM PULPS TO E-ZINES. .10

HELLO AND WELCOME...

...TO THE COLLEGE OF THE COMIC ARTS. I HOPE YOU'LL ENJOY YOUR STAY. MY NAME IS FRANKLIN EISNER, AND I AM THE PROFESSOR OF GRAPHIC NOVEL STUDIES AND SEQUENTIAL ART HERE AT THE COLLEGE. WITH THE HELP OF FOUR OF MY COURSE STUDENTS—YUMI, KEVIN, NAVINDER, AND JONATHAN—I'LL BE INTRODUCING YOU TO THE WORLD OF GRAPHIC NOVELS. WE'LL START WITH A DEFINITION OF WHAT THEY ARE, AND THEN RUN THROUGH THE MOST POPULAR STYLES AND GENRES, BEFORE MOVING ON TO INFORMATION ON CREATING YOUR OWN COMICS AND GRAPHIC NOVELS.

WHETHER YOU'RE A COMICS FAN, A CARTOONIST, A SCRIPTWRITER, OR EVEN A FILMMAKER, YOU'LL FIND SOMETHING HERE TO INTEREST, ENLIGHTEN, AND ENTERTAIN YOU. THE GRAPHIC NOVEL IS AN EXPANDING MEDIUM, AND ONE THAT IS RAPIDLY GAINING A WIDER AUDIENCE AS MORE MOVIE ADAPTATIONS ARE MADE AND AWARENESS IS RAISED. THERE'S NEVER BEEN A BETTER TIME TO GET INTO GRAPHIC NOVELS. WELCOME ABOARD.

THE PROFESSOR

FACT FILE:

HEIGHT:	5' 9"
AGE:	57
REAL NAME:	FRANKLIN EISNER
LIKES:	A CONTRACT WITH GOD

YUMI

FACT FILE:

HEIGHT:	5' 4"
AGE:	22
REAL NAME:	YUMI HOKUSAI
LIKES:	LOST AT SEA

KEV

FACT FILE:

HEIGHT:	5' 5"
AGE:	18
REAL NAME:	KEVIN SIEGEL
LIKES:	CEREBUS

NAZ

FACT FILE:

HEIGHT:	5' 9"
AGE:	20
REAL NAME:	NAVINDER KANE
LIKES:	X-MEN, BONE

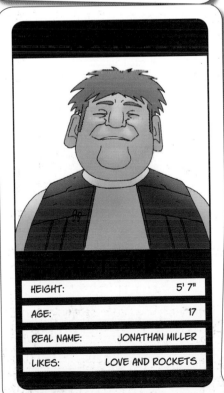

HEIGHT:	5' 7"
AGE:	17
REAL NAME:	JONATHAN MILLER
LIKES:	LOVE AND ROCKETS

THE HEADMASTER

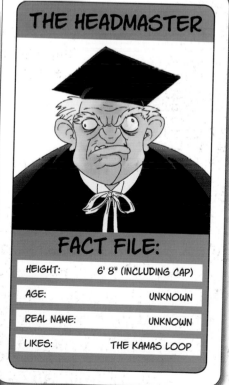

FACT FILE:

HEIGHT:	6' 8" (INCLUDING CAP)
AGE:	UNKNOWN
REAL NAME:	UNKNOWN
LIKES:	THE KAMAS LOOP

FROM PULPS TO E-ZINES

PICTURES HAVE BEEN USED TO TELL STORIES THROUGHOUT HISTORY, AND ACROSS ALL CULTURES.

AUSTRALIAN ABORIGINALS DREW RICHLY SYMBOLIC IMAGES OF THE DREAMTIME ON CLIFF FACES;

UNKNOWN HUNTERS PAINTED CAVE WALLS IN LASCAUX, FRANCE, WITH PICTURES OF ANIMALS BOTH REAL AND SHAMANIC.

EGYPTIAN, ASSYRIAN, AND BABYLONIAN RULERS HAD THEIR CONQUESTS AND PRIZES PROCLAIMED TO THE WORLD IN RELIEFS AND HIEROGLYPHICS;

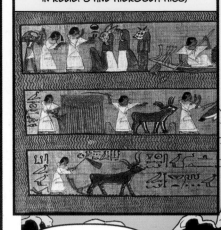

ILLUSTRATED MANUSCRIPTS AND BOOKS HAVE BEEN AROUND FOR CENTURIES, FROM THE WORK OF MEDIEVAL MONKS,

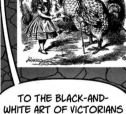

TO THE BLACK-AND-WHITE ART OF VICTORIANS SUCH AS SIR JOHN TENNIEL IN THE PAGES OF *ALICE'S ADVENTURES IN WONDERLAND*.

EVEN THE ROMAN EMPEROR TRAJAN CARVED HIS (SLIGHTLY BOASTFUL) LIST OF TRIUMPHS AROUND A PILLAR AS A CONTINUOUS, GRAPHIC NARRATIVE.

THE WORLD'S FIRST GRAPHIC NOVEL?

BUT IT'S ONLY IN THE MODERN WORLD THAT THE COMIC STRIP HAS COME INTO ITS OWN AS A RECOGNIZED AND (SEMI) LEGITIMATE ART FORM.

THE WORD *CARTOON* TOOK ON ITS MODERN DEFINITION IN THE 18TH AND 19TH CENTURIES…

…BEFORE THAT, A CARTOON WAS A SKETCH, OR ROUGH, DONE BY AN ARTIST PRIOR TO A LARGER WORK;

NOW IT'S A GAG:

A FEW SMALL PICTURES THAT TELL A JOKE (LIKE *PEANUTS*, *GARFIELD*, OR *HÄGAR THE HORRIBLE*).

THIS LED TO CARTOONS IN NEWSPAPERS BEING KNOWN AS *THE FUNNIES*, OR *THE COMIC PAPERS*, WHICH IS EXACTLY WHERE THE TERM *COMICS* AROSE.

SHORTLY AFTER WORLD WAR I, PUBLISHERS BEGAN TO ASSEMBLE THE WEEKLY FUNNIES INTO ANTHOLOGY FORM— COMIC BOOKS.

A REVOLUTION HAD BEGUN.

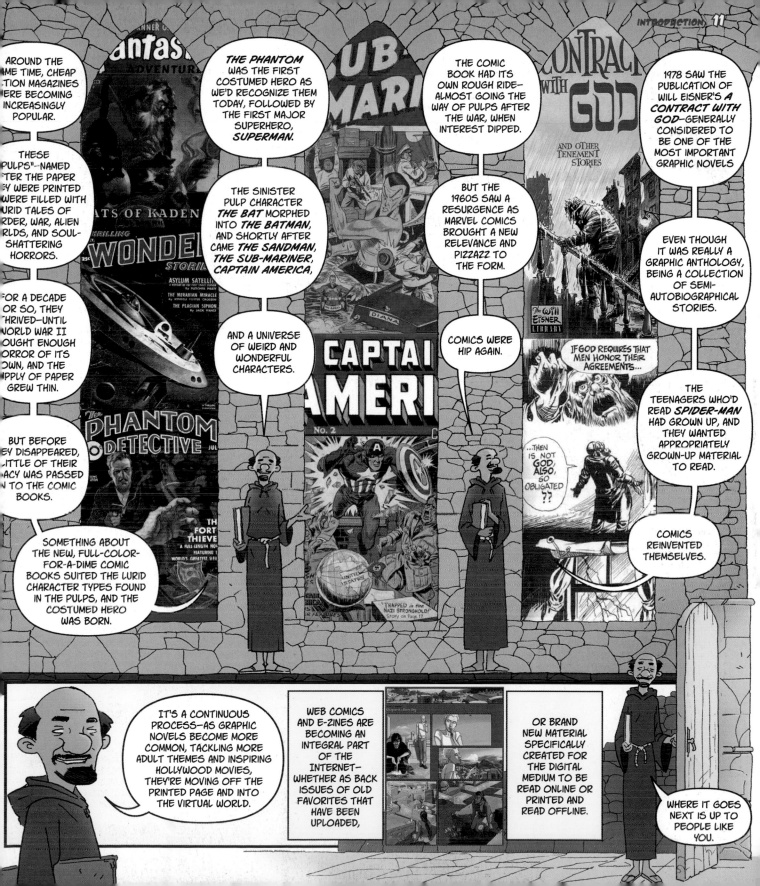

AROUND THE SAME TIME, CHEAP PULP FICTION MAGAZINES WERE BECOMING INCREASINGLY POPULAR.

THESE "PULPS"—NAMED AFTER THE PAPER THEY WERE PRINTED ON—WERE FILLED WITH LURID TALES OF MURDER, WAR, ALIEN WORLDS, AND SOUL-SHATTERING HORRORS.

FOR A DECADE OR SO, THEY THRIVED—UNTIL WORLD WAR II BROUGHT ENOUGH HORROR OF ITS OWN, AND THE SUPPLY OF PAPER GREW THIN.

BUT BEFORE THEY DISAPPEARED, A LITTLE OF THEIR LEGACY WAS PASSED ON TO THE COMIC BOOKS.

SOMETHING ABOUT THE NEW, FULL-COLOR-FOR-A-DIME COMIC BOOKS SUITED THE LURID CHARACTER TYPES FOUND IN THE PULPS, AND THE COSTUMED HERO WAS BORN.

THE PHANTOM WAS THE FIRST COSTUMED HERO AS WE'D RECOGNIZE THEM TODAY, FOLLOWED BY THE FIRST MAJOR SUPERHERO, SUPERMAN.

THE SINISTER PULP CHARACTER THE BAT MORPHED INTO THE BATMAN, AND SHORTLY AFTER CAME THE SANDMAN, THE SUB-MARINER, CAPTAIN AMERICA,

AND A UNIVERSE OF WEIRD AND WONDERFUL CHARACTERS.

THE COMIC BOOK HAD ITS OWN ROUGH RIDE—ALMOST GOING THE WAY OF PULPS AFTER THE WAR, WHEN INTEREST DIPPED.

BUT THE 1960S SAW A RESURGENCE AS MARVEL COMICS BROUGHT A NEW RELEVANCE AND PIZZAZZ TO THE FORM.

COMICS WERE HIP AGAIN.

1978 SAW THE PUBLICATION OF WILL EISNER'S A CONTRACT WITH GOD—GENERALLY CONSIDERED TO BE ONE OF THE MOST IMPORTANT GRAPHIC NOVELS

EVEN THOUGH IT WAS REALLY A GRAPHIC ANTHOLOGY, BEING A COLLECTION OF SEMI-AUTOBIOGRAPHICAL STORIES.

IF GOD REQUIRES THAT MEN HONOR THEIR AGREEMENTS...

...THEN IS NOT GOD, ALSO, SO OBLIGATED ??

THE TEENAGERS WHO'D READ SPIDER-MAN HAD GROWN UP, AND THEY WANTED APPROPRIATELY GROWN-UP MATERIAL TO READ.

COMICS REINVENTED THEMSELVES.

IT'S A CONTINUOUS PROCESS—AS GRAPHIC NOVELS BECOME MORE COMMON, TACKLING MORE ADULT THEMES AND INSPIRING HOLLYWOOD MOVIES, THEY'RE MOVING OFF THE PRINTED PAGE AND INTO THE VIRTUAL WORLD.

WEB COMICS AND E-ZINES ARE BECOMING AN INTEGRAL PART OF THE INTERNET—WHETHER AS BACK ISSUES OF OLD FAVORITES THAT HAVE BEEN UPLOADED,

OR BRAND NEW MATERIAL SPECIFICALLY CREATED FOR THE DIGITAL MEDIUM TO BE READ ONLINE OR PRINTED AND READ OFFLINE.

WHERE IT GOES NEXT IS UP TO PEOPLE LIKE YOU.

CHAPTER 1

GRAPHIC NOVELS VERSUS COMIC BOOKS14

GENRES AND BEYOND .16

SCIENCE FICTION. .18

HORROR . 20

FANTASY . 22

CRIME + ADULT . 24

MANGA . 26

IS THERE ANYTHING LEFT? 28

EXAMPLES IN PRINT . 30

GRAPHIC NOVELS VERSUS COMIC BOOKS

SO THE VERY FIRST QUESTION WE ASK OURSELVES IS: JUST WHAT IS A GRAPHIC NOVEL?

A COMIC BOOK ON STEROIDS OR MAYBE ONE WITH DELUSIONS OF GRANDEUR?

WHAT EXACTLY IS THE DIFFERENCE BETWEEN A GRAPHIC NOVEL AND A COMIC BOOK?

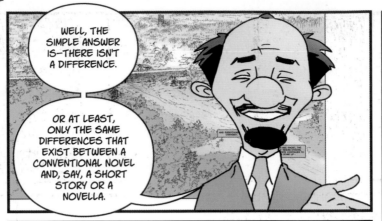

WELL, THE SIMPLE ANSWER IS—THERE ISN'T A DIFFERENCE.

OR AT LEAST, ONLY THE SAME DIFFERENCES THAT EXIST BETWEEN A CONVENTIONAL NOVEL AND, SAY, A SHORT STORY OR A NOVELLA.

GRAPHIC NOVELS *ARE* COMIC BOOKS—IN FACT, THEY'RE FREQUENTLY MORE THAN ONE COMIC BOOK.

THE PROBLEM IS THAT THERE'S OFTEN A GAP BETWEEN WHAT SOMEONE DEFINES AS A GRAPHIC NOVEL, AND WHAT IS PRESENTED AS ONE.

IN THE TRUEST SENSE, A NOVEL TELLS A COMPLEX AND INVOLVING STORY ABOUT A CHARACTER OR GROUP OF CHARACTERS.

BY THE CONCLUSION, THOSE CHARACTERS WILL HAVE BEEN CHANGED BY EVENTS—FOR GOOD OR ILL.

AND UNLESS IT'S PART OF A SERIES (AND MANY GENRE NOVELS ARE—WE'LL GET TO THAT LATER), THE ENDING IS JUST THAT: THE END.

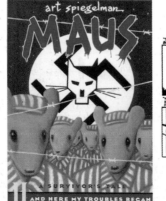

art spiegelman
MAUS
11 SURVIVOR'S TALE
AND HERE MY TROUBLES BEGAN

ART SPIEGELMAN'S *MAUS* IS THE STORY OF THE AUTHOR'S FATHER—A SURVIVOR OF THE AUSCHWITZ DEATH CAMP.

THE STORY IS WHAT HAPPENED TO BRING THAT CONCLUSION ABOUT.

WE KNOW HIS FATHER LIVES THROUGH THE HOLOCAUST, AND WE'RE PRETTY SURE THAT THE HORROR OF IT HAS SOMEHOW CHANGED HIM;

BUT *MAUS* WASN'T ORIGINALLY PUBLISHED IN A SINGLE VOLUME. THE VARIOUS CHAPTERS OF EACH VOLUME WERE PUBLISHED IN *RAW* MAGAZINE OVER A PERIOD OF TEN OR SO YEARS.

BUT BECAUSE THEY ARE CHAPTERS IN A CONTINUOUS STORYLINE, THE COMPLETE WORK DOESN'T FEEL FRAGMENTED.

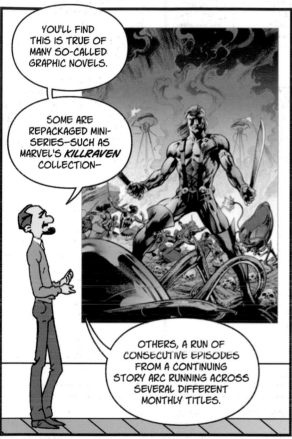

YOU'LL FIND THIS IS TRUE OF MANY SO-CALLED GRAPHIC NOVELS.

SOME ARE REPACKAGED MINI-SERIES—SUCH AS MARVEL'S *KILLRAVEN* COLLECTION—

OTHERS, A RUN OF CONSECUTIVE EPISODES FROM A CONTINUING STORY ARC RUNNING ACROSS SEVERAL DIFFERENT MONTHLY TITLES.

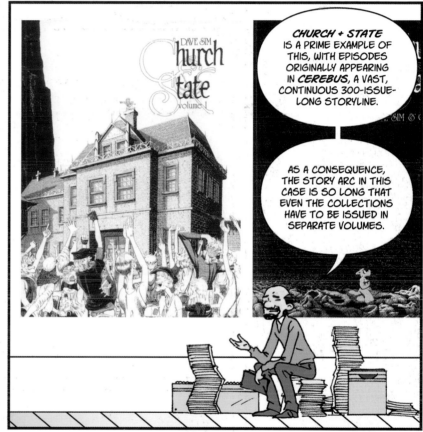

CHURCH + STATE IS A PRIME EXAMPLE OF THIS, WITH EPISODES ORIGINALLY APPEARING IN *CEREBUS*, A VAST, CONTINUOUS 300-ISSUE-LONG STORYLINE.

AS A CONSEQUENCE, THE STORY ARC IN THIS CASE IS SO LONG THAT EVEN THE COLLECTIONS HAVE TO BE ISSUED IN SEPARATE VOLUMES.

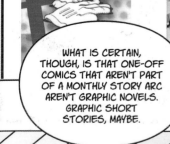

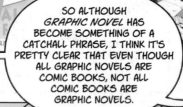

WHAT IS CERTAIN, THOUGH, IS THAT ONE-OFF COMICS THAT AREN'T PART OF A MONTHLY STORY ARC AREN'T GRAPHIC NOVELS. GRAPHIC SHORT STORIES, MAYBE.

A STORY THAT CAN BE TOLD IN 20-30 PAGES OF COMIC STRIP DOESN'T HAVE THE DEPTH OR RANGE TO BE A NOVEL OF ANY DESCRIPTION.

SO ALTHOUGH *GRAPHIC NOVEL* HAS BECOME SOMETHING OF A CATCHALL PHRASE, I THINK IT'S PRETTY CLEAR THAT EVEN THOUGH ALL GRAPHIC NOVELS ARE COMIC BOOKS, NOT ALL COMIC BOOKS ARE GRAPHIC NOVELS.

GENRES AND BEYOND

GENRE IS A TERM YOU'LL COME ACROSS MANY TIMES IN THE LITERARY WORLD. SO WHAT DOES IT MEAN?

SIMPLY PUT, A GENRE IS A TYPE OF FICTION.

WESTERNS, HORROR, FANTASY, SCIENCE FICTION, DETECTIVE, SPY FICTION—ALL ARE EXAMPLES OF GENRES.

GENRE LABELS ARE MAINLY USED IN THE PUBLISHING WORLD AS A MARKETING TOOL. BY PIGEONHOLING A BOOK, IT CAN BE TARGETED AT A SPECIFIC AUDIENCE.

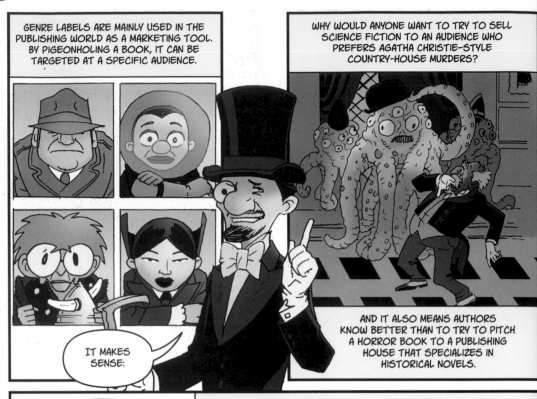

IT MAKES SENSE:

WHY WOULD ANYONE WANT TO TRY TO SELL SCIENCE FICTION TO AN AUDIENCE WHO PREFERS AGATHA CHRISTIE–STYLE COUNTRY-HOUSE MURDERS?

AND IT ALSO MEANS AUTHORS KNOW BETTER THAN TO TRY TO PITCH A HORROR BOOK TO A PUBLISHING HOUSE THAT SPECIALIZES IN HISTORICAL NOVELS.

THE SAD THING, HOWEVER, IS THAT GENRES ARE ALSO USED TO GHETTOIZE AND DEMEAN CERTAIN TYPES OF FICTION.

IN CONVENTIONAL PUBLISHING THERE'S THE SENSE THAT THERE ARE GENRE BOOKS… AND THEN THERE ARE THE PROPER WORKS OF FICTION.

THE LITERARY ONES.

BUT THE GOOD NEWS IS, AS FAR AS WE'RE CONCERNED, COMICS AND GRAPHIC NOVELS SEEM LARGELY FREE OF THIS KIND OF PIGEONHOLING.

COMICS ARE IN A GENRE ALL OF THEIR OWN—AT LEAST, AS FAR AS BOOKSELLERS ARE CONCERNED.

CHECK YOUR LOCAL BOOKSTORE. ARE THE SUPERHERO BOOKS ON DIFFERENT SHELVES THAN THE CRIME COMICS?

NO, EVERYTHING IN THE GRAPHICS MEDIUM—FROM WESTERNS TO WAR— IS IN ONE SECTION.

ONE OF COMICS' GREATEST STRENGTHS IS THEIR WILLINGNESS TO CROSS GENRE BOUNDARIES.

BRITISH STALWARTS NEIL GAIMAN AND ALAN MOORE HAVE MADE CAREERS OUT OF DOING THEIR OWN THING, AND THAT NORMALLY MEANS MIX'N'MATCH.

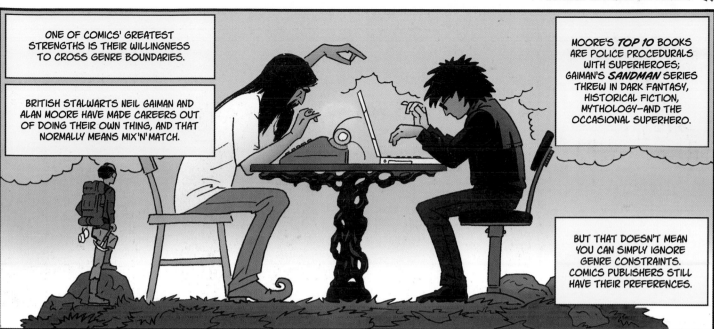

MOORE'S *TOP 10* BOOKS ARE POLICE PROCEDURALS WITH SUPERHEROES; GAIMAN'S *SANDMAN* SERIES THREW IN DARK FANTASY, HISTORICAL FICTION, MYTHOLOGY—AND THE OCCASIONAL SUPERHERO.

BUT THAT DOESN'T MEAN YOU CAN SIMPLY IGNORE GENRE CONSTRAINTS. COMICS PUBLISHERS STILL HAVE THEIR PREFERENCES.

A VERTIGO TITLE, FOR EXAMPLE, IS ALWAYS GOING TO BE DARKER AND MORE ADULT THAN THE MAINSTREAM DC UNIVERSE,

WHEREAS WILDSTORM STORIES WILL BE MORE OFFBEAT.

IT'S ALWAYS BEST TO REMEMBER THAT THE MAJOR PUBLISHERS TEND TO BE MORE CONSERVATIVE AND STICK WITH WHAT THEY KNOW SELLS.

IF YOU'RE GOING TO COME UP WITH SOMETHING A LITTLE DIFFERENT, THEN YOUR BEST COURSE IS GOING TO BE TRYING THE SMALLER, INDEPENDENT PUBLISHERS

LIKE KNOCKABOUT COMICS, FANTAGRAPHICS, DRAWN AND QUARTERLY, AND SLAVE LABOR.

AND OF COURSE, THERE'S ALWAYS SELF-PUBLISHING, SUCH AS *FRED THE CLOWN* BY ROGER LANGRIDGE AND *BONE* BY JEFF SMITH.

SCIENCE FICTION

EVERYONE KNOWS SCIENCE FICTION.

IT'S THAT STUFF WITH THE RAY GUNS AND BUG-EYED ALIENS AND CITY-SIZED SPACESHIPS BLASTING EACH OTHER TO COSMIC DUST.

WELL, YEAH—SOME OF IT IS.

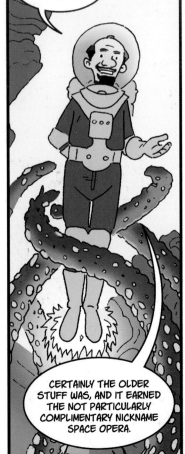

CERTAINLY THE OLDER STUFF WAS, AND IT EARNED THE NOT PARTICULARLY COMPLIMENTARY NICKNAME SPACE OPERA.

EARLY NEWSPAPER STRIPS LIKE *BUCK ROGERS* AND *FLASH GORDON* FELL INTO THAT CATEGORY...

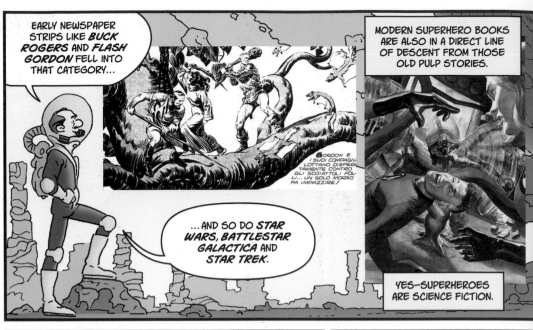

GORDON E I SUOI COMPAGNI LOTTANO DISPERATAMENTE CONTRO GLI SCOIATTOLI FOLLI... UN SOLO MORSO FA IMPAZZIRE!

...AND SO DO *STAR WARS, BATTLESTAR GALACTICA* AND *STAR TREK.*

MODERN SUPERHERO BOOKS ARE ALSO IN A DIRECT LINE OF DESCENT FROM THOSE OLD PULP STORIES.

YES—SUPERHEROES ARE SCIENCE FICTION.

BUT THE NEAR-FUTURE DYSTOPIAN BRITAIN OF ALAN MOORE'S *V FOR VENDETTA* IS ALSO SF.

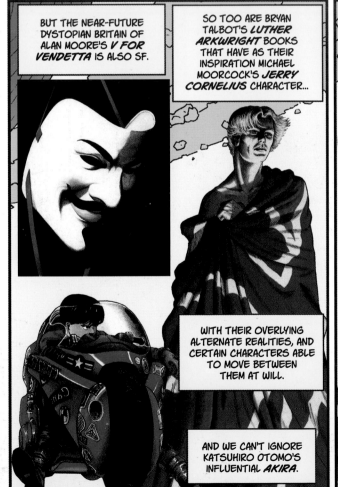

SO TOO ARE BRYAN TALBOT'S *LUTHER ARKWRIGHT* BOOKS THAT HAVE AS THEIR INSPIRATION MICHAEL MOORCOCK'S *JERRY CORNELIUS* CHARACTER...

WITH THEIR OVERLYING ALTERNATE REALITIES, AND CERTAIN CHARACTERS ABLE TO MOVE BETWEEN THEM AT WILL.

AND WE CAN'T IGNORE KATSUHIRO OTOMO'S INFLUENTIAL *AKIRA.*

WHAT YOU MUST NEVER DO IS MAKE THE MISTAKE OF BELIEVING ALL SF IS SET IN THE FUTURE. ITS MAJOR UNDERLYING THEMES ARE CONFLICT EITHER WITH TECHNOLOGY OR SOCIETY.

SOME MIGHT EVEN SAY IT'S OUR FEAR OF CHANGE...

...AND EXTRATERRESTRIALS ARE FREQUENTLY CONVENIENT CIPHERS FOR BOTH THAT AND MORE EARTHLY, REAL-LIFE FEARS.

THE X-MEN ARE A BEAUTIFUL EXAMPLE OF THIS: INITIALLY MEANT AS A PLEA FOR INTERRACIAL TOLERANCE, THE RECENT MOVIES HAVE BROADENED THE THEME.

NOW, IT INCLUDES ALL KINDS OF FEARED AND MISUNDERSTOOD "OUTSIDERS" (SUCH AS THE WELL-OBSERVED PARALLEL WITH HOMOPHOBIA).

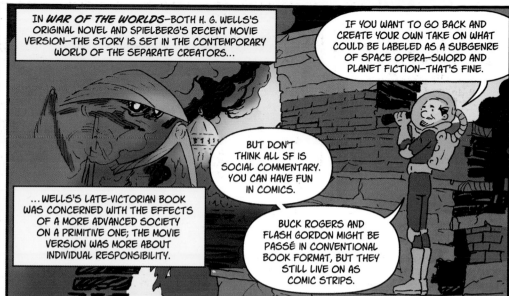

IN *WAR OF THE WORLDS*—BOTH H. G. WELLS'S ORIGINAL NOVEL AND SPIELBERG'S RECENT MOVIE VERSION—THE STORY IS SET IN THE CONTEMPORARY WORLD OF THE SEPARATE CREATORS...

...WELLS'S LATE-VICTORIAN BOOK WAS CONCERNED WITH THE EFFECTS OF A MORE ADVANCED SOCIETY ON A PRIMITIVE ONE; THE MOVIE VERSION WAS MORE ABOUT INDIVIDUAL RESPONSIBILITY.

IF YOU WANT TO GO BACK AND CREATE YOUR OWN TAKE ON WHAT COULD BE LABELED AS A SUBGENRE OF SPACE OPERA—SWORD AND PLANET FICTION—THAT'S FINE.

BUT DON'T THINK ALL SF IS SOCIAL COMMENTARY. YOU CAN HAVE FUN IN COMICS.

BUCK ROGERS AND FLASH GORDON MIGHT BE PASSÉ IN CONVENTIONAL BOOK FORMAT, BUT THEY STILL LIVE ON AS COMIC STRIPS.

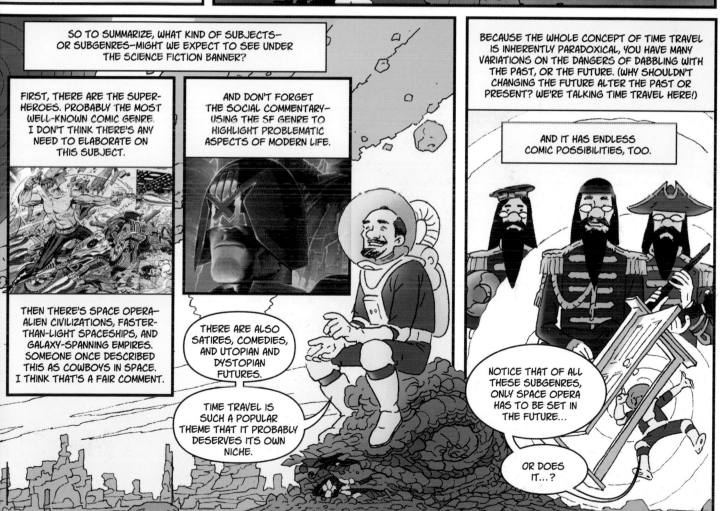

SO TO SUMMARIZE, WHAT KIND OF SUBJECTS—OR SUBGENRES—MIGHT WE EXPECT TO SEE UNDER THE SCIENCE FICTION BANNER?

FIRST, THERE ARE THE SUPER-HEROES. PROBABLY THE MOST WELL-KNOWN COMIC GENRE. I DON'T THINK THERE'S ANY NEED TO ELABORATE ON THIS SUBJECT.

AND DON'T FORGET THE SOCIAL COMMENTARY—USING THE SF GENRE TO HIGHLIGHT PROBLEMATIC ASPECTS OF MODERN LIFE.

BECAUSE THE WHOLE CONCEPT OF TIME TRAVEL IS INHERENTLY PARADOXICAL, YOU HAVE MANY VARIATIONS ON THE DANGERS OF DABBLING WITH THE PAST, OR THE FUTURE. (WHY SHOULDN'T CHANGING THE FUTURE ALTER THE PAST OR PRESENT? WE'RE TALKING TIME TRAVEL HERE!)

AND IT HAS ENDLESS COMIC POSSIBILITIES, TOO.

THEN THERE'S SPACE OPERA—ALIEN CIVILIZATIONS, FASTER-THAN-LIGHT SPACESHIPS, AND GALAXY-SPANNING EMPIRES. SOMEONE ONCE DESCRIBED THIS AS COWBOYS IN SPACE. I THINK THAT'S A FAIR COMMENT.

THERE ARE ALSO SATIRES, COMEDIES, AND UTOPIAN AND DYSTOPIAN FUTURES.

TIME TRAVEL IS SUCH A POPULAR THEME THAT IT PROBABLY DESERVES ITS OWN NICHE.

NOTICE THAT OF ALL THESE SUBGENRES, ONLY SPACE OPERA HAS TO BE SET IN THE FUTURE...

OR DOES IT...?

HORROR

HORROR HAS BEEN A MAINSTAY OF THE COMIC STRIP FOR ALMOST AS LONG AS SCIENCE FICTION. HOWEVER, UNLIKE SF, IT'S HAD QUITE A HARD RIDE.

THE TEMPTATION IN HORROR (BOTH MOVIES AND COMICS) HAS ALWAYS BEEN TO TRY TO TOP THE GROSS-OUT EFFECT OF THE LAST PIECE.

WHILE PRINTING WAS STILL DONE ONLY IN BLACK AND WHITE, THE EFFECT WAS MOSTLY OF ATMOSPHERE—DARK, BROODING SHADOWS—

BUT ONCE COMIC BOOKS BEGAN TO APPEAR IN FULL COLOR, THE CRITICS SAT UP AND TOOK NOTICE.

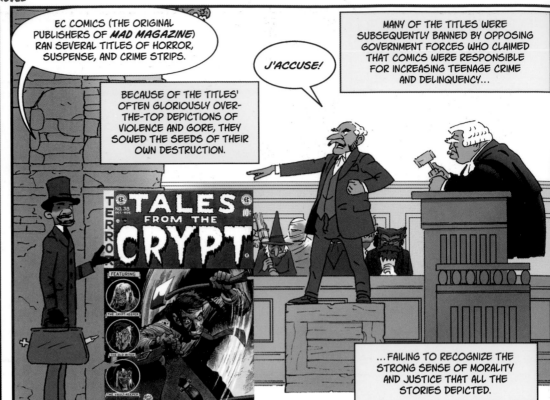

EC COMICS (THE ORIGINAL PUBLISHERS OF *MAD MAGAZINE*) RAN SEVERAL TITLES OF HORROR, SUSPENSE, AND CRIME STRIPS.

BECAUSE OF THE TITLES' OFTEN GLORIOUSLY OVER-THE-TOP DEPICTIONS OF VIOLENCE AND GORE, THEY SOWED THE SEEDS OF THEIR OWN DESTRUCTION.

J'ACCUSE!

MANY OF THE TITLES WERE SUBSEQUENTLY BANNED BY OPPOSING GOVERNMENT FORCES WHO CLAIMED THAT COMICS WERE RESPONSIBLE FOR INCREASING TEENAGE CRIME AND DELINQUENCY...

...FAILING TO RECOGNIZE THE STRONG SENSE OF MORALITY AND JUSTICE THAT ALL THE STORIES DEPICTED.

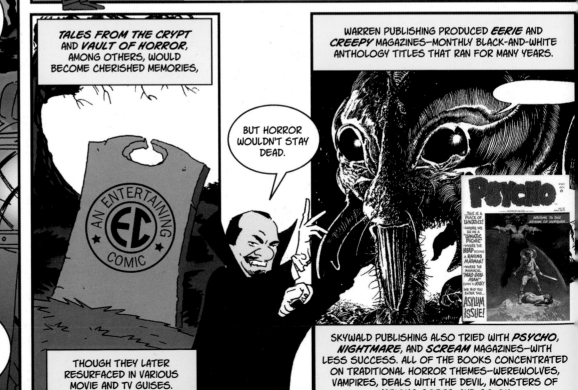

TALES FROM THE CRYPT AND *VAULT OF HORROR*, AMONG OTHERS, WOULD BECOME CHERISHED MEMORIES,

THOUGH THEY LATER RESURFACED IN VARIOUS MOVIE AND TV GUISES.

BUT HORROR WOULDN'T STAY DEAD.

WARREN PUBLISHING PRODUCED *EERIE* AND *CREEPY* MAGAZINES—MONTHLY BLACK-AND-WHITE ANTHOLOGY TITLES THAT RAN FOR MANY YEARS.

SKYWALD PUBLISHING ALSO TRIED WITH *PSYCHO, NIGHTMARE,* AND *SCREAM* MAGAZINES—WITH LESS SUCCESS. ALL OF THE BOOKS CONCENTRATED ON TRADITIONAL HORROR THEMES—WEREWOLVES, VAMPIRES, DEALS WITH THE DEVIL, MONSTERS OF VARIOUS SORTS, AND SO ON.

ALTHOUGH THE SKYWALD TITLES HAD A FAMILIAR SENSE OF JUSTICE AND MORALITY TO TEMPER THEIR OFTEN GRATUITOUS ARTWORK,

DEMONS AND MONSTERS ARE THERE TO PLAY A ROLE,

BUT UNLIKE ALIENS—WHO REPRESENT EXTERNAL FEARS AND ANXIETIES—THE CREATURES OF THE HORROR WORLD ARE OUR INTERNAL FEARS MADE GOOEY FLESH.

ALL THOSE REPRESSED EMOTIONS AND THOUGHTS THAT ANALYSTS GET PAID TOP DOLLAR TO FIND ARE SET FREE IN DISGUISE.

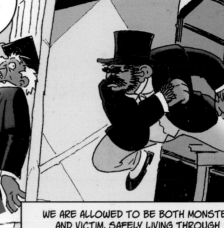

THE WARREN TITLES TENDED TO BE MORE TONGUE IN CHEEK—MORE CONCERNED WITH A SURPRISE OR TRICK ENDING THAN ANY MORAL LESSON.

WE ARE ALLOWED TO BE BOTH MONSTER AND VICTIM, SAFELY LIVING THROUGH THOSE EMOTIONS—SECURE IN THE KNOWLEDGE THAT WHEN WE CLOSE THE BOOK, IT WILL ALL GO AWAY.

THESE DAYS, HORROR OFTEN MIXES IN SOME ASPECTS OF THE SUPERHERO GENRE...

AHH JEEZ!

BUT THERE ARE STILL EXAMPLES OF ANTHOLOGY MAGAZINES THAT DATE THEIR STYLE BACK TO THE EC TRADITION.

GRAVE TALES FROM CEMETERY DANCE IS ONE EXAMPLE, WITH ITS STARK BLACK-AND-WHITE ARTWORK,

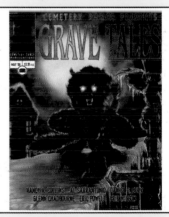

...*BLADE, SPAWN,* AND *HELLBOY* SUCCESSFULLY CHERRY-PICKED ASPECTS FROM MANY COMICS AND WENT ON TO BE MAJOR HOLLYWOOD MOVIES.

AND FICTION THAT'S OFTEN BY AUTHORS NOT USUALLY ASSOCIATED WITH COMICS.

ANOTHER IS *HORROR CLASSICS,* PUBLISHED BY EUREKA PRODUCTIONS,

ALTHOUGH THE FICTION HERE IS, AS YOU CAN GUESS, ADAPTED FROM CLASSIC TALES BY SUCH LUMINARIES AS *HP LOVECRAFT, EDGAR ALLAN POE, JACK LONDON,* AND *WW JACOBS.*

FANTASY

THE TERM *FANTASY* ALWAYS CONJURES UP IMMEDIATE IMAGES OF *LORD OF THE RINGS*, *HARRY POTTER*, AND VARIOUS MIGHTILY THEWED BARBARIANS.

CERTAINLY THEY'RE THE BACKBONE—BUT THERE'S MORE TO FANTASY THAN JUST THAT.

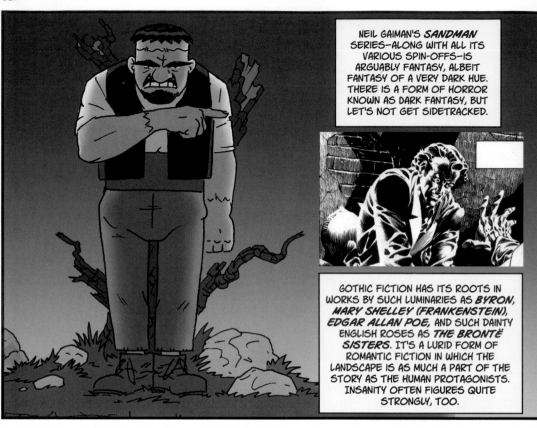

NEIL GAIMAN'S *SANDMAN* SERIES—ALONG WITH ALL ITS VARIOUS SPIN-OFFS—IS ARGUABLY FANTASY, ALBEIT FANTASY OF A VERY DARK HUE. THERE IS A FORM OF HORROR KNOWN AS DARK FANTASY, BUT LET'S NOT GET SIDETRACKED.

GOTHIC FICTION HAS ITS ROOTS IN WORKS BY SUCH LUMINARIES AS *BYRON*, *MARY SHELLEY (FRANKENSTEIN)*, *EDGAR ALLAN POE*, AND SUCH DAINTY ENGLISH ROSES AS *THE BRONTË SISTERS*. IT'S A LURID FORM OF ROMANTIC FICTION IN WHICH THE LANDSCAPE IS AS MUCH A PART OF THE STORY AS THE HUMAN PROTAGONISTS. INSANITY OFTEN FIGURES QUITE STRONGLY, TOO.

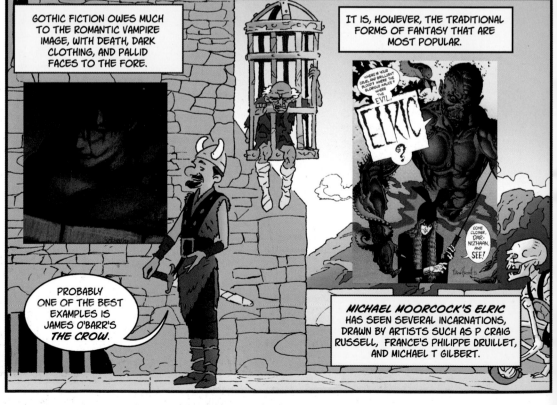

GOTHIC FICTION OWES MUCH TO THE ROMANTIC VAMPIRE IMAGE, WITH DEATH, DARK CLOTHING, AND PALLID FACES TO THE FORE.

PROBABLY ONE OF THE BEST EXAMPLES IS JAMES O'BARR'S *THE CROW*.

IT IS, HOWEVER, THE TRADITIONAL FORMS OF FANTASY THAT ARE MOST POPULAR.

MICHAEL MOORCOCK'S ELRIC HAS SEEN SEVERAL INCARNATIONS, DRAWN BY ARTISTS SUCH AS P CRAIG RUSSELL, FRANCE'S PHILIPPE DRUILLET, AND MICHAEL T GILBERT.

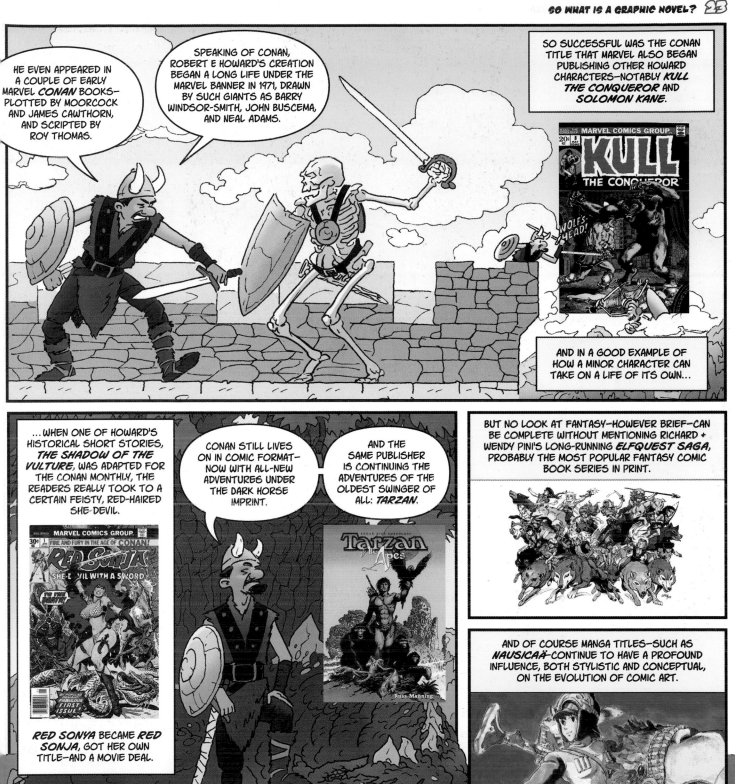

HE EVEN APPEARED IN A COUPLE OF EARLY MARVEL *CONAN* BOOKS—PLOTTED BY MOORCOCK AND JAMES CAWTHORN, AND SCRIPTED BY ROY THOMAS.

SPEAKING OF CONAN, ROBERT E HOWARD'S CREATION BEGAN A LONG LIFE UNDER THE MARVEL BANNER IN 1971, DRAWN BY SUCH GIANTS AS BARRY WINDSOR-SMITH, JOHN BUSCEMA, AND NEAL ADAMS.

SO SUCCESSFUL WAS THE CONAN TITLE THAT MARVEL ALSO BEGAN PUBLISHING OTHER HOWARD CHARACTERS—NOTABLY *KULL THE CONQUEROR* AND *SOLOMON KANE*.

AND IN A GOOD EXAMPLE OF HOW A MINOR CHARACTER CAN TAKE ON A LIFE OF ITS OWN...

...WHEN ONE OF HOWARD'S HISTORICAL SHORT STORIES, *THE SHADOW OF THE VULTURE*, WAS ADAPTED FOR THE CONAN MONTHLY, THE READERS REALLY TOOK TO A CERTAIN FEISTY, RED-HAIRED SHE-DEVIL.

CONAN STILL LIVES ON IN COMIC FORMAT—NOW WITH ALL-NEW ADVENTURES UNDER THE DARK HORSE IMPRINT.

AND THE SAME PUBLISHER IS CONTINUING THE ADVENTURES OF THE OLDEST SWINGER OF ALL: *TARZAN*.

RED SONYA BECAME *RED SONJA*, GOT HER OWN TITLE—AND A MOVIE DEAL.

BUT NO LOOK AT FANTASY—HOWEVER BRIEF—CAN BE COMPLETE WITHOUT MENTIONING RICHARD + WENDY PINI'S LONG-RUNNING *ELFQUEST SAGA*, PROBABLY THE MOST POPULAR FANTASY COMIC BOOK SERIES IN PRINT.

AND OF COURSE MANGA TITLES—SUCH AS *NAUSICAÄ*—CONTINUE TO HAVE A PROFOUND INFLUENCE, BOTH STYLISTIC AND CONCEPTUAL, ON THE EVOLUTION OF COMIC ART.

CRIME & ADULT

ONE GENRE THAT HAS REALLY TAKEN OFF IN GRAPHIC NOVELS IS CRIME.

BECAUSE THE TARGET AUDIENCE HAS ALWAYS BEEN OLDER (FOR MATURE READERS, AS THE COVER BLURB HAS IT...), SUBJECT MATTER CAN BE A LITTLE MORE HARD-HITTING.

AND THERE'S NOTHING MORE HARD-HITTING THAN A SERIES OF BOOKS LIKE FRANK MILLER'S *SIN CITY*:

A LOOK THAT TRANSFERRED PERFECTLY TO THE BIG SCREEN.

NO WONDER QUENTIN TARANTINO, THE KING OF CINEMA COOL, WAS ASKED TO GUEST-DIRECT A SEGMENT OF THE FRANK MILLER/ROBERT RODRIGUEZ MOVIE.

ULTRA-VIOLENT, ULTRA-NOIR, WHERE MEN ARE TOUGHER AND WOMEN SEXIER THAN YOU'LL EVER FIND IN REAL LIFE.

NOT ONLY THAT, BUT THE ARTWORK IS INCREDIBLY STYLISH—BLACK AND WHITE WITH OCCASIONAL SPOT COLOR,

NOW PLAY

SIN CIT

ONE OF THE EARLIEST GRAPHIC NOVELS (1968) WAS ARTIST/WRITER GIL KANE'S *HIS NAME IS SAVAGE*; A BRUTAL TALE THAT HAD THE CRITICS UP IN ARMS. JUST AS WELL IT WAS ONLY IN BLACK AND WHITE.

THE TRADITION CONTINUES TODAY.

THE ROAD TO PERDITION (1998) BEGAN LIFE AS A GRAPHIC NOVEL WRITTEN BY MAX ALLAN COLLINS AND ILLUSTRATED BY RICHARD PIERS RAYNER...

A HARD, BRUTAL RECREATION OF LIFE IN DEPRESSION-STRUCK AMERICA WHEN THE ONLY RULE WAS MOB RULE.

RAYMOND CHANDLER'S ICONIC DETECTIVE *PHILIP MARLOWE* HAS ALSO MADE IT INTO A GRAPHIC NOVEL...

FAREWELL, MY LOVELY.

THIS VOLUME COLLECTS THREE CLASSIC STORIES ADAPTED FOR COMIC BOOKS—APPROPRIATELY, WITH ONLY ONE IN (VERY MEAGER) COLOR.

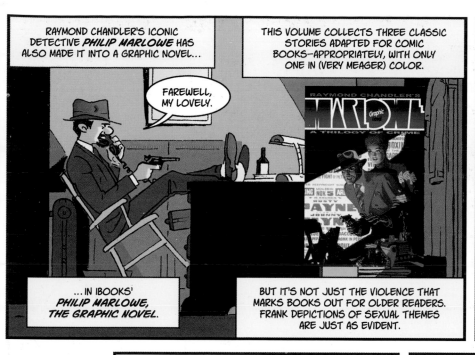

...IN IBOOKS' *PHILIP MARLOWE, THE GRAPHIC NOVEL.*

BUT IT'S NOT JUST THE VIOLENCE THAT MARKS BOOKS OUT FOR OLDER READERS. FRANK DEPICTIONS OF SEXUAL THEMES ARE JUST AS EVIDENT.

HOWARD CHAYKIN'S *BLACK KISS* PROVOKED MUCH PROTEST WHEN FIRST PUBLISHED, NOT ONLY FOR ITS VIOLENCE AND SUGGESTION THAT SOCIETY IS INNATELY CORRUPT AND SLEAZY,

BUT ALSO FOR ITS SEX SCENES THAT VERGED ON THE PORNOGRAPHIC. NONE OF THIS HURT THE SALES, OF COURSE.

EUROPE HAS ITS OWN HISTORY OF ADULT AND EROTIC COMICS.

THE ITALIAN ARTIST MILO MANARA, BEST KNOWN FOR HIS NOTORIOUS *CLICK (IL GIOTTO)* SERIES, FIRST CAME TO BE NOTICED IN 1978 WITH *GIUSEPPE BERGMAN,*

CENSORED

A COMBINATION OF EXPERIMENTAL NARRATIVE AND EXPLICIT SEX.

THE FOUR EPISODES OF *CLICK* (BEGUN IN 1983) REVOLVE AROUND THE ADVENTURES OF CLAUDIA CHRISTIANI—A SHY WOMAN MARRIED TO A MAN OLDER (AND RICHER) THAN HER—

WHO TURNS INTO A NYMPHOMANIAC AFTER A FRIEND OF HER HUSBAND ACTIVATES A REMOTE CONTROL DEVICE.

IN BRITAIN, THE UBIQUITOUS ALAN MOORE'S *LOST GIRLS* PROJECT HAS HAD EXTRACTS PUBLISHED VARIOUSLY IN *TABOO* MAGAZINE AND KITCHEN SINK PRESS'S *TUNDRA.*

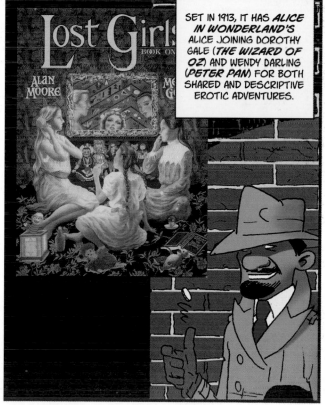

SET IN 1913, IT HAS *ALICE IN WONDERLAND'S* ALICE JOINING DOROTHY GALE (*THE WIZARD OF OZ*) AND WENDY DARLING (*PETER PAN*) FOR BOTH SHARED AND DESCRIPTIVE EROTIC ADVENTURES.

MANGA

JAPANESE COMICS (MANGA) AND THEIR ANIMATED CARTOON OFFSHOOTS (ANIME) HAVE BECOME SO POPULAR WORLDWIDE THAT MAYBE THEY DESERVE A GENRE SLOT ALL TO THEMSELVES.

CERTAINLY, BOOKSTORES AND COMICS STORES NOW NORMALLY RESERVE SHELF SPACE JUST FOR MANGA. BUT THE FUNNY THING IS THAT MANGA COVERS A BAFFLING ARRAY OF GENRES ITSELF, FAR MORE THAN AMERICAN AND EUROPEAN COMICS.

WOULD A COMIC STYLE BE USED FOR CRIMINAL "WANTED" POSTERS IN THE WEST, FOR INSTANCE? OR RECIPE BOOKS?

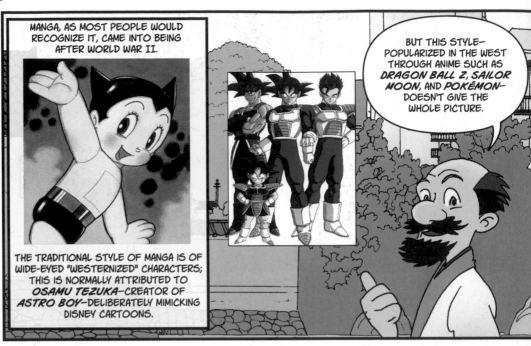

MANGA, AS MOST PEOPLE WOULD RECOGNIZE IT, CAME INTO BEING AFTER WORLD WAR II.

THE TRADITIONAL STYLE OF MANGA IS OF WIDE-EYED "WESTERNIZED" CHARACTERS; THIS IS NORMALLY ATTRIBUTED TO *OSAMU TEZUKA*—CREATOR OF *ASTRO BOY*—DELIBERATELY MIMICKING DISNEY CARTOONS.

BUT THIS STYLE— POPULARIZED IN THE WEST THROUGH ANIME SUCH AS *DRAGON BALL Z, SAILOR MOON,* AND *POKÉMON*— DOESN'T GIVE THE WHOLE PICTURE.

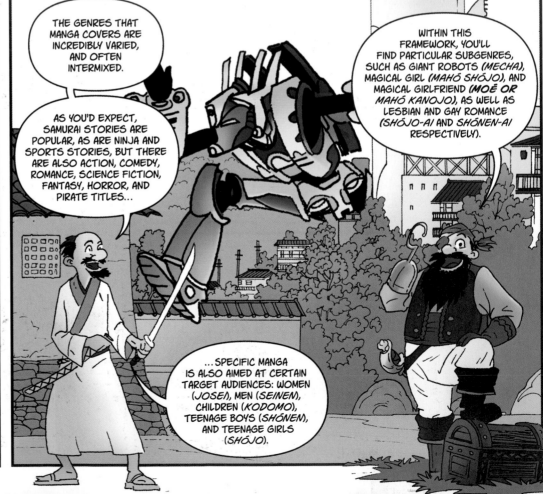

THE GENRES THAT MANGA COVERS ARE INCREDIBLY VARIED, AND OFTEN INTERMIXED.

AS YOU'D EXPECT, SAMURAI STORIES ARE POPULAR, AS ARE NINJA AND SPORTS STORIES, BUT THERE ARE ALSO ACTION, COMEDY, ROMANCE, SCIENCE FICTION, FANTASY, HORROR, AND PIRATE TITLES...

WITHIN THIS FRAMEWORK, YOU'LL FIND PARTICULAR SUBGENRES, SUCH AS GIANT ROBOTS (*MECHA*), MAGICAL GIRL (*MAHÓ SHÓJO*), AND MAGICAL GIRLFRIEND (*MOÉ OR MAHÓ KANOJO*), AS WELL AS LESBIAN AND GAY ROMANCE (*SHÓJO-AI* AND *SHÓNEN-AI* RESPECTIVELY).

...SPECIFIC MANGA IS ALSO AIMED AT CERTAIN TARGET AUDIENCES: WOMEN (*JOSEI*), MEN (*SEINEN*), CHILDREN (*KODOMO*), TEENAGE BOYS (*SHÓNEN*), AND TEENAGE GIRLS (*SHÓJO*).

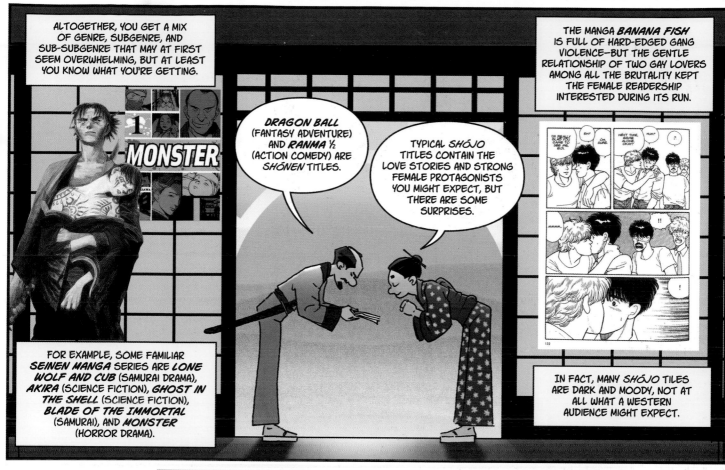

ALTOGETHER, YOU GET A MIX OF GENRE, SUBGENRE, AND SUB-SUBGENRE THAT MAY AT FIRST SEEM OVERWHELMING, BUT AT LEAST YOU KNOW WHAT YOU'RE GETTING.

DRAGON BALL (FANTASY ADVENTURE) AND *RANMA ½* (ACTION COMEDY) ARE *SHŌNEN* TITLES.

TYPICAL *SHŌJO* TITLES CONTAIN THE LOVE STORIES AND STRONG FEMALE PROTAGONISTS YOU MIGHT EXPECT, BUT THERE ARE SOME SURPRISES.

THE MANGA *BANANA FISH* IS FULL OF HARD-EDGED GANG VIOLENCE—BUT THE GENTLE RELATIONSHIP OF TWO GAY LOVERS AMONG ALL THE BRUTALITY KEPT THE FEMALE READERSHIP INTERESTED DURING ITS RUN.

FOR EXAMPLE, SOME FAMILIAR *SEINEN MANGA* SERIES ARE *LONE WOLF AND CUB* (SAMURAI DRAMA), *AKIRA* (SCIENCE FICTION), *GHOST IN THE SHELL* (SCIENCE FICTION), *BLADE OF THE IMMORTAL* (SAMURAI), AND *MONSTER* (HORROR DRAMA).

IN FACT, MANY *SHŌJO* TILES ARE DARK AND MOODY, NOT AT ALL WHAT A WESTERN AUDIENCE MIGHT EXPECT.

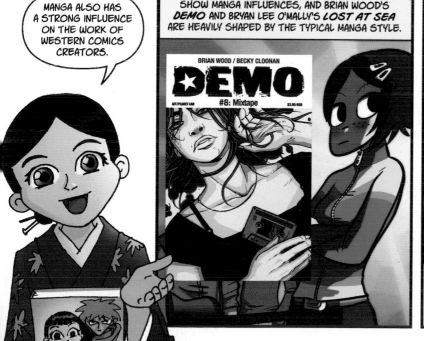

MANGA ALSO HAS A STRONG INFLUENCE ON THE WORK OF WESTERN COMICS CREATORS.

FRANK MILLER'S *RONIN* AND SCOTT MCCLOUD'S *ZOT!* SHOW MANGA INFLUENCES, AND BRIAN WOOD'S *DEMO* AND BRYAN LEE O'MALLY'S *LOST AT SEA* ARE HEAVILY SHAPED BY THE TYPICAL MANGA STYLE.

IN FRANCE, *LA NOUVELLE MANGA* IS A MOVEMENT SEEKING TO COMBINE MANGA WITH TRADITIONAL FRANCO-BELGIAN COMICS.

AND IS ENCOURAGING OTHER ARTISTS TO JOIN IN.

FRÉDÉRIC BOILET—AN EXPATRIATE FRENCHMAN LIVING IN JAPAN—ADOPTED THE TERM (FIRST USED BY THE EDITOR OF JAPANESE MANGA MAGAZINE *COMIKER*, KIYOSHI KUSUMI)

IS THERE ANYTHING LEFT?

THE GENRES THAT ARE POPULAR IN MODERN COMICS HAVE NOT ALWAYS BEEN, AND WILL NOT ALWAYS BE, THE MOST POPULAR GENRES WITH THE PUBLIC.

IN FACT, GENRE POPULARITY CAN CHANGE ACCORDING TO MANY FACTORS—GEOGRAPHICAL REGIONS, IMPORTANT EVENTS, OR JUST A FILM OR BOOK THAT CAPTURES THE PUBLIC'S IMAGINATION AND INCREASES INTEREST IN A CERTAIN SUBJECT.

WITH THAT IN MIND, IT STANDS TO REASON THAT THERE ARE MANY OTHER GENRES AND SUB-GENRES ASIDE FROM THE ONES COVERED HERE, BUT FOR WHATEVER REASON THEY DON'T FIGURE SO STRONGLY IN MODERN COMICS.

WESTERNS ARE AN OBVIOUS ONE.

WHERE ONCE MOVIES, TV SERIES, NOVELS, AND COMIC STRIPS ABOUNDED, COWBOYS JUST DON'T SEEM TO EXCITE OUR ATTENTION THEY WAY THEY USED TO.

THE SPY/THRILLER STRIP SEEMS ALSO TO BE AS MUCH A PART OF HISTORY AS THE COLD WAR AND THE BERLIN WALL.

ONCE A MAINSTAY OF MANY NEWSPAPER STRIPS, IT TOO HAS SLIPPED AWAY INTO NOSTALGIA.

Modesty Blaise
by Peter O'Donnell

EVEN THOUGH THE BRITISH BLACK-AND-WHITE NEWSPAPER STRIPS OF *JAMES BOND* AND PETER O'DONNELL'S *MODESTY BLAISE* HAVE RECENTLY BEEN PACKAGED AND REPRINTED IN COLLECTED VOLUMES,

THE TARGET AUDIENCE IS MORE LIKELY THOSE WHO REMEMBER THE ORIGINALS THAN A NEW, YOUNGER AUDIENCE.

GUNSMOKE, *THE LONE RANGER*, AND *RANGE RIDER* ARE NOW OBJECTS OF NOSTALGIA. HOWEVER, THERE ARE EXCEPTIONS.

MARVEL'S *RAWHIDE KID* IS STILL GOING, AND WAS RELAUNCHED IN 2003 AFTER A HIATUS OF MORE THAN THIRTY YEARS,

BUT ITS SUCCESS MAY BE MORE BECAUSE OF THE RISQUÉ COMEDY THAN ANY TRADITIONAL WESTERN THEME.

THE LONG-RUNNING FRENCH SERIES *BLUEBERRY* WAS POPULAR ENOUGH TO INSPIRE A MOVIE IN 2004, SOME FORTY YEARS AFTER THE CHARACTER FIRST APPEARED (IN *PILOTE*, OCTOBER 1963).

BLUEBERRY'S CREATOR WAS ONE JEAN GIRAUD—BETTER KNOWN THESE DAYS AS SCIENCE-FICTION ARTIST AND WRITER MOEBIUS.

THE SWASHBUCKLER IS ANOTHER GENRE THAT CURRENTLY SEEMS TO BE RESTING. HAL FOSTER'S *PRINCE VALIANT* STRIP, STARTED IN 1937, IS ONE OF THE FEW SURVIVORS...

WHEREAS *ZORRO*—DRAWN BY THE INIMITABLE ALEX TOTH—IS PROBABLY BETTER KNOWN NOW FOR THE MOVIE VERSION THAN EITHER THE ORIGINAL BOOK OR COMIC STRIP.

ANOTHER GREAT STAPLE OF COMIC BOOKS USED TO BE THE WAR STORY.

FOR YEARS, DC'S *SGT. ROCK* (WITH ARTWORK BY THE GREAT JOE KUBERT) TOOK ON THE NAZIS ALMOST SINGLE-HANDEDLY.

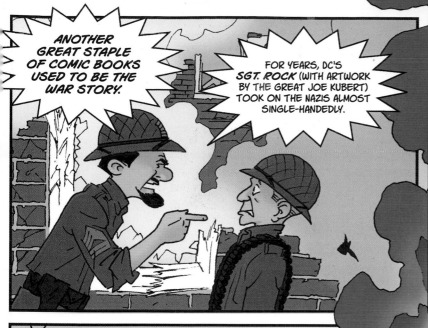

OVER AT MARVEL, *SGT. FURY* WAS DOING MUCH THE SAME (BEFORE HE WAS RESURRECTED IN THE MODERN WORLD AS SUPERSPY *NICK FURY, AGENT OF S.H.I.E.L.D.*).

ALL OF THE COMPANIES—BIG AND SMALL—PUBLISHED WAR COMICS. AND IT WASN'T ONLY WORLD WAR II THAT INSPIRED THE STORIES: WORLD WAR I, THE KOREAN WAR, THE AMERICAN REVOLUTIONARY WAR—ALL HAD THEIR HEROES.

MARVEL'S *THE 'NAM* IS A RECENT EXAMPLE OF THE GENRE, SET IN THE VIETNAM WAR.

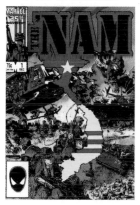

WRITTEN BY A VIETNAM VETERAN, IT WAS TOLD IN REAL TIME—A MONTH IN THE STORY PASSING WITH EACH MONTHLY ISSUE.

THE STORIES WEREN'T ALWAYS SO TRUE TO LIFE, THOUGH. *TOMAHAWK*—DC'S REVOLUTIONARY HERO—BECAME INVOLVED IN INCREASINGLY BIZARRE ADVENTURES, TAKING HIM AND HIS FRIENDS FARTHER AWAY FROM FIGHTING THE BRITISH AND INSTEAD, ENGAGING A VARIETY OF MONSTERS.

IN A SIMILAR CURIOUS WAR CROSSOVER SERIES—*WEIRD WAR TALES*—DC PITCHED VARIOUS GROUPS OF MARINES AND GIS AGAINST DINOSAURS, GHOSTS, MONSTERS, AND OTHER SUPERNATURAL PHENOMENA.

GOLD KEY'S *TUROK, SON OF STONE* WAS A NATIVE AMERICAN TRAPPED IN A LOST VALLEY,

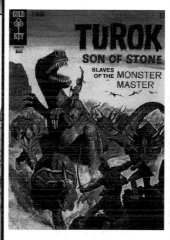

TAKING ON A VARIETY OF PREHISTORIC CREATURES.

AS WE SAW EARLIER, ALTHOUGH GENRES PASS IN AND OUT OF FASHION, THEY NEVER REALLY DISAPPEAR.

THE INTERNET HAS OPENED THE DOOR FOR MANY NEW ARTISTS, AND HAS GIVEN THEM A FORUM IN WHICH TO EXPLORE ANY GENRE...

...AND EVEN CREATE A FEW NEW ONES.

EXAMPLES IN PRINT

IN SUPERHERO TERMS, PROBABLY THE TWO MOST FAMOUS TITLES ARE ALAN MOORE + DAVE GIBBONS'S *WATCHMEN* AND FRANK MILLER'S *THE DARK KNIGHT RETURNS.*

MOORE + GIBBONS TRIED TO IMAGINE THE IMPACT OF SUPERHEROES IN THE "REAL" WORLD,

AND MILLER'S GRIM BOOK WOULD FORM THE TEMPLATE FOR THE LATEST INCARNATION OF BATMAN, ONE OF THE WORLD'S MOST FAMOUS COSTUMED CHARACTERS.

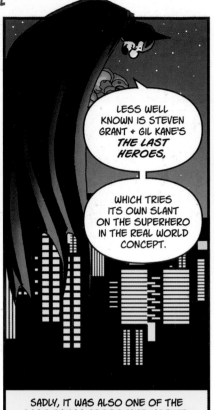

LESS WELL KNOWN IS STEVEN GRANT + GIL KANE'S *THE LAST HEROES,*

WHICH TRIES ITS OWN SLANT ON THE SUPERHERO IN THE REAL WORLD CONCEPT.

SADLY, IT WAS ALSO ONE OF THE LAST THINGS ARTIST KANE WORKED ON BEFORE SUCCUMBING TO CANCER.

OFFBEAT SCIENCE FICTION CAN BE FOUND IN ENKI BILAL'S *GODS IN CHAOS* AND *THE WOMAN TRAP,*

MIXING EGYPTIAN GODS WITH A FUTUR DYSTOPIA THAT FEELS STRANGELY PLAUSIBLE.

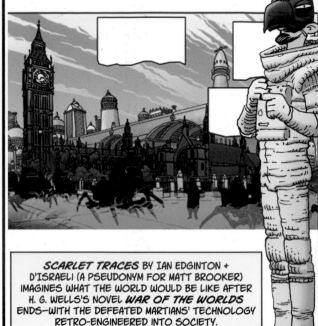

SCARLET TRACES BY IAN EDGINTON + D'ISRAELI (A PSEUDONYM FOR MATT BROOKER) IMAGINES WHAT THE WORLD WOULD BE LIKE AFTER H. G. WELLS'S NOVEL *WAR OF THE WORLDS* ENDS—WITH THE DEFEATED MARTIANS' TECHNOLOGY RETRO-ENGINEERED INTO SOCIETY.

ONE OF THE BEST HORROR TITLES IN RECENT YEARS HAS BEEN *LOVECRAFT,* ADAPTED BY KEITH GIFFEN FROM A SCREENPLAY BY HANS RODIONOFF, AND ILLUSTRATED BY ENRIQUE BRECCIA.

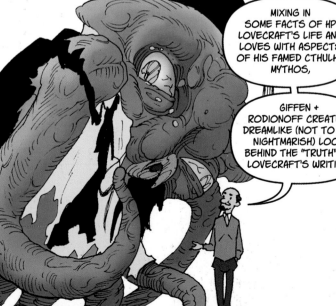

MIXING IN SOME FACTS OF HP LOVECRAFT'S LIFE AND LOVES WITH ASPECTS OF HIS FAMED CTHULHU MYTHOS,

GIFFEN + RODIONOFF CREATE A DREAMLIKE (NOT TO SAY NIGHTMARISH) LOOK BEHIND THE "TRUTH" OF LOVECRAFT'S WRITING.

FANTASY IS WELL REPRESENTED IN COMIC BOOKS. ONE INTERESTING CASE IS *MICHAEL MOORCOCK'S MULTIVERSE.*

MOORCOCK'S IDEA OF INITIALLY SEPARATE LITERARY CREATIONS (FOR EXAMPLE, *ELRIC, HAWKMOON,* AND *JERRY CORNELIUS*) THAT ARE IN FACT ALL INCARNATIONS OF THE SAME "ETERNAL CHAMPION" WHO EXISTS IN ALL TIMELINES AND UNIVERSES.

WE CAN'T MENTION CRIME BOOKS WITHOUT AGAIN BRINGING UP FRANK MILLER'S SEVERAL *SIN CITY* VOLUMES, BUT THERE ARE MANY OTHER EXAMPLES.

JOHN WAGNER + VINCENT LOCKE'S *A HISTORY OF VIOLENCE* IS SIMILARLY DISTURBING, IF LESS STYLIZED, PROBING THE EFFECTS OF VIOLENCE ON ORDINARY PEOPLE'S LIVES.

BRIAN AZZARELLO + EDUARDO RISSO'S *100 BULLETS* IS A NOIR MASTERPIECE ON THE SUBJECT OF REVENGE.

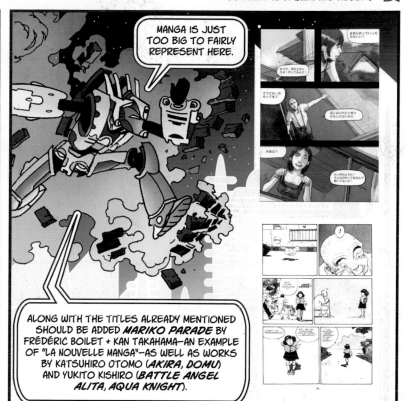

MANGA IS JUST TOO BIG TO FAIRLY REPRESENT HERE.

ALONG WITH THE TITLES ALREADY MENTIONED SHOULD BE ADDED *MARIKO PARADE* BY FRÉDÉRIC BOILET + KAN TAKAHAMA—AN EXAMPLE OF "LA NOUVELLE MANGA"—AS WELL AS WORKS BY KATSUHIRO OTOMO (*AKIRA, DOMU*) AND YUKITO KISHIRO (*BATTLE ANGEL ALITA, AQUA KNIGHT*).

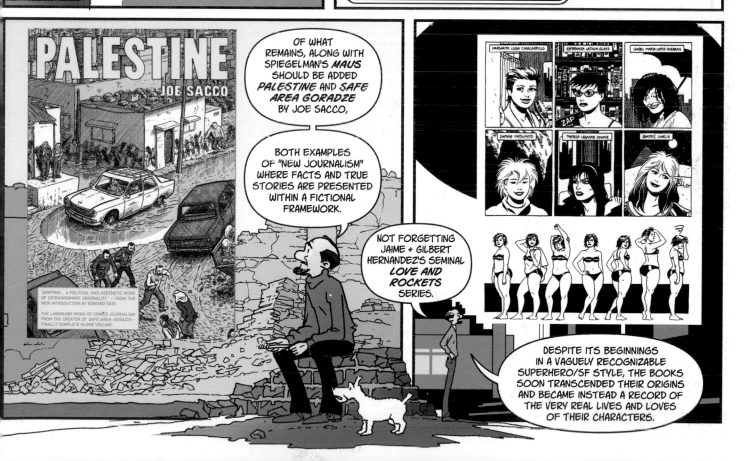

OF WHAT REMAINS, ALONG WITH SPIEGELMAN'S *MAUS* SHOULD BE ADDED *PALESTINE* AND *SAFE AREA GORAZDE* BY JOE SACCO,

BOTH EXAMPLES OF "NEW JOURNALISM" WHERE FACTS AND TRUE STORIES ARE PRESENTED WITHIN A FICTIONAL FRAMEWORK.

NOT FORGETTING JAIME + GILBERT HERNANDEZ'S SEMINAL *LOVE AND ROCKETS* SERIES.

DESPITE ITS BEGINNINGS IN A VAGUELY RECOGNIZABLE SUPERHERO/SF STYLE, THE BOOKS SOON TRANSCENDED THEIR ORIGINS AND BECAME INSTEAD A RECORD OF THE VERY REAL LIVES AND LOVES OF THEIR CHARACTERS.

...AND ELEMENTS

CHAPTER 2

TERMINOLOGY . 34
FRAMES OR PANELS? . 36
CONSTRUCTING A STORYLINE 38
BALLOONS + BOXES . 40
CHARACTERIZATION . 42

TERMINOLOGY

THERE ARE VARIOUS TERMS THAT, IF YOU HAVEN'T ALREADY DONE SO, YOU'LL COME ACROSS IN WRITING AND ILLUSTRATING A GRAPHIC NOVEL.

THE PART OF THE PROCESS YOU'RE INVOLVED IN WILL DICTATE WHICH TERMS YOU NEED TO BE FAMILIAR WITH.

EVERYBODY KNOWS A COMIC STRIP IS SPLIT INTO A PROGRESSION OF SMALL PICTURES THAT FOLLOW THE ACTION. THESE ARE KNOWN AS PANELS (OR, SOMETIMES, FRAMES) AND FOLLOW A WELL-WORN CONVENTION— TRACKING FROM LEFT TO RIGHT AND DOWN THE PAGE.

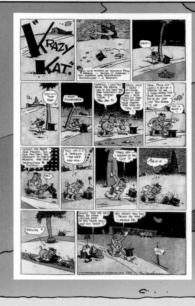

THERE ARE A COUPLE OF IMMEDIATE EXCEPTIONS TO THIS: MANGA FOLLOWS EASTERN TRADITION BY STARTING AT WHAT WESTERNERS WOULD CONSIDER THE BACK OF THE BOOK AND READING RIGHT TO LEFT.

QUITE A LOT OF MANGA AVAILABLE IN THE WEST HAS BEEN COMPLETELY REARRANGED SO THAT IT FOLLOWS WESTERN CONVENTION,

AND THE LATE WILL EISNER DEVELOPED A STYLE IN WHICH PANELS WERE IGNORED ALTOGETHER, AND THE ARTWORK FLOWS ACROSS THE PAGE IN AN ORGANIC MANNER.

WITHIN THE PANEL FRAMEWORK IT IS USUAL TO FRAME EACH PANEL ALMOST LIKE A CAMERA SHOT, AND APPROPRIATELY CINEMATIC TERMS ARE USED:

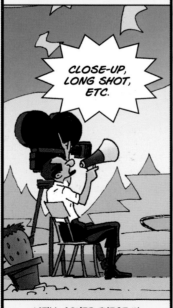

CLOSE-UP, LONG SHOT, ETC.

WE'LL COVER THESE IN MORE DETAIL LATER.

FOR SPEECH AND NARRATIVE, THERE ARE THE FAMOUS SPEECH BALLOONS AND NARRATIVE BOXES.

A VARIETY OF BALLOONS COVER NORMAL SPEECH, THOUGHT, AND OTHER EFFECTS (SHOUTING, WHISPERING, ETC.).

THE APTLY NAMED NARRATIVE BOXES ARE THERE TO FILL IN DETAIL THAT CAN'T BE PORTRAYED IN THE ARTWORK, OR PROVIDE THE AUTHOR WITH AN OMNISCIENT VOICE:

ASIDES AND COMMENTS ON THE ACTION—THAT KIND OF THING.

ALTHOUGH BOTH ARE USED ROUTINELY IN AN AVERAGE COMIC BOOK, IT'S NOT UNUSUAL TO FIND A STORY ATTEMPTED WITH ONLY ONE OR THE OTHER (AND, RARELY, NEITHER).

AND OF COURSE, THERE ARE THE SOUND EFFECTS. WHO DOESN'T KNOW ABOUT THEM?

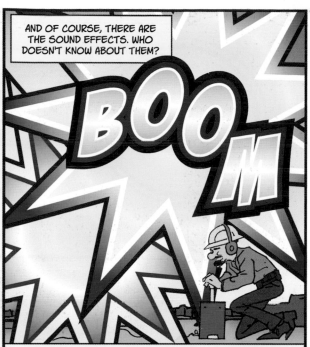

BOOM

THE ADDITION OF THESE IS A MATTER OF PERSONAL PREFERENCE; SOME AUTHORS PREFER TO WRITE THE EXACT ONOMATOPOEIC DESCRIPTION OF THE SOUND, WHEREAS OTHERS ARE HAPPY TO LEAVE THEM TO THE ARTIST. ALTERNATIVELY, THE WRITER MIGHT NOT WANT SOUND EFFECTS IN THE FINISHED ARTWORK AT ALL.

ONE OF THE TERMS THAT THE ARTIST WILL ENCOUNTER IS *GUTTERS*.

THESE ARE THE WHITE SPACES BETWEEN PANELS

THEY WILL NORMALLY BE QUITE REGULAR, BUT OCCASIONALLY PANELS CAN OVERLAP AND THE GUTTER DISAPPEARS ALTOGETHER.

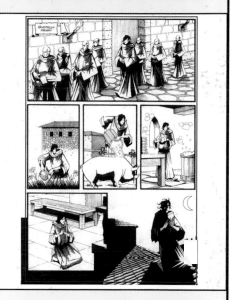

ANOTHER ARTISTIC TERM IS *BLEED*, WHICH IS APPLIED WHEREVER INK IS REQUIRED TO RUN UP TO AND OVER THE EDGES OF THE PAPER (LITERALLY BLEED OFF THE PAGE).

AND FINALLY, *TYPOGRAPHY*.

BACK IN THE GOOD OLD DAYS, WHEN COMICS WERE HAND-LETTERED, THE STYLE OF LETTERING (TYPOGRAPHY) WAS LEFT VERY MUCH IN THE HANDS OF THE LETTERER.

NOW, LETTERING IS MOSTLY APPLIED DIGITALLY, USING A WIDE VARIETY OF FONTS THAT COME READY-PACKAGED IN SOFTWARE, OR ARE AVAILABLE OVER THE INTERNET.

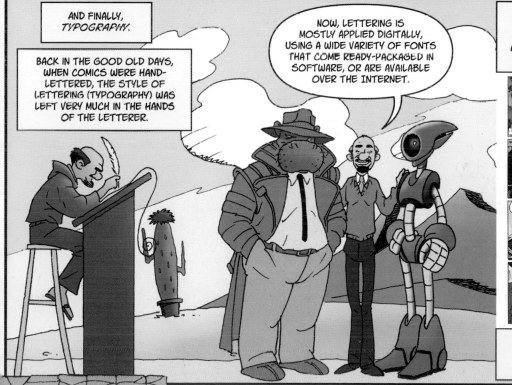

THE STYLE AND SIZE OF FONT USED DEPENDS VERY MUCH ON THE CIRCUMSTANCES—SOMETHING RELAXED AND INFORMAL (BUT EASY TO READ!) FOR REGULAR SPEECH AND NARRATIVE,

AND SOMETHING MORE EXOTIC FOR FOREIGN OR ALIEN LANGUAGES, OR UNUSUAL SITUATIONS.

FRAMES OR PANELS?

COMIC BOOKS ARE SPLIT UP INTO A SERIES OF INTERLINKING PICTURES, OR SCENES, ON EACH PAGE.

CALLED EITHER PANELS OR FRAMES (IT DOESN'T PARTICULARLY MATTER WHICH), THESE PICTURES ARE SPREAD OUT IN A FRAMEWORK THAT IS DESIGNED TO HELP TELL THE STORY CLEARLY.

THE PANELS DRAW THE EYE ACROSS THE PAGE IN THE CORRECT SEQUENCE—JUST LIKE PRINTED WORDS ON A PAGE.

THE NUMBER OF PANELS PER PAGE VARIES, DEPENDING ON THE PREFERENCES OF THE CREATOR (AND SOMETIMES THE PUBLISHER) AND HOW BIG EACH SCENE HAS TO BE.

APART FROM THE REGULAR TYPES, THERE ARE SPLASH PANELS, WHICH ARE FULL-PAGE—OR SOMETIMES TWO-PAGE SPREAD—PANELS.

THEY'RE PRETTY SELF-EXPLANATORY.

A ONE-PAGE PANEL CAN BE HIGHLY DETAILED, CONTAINING A LOT OF VISUALS THAT A SMALLER PANEL WOULD CRAMP,

NORMALLY, THE AVERAGE NUMBER OF PANELS IS BETWEEN FIVE AND SEVEN A PAGE, BUT IT CAN GO AS HIGH AS NINE OR AS LOW AS TWO.

THESE FACTORS DEPEND ON EXACTLY WHAT TYPE OF PANEL IT IS, AND HOW BIG THE PUBLISHED COMIC PAGE WILL BE.

THE SMALLER THE PAGE, THE FEWER PANELS YOU WANT, OR DETAIL WILL BE THE FIRST THING TO SUFFER...

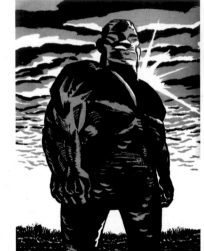

OR COULD BE SIMPLE, BUT LARGE ENOUGH TO MAKE AN IMPACT—MAGNIFYING A SMALL PART OF A MUCH BIGGER SCENE, FOR INSTANCE.

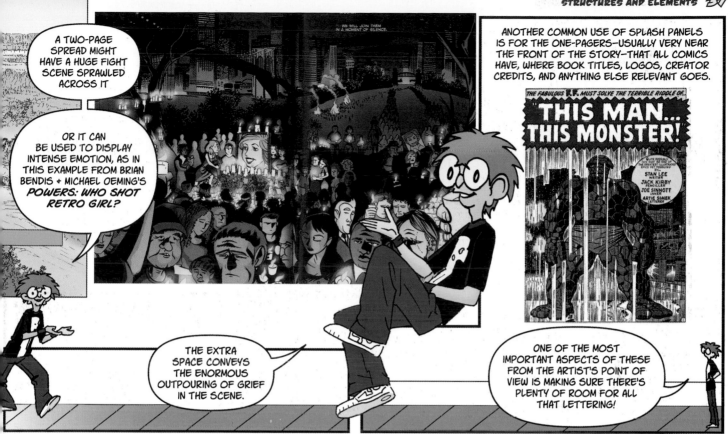

A TWO-PAGE SPREAD MIGHT HAVE A HUGE FIGHT SCENE SPRAWLED ACROSS IT

OR IT CAN BE USED TO DISPLAY INTENSE EMOTION, AS IN THIS EXAMPLE FROM BRIAN BENDIS + MICHAEL OEMING'S *POWERS: WHO SHOT RETRO GIRL?*

THE EXTRA SPACE CONVEYS THE ENORMOUS OUTPOURING OF GRIEF IN THE SCENE.

ANOTHER COMMON USE OF SPLASH PANELS IS FOR THE ONE-PAGERS—USUALLY VERY NEAR THE FRONT OF THE STORY—THAT ALL COMICS HAVE, WHERE BOOK TITLES, LOGOS, CREATOR CREDITS, AND ANYTHING ELSE RELEVANT GOES.

THE FABULOUS F.F. MUST SOLVE THE TERRIBLE RIDDLE OF...

"THIS MAN... THIS MONSTER!"

STAN LEE
JACK KIRBY
JOE SINNOTT
ARTIE SIMEK

ONE OF THE MOST IMPORTANT ASPECTS OF THESE FROM THE ARTIST'S POINT OF VIEW IS MAKING SURE THERE'S PLENTY OF ROOM FOR ALL THAT LETTERING!

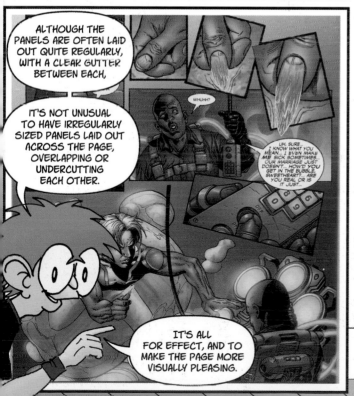

ALTHOUGH THE PANELS ARE OFTEN LAID OUT QUITE REGULARLY, WITH A CLEAR GUTTER BETWEEN EACH,

IT'S NOT UNUSUAL TO HAVE IRREGULARLY SIZED PANELS LAID OUT ACROSS THE PAGE, OVERLAPPING OR UNDERCUTTING EACH OTHER.

IT'S ALL FOR EFFECT, AND TO MAKE THE PAGE MORE VISUALLY PLEASING.

YOU CAN ALSO DISPENSE WITH PANELS ALTOGETHER IF YOU WANT, CREATING A FRAMELESS SPACE ACROSS WHICH THE ARTWORK FLOWS.

OBVIOUSLY IN THIS CASE YOU NEED TO BE CERTAIN THAT THE READER WILL STILL BE ABLE TO FOLLOW THE DIRECTION OF THE STORY, SO THE ARTWORK ITSELF SHOULD PULL THE EYE AFTER IT.

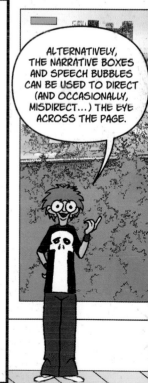

ALTERNATIVELY, THE NARRATIVE BOXES AND SPEECH BUBBLES CAN BE USED TO DIRECT (AND OCCASIONALLY, MISDIRECT...) THE EYE ACROSS THE PAGE.

CONSTRUCTING A STORYLINE

THERE'S A VERY SIMPLE AND WELL-KNOWN TEMPLATE FOR CONSTRUCTING ANY KIND OF STORYLINE—BE IT BOOK, PLAY, MOVIE, OR GRAPHIC NOVEL:

THE THREE-ACT STRUCTURE!

THESE ARE OFTEN SPLIT INTO BEGINNING, MIDDLE, AND END, BUT I'LL GO WITH THE MORE PRECISE *ACT 1: INTRODUCTION ACT 2: ESCALATION ACT 3: RESOLUTION.*

IN ACT 1, YOU INTRODUCE YOUR MAIN CHARACTERS AND THE SITUATION THEY HAVE TO DEAL WITH. A PERFECT WAY IS TO SIMPLY JUMP INTO THE ACTION.

A GOOD EXAMPLE OF THIS IS IN BRYAN TALBOT'S *THE ADVENTURES OF LUTHER ARKWRIGHT.*

THE OPENING SCENE IS OF LUTHER MEETING A MYSTERIOUS CONTACT, WITH SNAPSHOTS OF OTHERS AROUND, PLOTTING AND PLANNING.

SUDDENLY, A BOMB GOES OFF, GRABBING THE READER'S ATTENTION.

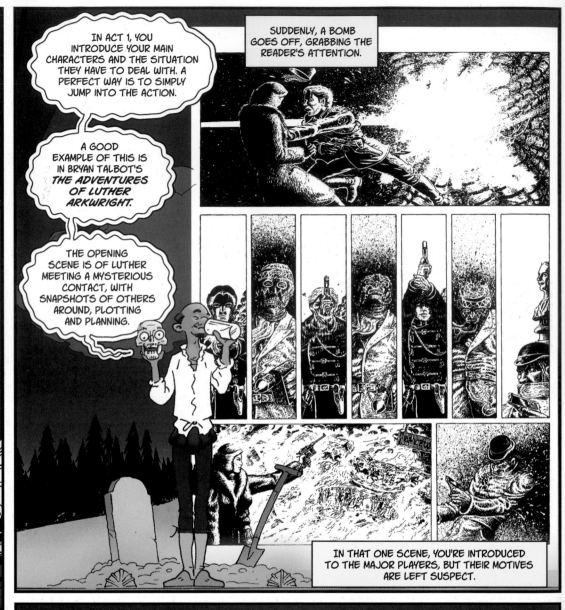

IN THAT ONE SCENE, YOU'RE INTRODUCED TO THE MAJOR PLAYERS, BUT THEIR MOTIVES ARE LEFT SUSPECT.

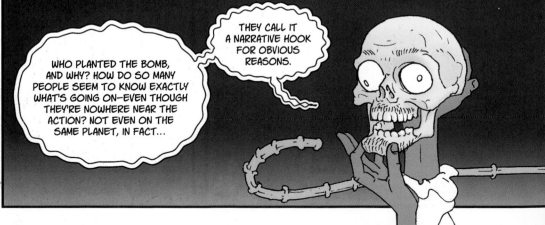

THEY CALL IT A NARRATIVE HOOK FOR OBVIOUS REASONS.

WHO PLANTED THE BOMB, AND WHY? HOW DO SO MANY PEOPLE SEEM TO KNOW EXACTLY WHAT'S GOING ON—EVEN THOUGH THEY'RE NOWHERE NEAR THE ACTION? NOT EVEN ON THE SAME PLANET, IN FACT...

ACT 2 BUILDS UP THE TENSION.

BY NOW, YOU SHOULD HAVE INTRODUCED THE REST OF THE CAST AND EXPLAINED A FAIR AMOUNT OF THE PLOT—JUST WHAT'S HAPPENED, OR PLANNED. THAT WAY, WHEN IT ALL STARTS TO GO WRONG, THE READER COMES ALONG WITH YOU.

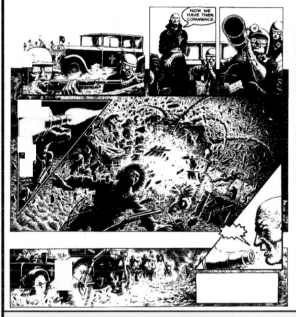

USING *LUTHER ARKWRIGHT* AS AN EXAMPLE AGAIN, WE FIND THE WAR THAT'S BEING FOUGHT ACROSS THE VARIOUS EARTHS THREATENING TO ESCALATE BEYOND THE POINT AT WHICH ANYONE CAN CONTROL IT.

ACT 3 BRINGS THE CONCLUSION.

WHATEVER IT MAY BE, YOUR NOVEL SHOULD CAUSE MAJOR CHANGES IN YOUR CHARACTERS' LIVES—THEY MAY EVEN HAVE LOST THEM.

LUTHER'S OWN CHANGES PUT HIM BEYOND NORMAL HUMANITY—HE WINS, BUT HE ALSO LOSES SOMETHING. AS THE MOVIES HAVE IT: FADE TO CREDITS, MUSIC UP.

AND THAT'S EXACTLY THE STRUCTURE YOUR BOOK SHOULD FOLLOW... MORE OR LESS.

IT'S A SIMPLE DEVICE, WELL USED (EVEN THE ANCIENT GREEKS USED IT FOR THEIR DRAMAS) BUT IT WORKS.

INTRODUCE EVERYONE, TURN UP THE HEAT, AND SOLVE THE PUZZLE.

THERE'S ANOTHER SIMPLE MAXIM THAT GOES ALONGSIDE THE THREE-ACT PLAY:

MAKE THEM LAUGH,

MAKE THEM CRY

—MAKE THEM WAIT.

AND THAT APPLIES TO ALL FICTION.

BALLOONS & BOXES

COMIC BOOKS ARE, QUITE OBVIOUSLY, A SILENT MEDIUM,

AND UNLESS YOU'RE READING A FLASH COMIC ON THE INTERNET THAT SOMEONE HAS ADDED A SOUNDTRACK TO, THEY'RE GOING TO STAY THAT WAY.

SOUNDS AND DIALOGUE HAVE TO BE REPRESENTED IN A RECOGNIZED WAY.

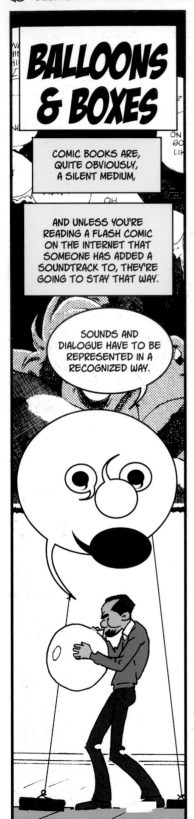

A VARIETY OF SPEECH BALLOONS ARE COMMONLY USED IN COMIC BOOKS...

YOU'RE ALMOST CERTAINLY FAMILIAR WITH MOST OF THEM.

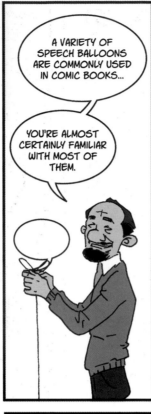
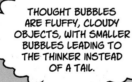

REGULAR SPEECH IS NORMALLY CONVEYED IN SIMPLE ROUND BUBBLES, WITH A TAIL LEADING TO THE SPEAKER.

AND IT'S NOT UNUSUAL TO HAVE A SERIES OF LINKED BUBBLES—OFTEN USED TO CONVEY THE BROKEN NATURE OF DIALOGUE, OR PARAGRAPHS,

OR EVEN HESITANCY.

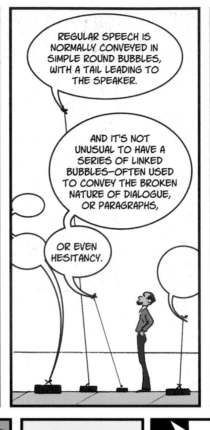

HAVING TWO STRANDS OF OVERLAPPING BUBBLES FROM TWO CHARACTERS—OR MORE, IF YOU'RE FEELING BRAVE—

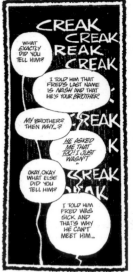

CAN GIVE THE IMPRESSION OF A RAPID ARGUMENT, OR QUICK-FIRE REPARTEE.

THOUGHT BUBBLES ARE FLUFFY, CLOUDY OBJECTS, WITH SMALLER BUBBLES LEADING TO THE THINKER INSTEAD OF A TAIL.

THEY MIGHT LOOK A BIT SILLY—WHO ORIGINALLY CAME UP WITH THE IDEA THAT THOUGHT BALLOONS SHOULD LOOK LIKE CUMULUS CLOUDS?—

BUT AT LEAST THEY'RE BETTER THAN THE OLD-FASHIONED OVAL BALLOON—NOT UNLIKE A SPEECH ONE—WITH THE WORD "THINKS" STUCK IN IT!

THINKS...

LOUDER SPEECH—SUCH AS SHOUTING OR SCREAMING—COMES IN A SHARPLY JAGGED BALLOON.

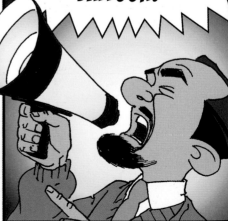

THE SAME SHAPE CAN ALSO BE USED TO DEPICT RADIO AND TV SOUND TRACKS, PHONES, AND SECURITY TRANSPONDERS,

BUT THAT SEEMS TO BE GOING OUT OF FASHION. INSTEAD, A MUTATION OF THE OVAL BALLOON IS TAKING OVER,

A STRANGE, REGULARLY PATTERNED THING THAT HAS NO TAIL.

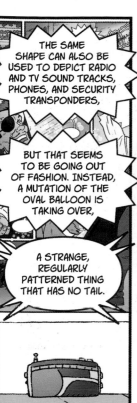

YOU CAN ALSO USE FANCY FONTS TO REPRESENT VOLUME...

...ONES SIMILAR TO SOUND EFFECTS. COMBINED WITH LARGER-THAN-NORMAL OVAL BALLOONS THAT HAVE THICK, COLORED EDGES, THEY CAN BE QUITE EFFECTIVE.

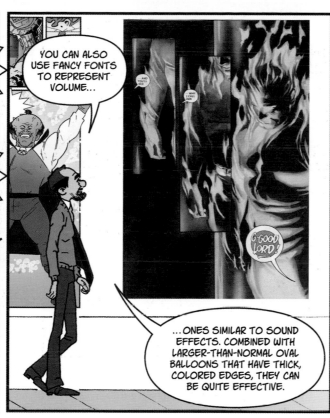

G-GOOD LORD!

CHOICE OF TYPOGRAPHY CAN SHOW ANYTHING FROM A FOREIGN LANGUAGE (SUCH AS FAKE CYRILLIC LETTERING TO SUGGEST RUSSIAN) TO MACHINE LANGUAGE.

EVEN GIBBERISH HAS BEEN USED TO CONVEY AN UNINTELLIGIBLE ALIEN TONGUE OR THE EFFECTS OF DRUGS OR SEMICONSCIOUSNESS.

IN DUICK'S BE AR BITYYY...

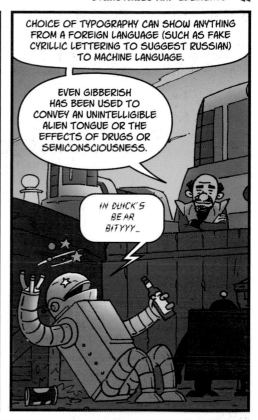

SPEECH BALLOONS CAN ALSO BE USED TO MISDIRECT THE READER. IN BRYAN TALBOT'S *HEART OF EMPIRE*, THERE IS ONE PAGE WHERE A LINE OF BALLOONS GOES DIAGONALLY DOWN THE PAGE.

THIS IS DONE TO LEAD THE READER'S EYE AWAY FROM A PIVOTAL SCENE TAKING PLACE IN THE BOTTOM LEFT OF THE PAGE.

AN ACTION THAT HAS GREAT SIGNIFICANCE LATER IN THE BOOK. VISUAL SLEIGHT-OF-HAND.

SQUARE NARRATIVE BOXES CAN BE PLACED ANYWHERE ON THE PAGE OR WITHIN PANELS.

THEY WILL BE TELLING ANOTHER STORY—ONE THE PICTURES AND ARTWORK EITHER CAN'T OR WON'T.

THE NARRATIVE CAN HAVE ITS OWN PERSONALITY—IT CAN EVEN BE ANOTHER CHARACTER IN THE STORY—

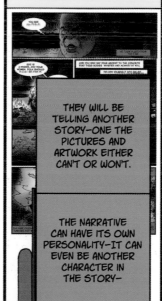

AND THE PLACEMENT OF THE BOXES REFLECTS THIS. THE AUTHOR CAN TAKE READERS INTO HIS OR HER CONFIDENCE:

POINTING OUT DETAILS IT WOULD BE IMPOSSIBLE FOR THE CHARACTERS WITHIN THE STORY TO KNOW,

OR JUST USE THEM FOR EDITORIALIZING.

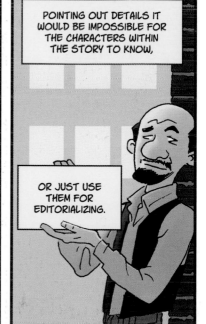

CHARACTER-IZATION

IT'S ONE OF THE BASIC ELEMENTS OF STORYTELLING—ALL OF YOUR CHARACTERS NEED TO HAVE... *CHARACTER.*

WHAT DRIVES THEM, WHAT THEIR MOTIVATIONS ARE, HOW WILLING THEY MIGHT BE TO MAKE MORAL SHORT CUTS IN ORDER TO REACH THOSE ENDS, AND SO ON.

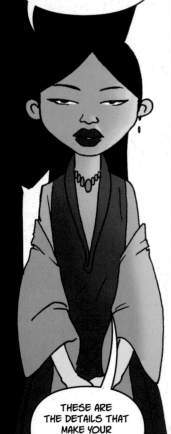

THESE ARE THE DETAILS THAT MAKE YOUR CHARACTERS INTO INDIVIDUALS.

YOU CAN CREATE CHARACTER IN THREE WAYS IN COMICS.

OBVIOUSLY, THE FIRST IS VISUALLY: YOU'RE TELLING A GREAT DEAL OF THE STORY IN PICTURES, AND READERS ARE GOING TO PICK UP ON ANY VISUAL CLUES YOU GIVE THEM.

SECOND IS THE WAY THEY TALK AND THINK. DO THEY USE SLANG OR ODD PHRASES? THAT KIND OF STUFF.

AND THIRD IS THROUGH THE NARRATIVE. THERE'S AN OLD SAYING WHEN IT COMES TO WRITING: SHOW, DON'T TELL.

COMICS DO A LOT OF SHOWING, BUT THE ODD BIT OF TELLING DOESN'T HURT. JUST DON'T DO TOO MUCH OR TOO OFTEN.

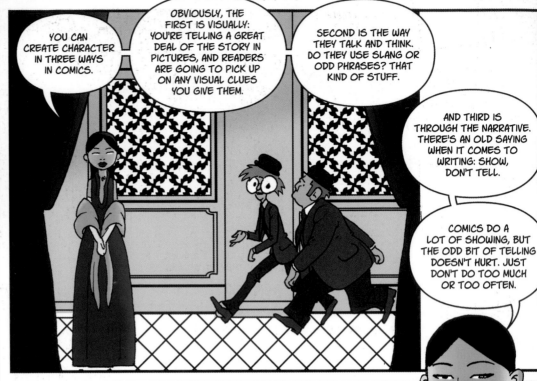

SO, HOW DOES THIS WORK?

PEOPLE PICK UP MORE THAN THEY REALIZE VISUALLY.

BODY LANGUAGE IS A BIG THING, AND EVERYBODY'S HEARD OF IT:

THE WAY SOMEONE STANDS (OR SITS), HOW THEY FOLD THEIR ARMS, HOW THEY LOOK AT OTHER PEOPLE—ALL OF THOSE THINGS.

AGGRESSIVE PEOPLE ARE ALL ABOUT BIG MOVEMENTS, POINTING AND WAVING, GETTING RIGHT IN CLOSE (LITERALLY "IN YOUR FACE").

SUBMISSIVE PEOPLE TEND TO SHRINK AWAY, HUG THEMSELVES, AND NOT MAKE EYE CONTACT.

WITH A FEW WELL-CHOSEN POSITIONS, YOU'VE ALREADY DONE A QUICK SKETCH OF YOUR CHARACTER.

A HIDDEN SMILE IS AN INSTANT CLUE AND MAKES THE READER WONDER JUST WHAT THIS PERSON IS HIDING—AND WHY.

THEN THERE ARE THE SIGNS THAT ONLY THE READER PICKS UP ON, SOMETHING THAT THE CHARACTERS WITHIN THE STORY DELIBERATELY SCREEN FROM EACH OTHER.

THE SAME GOES FOR SMALL DROPS OF SWEAT THAT CAN BE SEEN ONLY BY ANYONE GETTING IN CLOSE—WHICH THE SWEATY GUY WON'T ALLOW. WHY IS THAT?

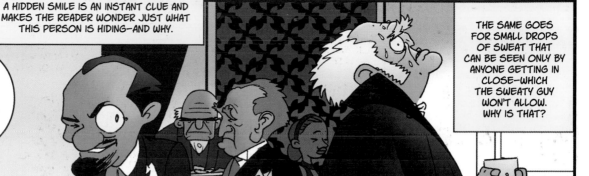

DIALOGUE IS ANOTHER BIG CLUE. IN COMICS YOU HAVE THE BIG ADVANTAGE OF NOT ONLY SEEING WHAT SOMEONE SAYS, BUT ALSO WHAT THEY THINK. IMAGINE HOW FAST YOU'D BE ABLE TO JUDGE SOMEONE'S REAL CHARACTER IF YOU COULD READ HIS OR HER MIND. PEOPLE DON'T ALWAYS SAY WHAT THEY MEAN. REVEALING THE GAP BETWEEN WHAT'S ON THEIR LIPS AND WHAT'S IN THEIR HEARTS IS OFTEN MORE THAN ENOUGH. NO OTHER COMMENT IS NEEDED.

USE OF SLANG AND IDIOM IS ALSO USEFUL.

A SURFER DUDE'S GOING TO TALK DIFFERENTLY THAN A COMPUTER GEEK.

LET'S HANG 18, DUD. YOU'RE GNARLED.

AND THERE'S ALWAYS THE ONE WHO NEVER QUITE GETS THE PHRASES RIGHT, SHOWING THAT THEY'RE NOT NEARLY AS COOL AS THEY THINK THEY ARE.

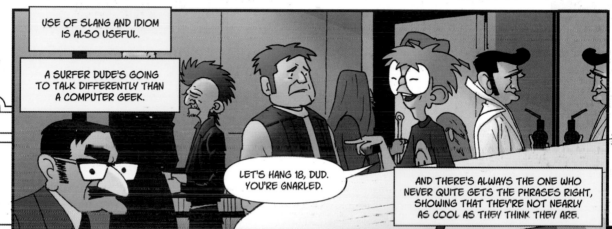

FINALLY, THE NARRATIVE.

HERE YOU'RE GOING TO BE TELLING THE READER WHAT THE CHARACTER TRAITS ARE, RATHER THAN REVEALING THEM, BUT YOU DON'T ALWAYS NEED TO SAY TOO MUCH.

IF A CHARACTER HAS TO BE SKETCHED IN QUICKLY—AND YOU DON'T INTEND TO SPRING A SURPRISE ON THE READERS LATER—NARRATIVE SHORTCUTS ARE ACCEPTABLE.

POINTING OUT THAT SOMEONE IS A LOWLIFE WEASEL IS FINE, ESPECIALLY IF THE WEASEL IN QUESTION LOOKS LIKE A PERFECTLY RESPECTABLE PERSON ON THE OUTSIDE.

THE CONFLICT BETWEEN WHAT THE WORLD OF YOUR STORY SEES, AND WHAT THE READERS SEE, IS WHAT GIVES YOUR CHARACTERS A MULTIDIMENSIONAL QUALITY.

AS CREATORS

CHAPTER 3

QUICK REFERENCE. 46
WORKING ONLINE. 48
WORD-CRUNCHING . 50
DRAWING WITH SOFTWARE 52
COLORING. 54
SAVING. 56
PUBLISHING: PRINT OR WEB? 58

QUICK REFERENCE

WHAT IS THE FIRST THING THAT COMES TO MIND WHEN ANYONE MENTIONS USING YOUR COMPUTER AS A REFERENCE TOOL? THE *INTERNET* (OR WORLD WIDE WEB).

MILLIONS OF PEOPLE ACROSS THE GLOBE LOG ON DAILY TO GOOGLE, YAHOO, OR ANY OF THE MANY OTHER SEARCH ENGINES, TO ACCESS ALL KINDS OF TRIVIA. *"TO GOOGLE"* HAS EVEN BECOME A VERB.

BUT IS THE WEB AS USEFUL AS IT'S SUPPOSED TO BE?

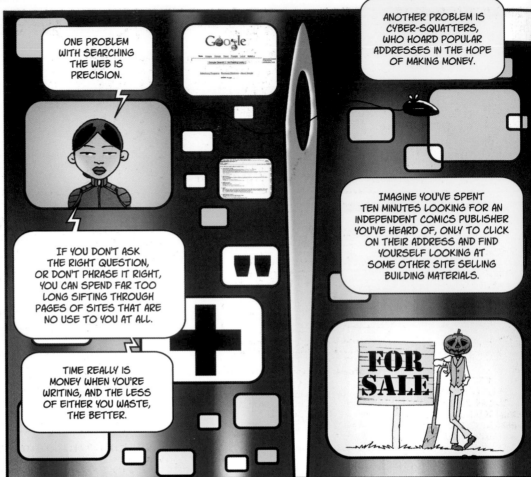

ONE PROBLEM WITH SEARCHING THE WEB IS PRECISION.

IF YOU DON'T ASK THE RIGHT QUESTION, OR DON'T PHRASE IT RIGHT, YOU CAN SPEND FAR TOO LONG SIFTING THROUGH PAGES OF SITES THAT ARE NO USE TO YOU AT ALL.

TIME REALLY IS MONEY WHEN YOU'RE WRITING, AND THE LESS OF EITHER YOU WASTE, THE BETTER.

ANOTHER PROBLEM IS CYBER-SQUATTERS, WHO HOARD POPULAR ADDRESSES IN THE HOPE OF MAKING MONEY.

IMAGINE YOU'VE SPENT TEN MINUTES LOOKING FOR AN INDEPENDENT COMICS PUBLISHER YOU'VE HEARD OF, ONLY TO CLICK ON THEIR ADDRESS AND FIND YOURSELF LOOKING AT SOME OTHER SITE SELLING BUILDING MATERIALS.

FOR SALE

A THIRD STUMBLING BLOCK IS THE VARIABLE AMOUNT OF MATERIAL AVAILABLE.

A GREAT DEAL OF WHAT YOU'LL FIND HAS BEEN PUT THERE BY INDIVIDUALS OR GROUPS WITH SPECIFIC INTERESTS (FANS, IN OTHER WORDS) AND AS SUCH IT'S SUBJECT TO FASHION.

YOU CAN FIND ANYTHING YOU EVER CARED ABOUT (OR NOT) REGARDING *STAR WARS*; BUT *X-FILES* SITES ARE NO LONGER AS NUMEROUS AND FREQUENTLY UPDATED AS THEY WERE.

BUT DON'T LET SUCH MINOR INCONVENIENCES PUT YOU OFF. THE WEB IS FULL OF INFORMATION—ONCE YOU FIND IT.

ALL THE MAJOR PUBLISHERS HAVE WEB SITES THAT NOT ONLY TELL YOU ABOUT THEIR LATEST TITLES, BUT ALSO OFFER SUBMISSION GUIDELINES FOR CONTRIBUTORS, CONTACT ADDRESSES, AND UP-TO-DATE INFORMATION ON JUST WHAT KIND OF MATERIAL THEY'RE LOOKING FOR.

MICROSOFT'S *ENCARTA* SOFTWARE IS ANOTHER USEFUL RESEARCH TOOL, AND IT'S NOW AVAILABLE ONLINE, FREE, AS PART OF THE *MICROSOFT NETWORK (MSN)*.

JUST LIKE THE ORIGINAL SOFTWARE, YOU CAN DO A SEARCH ON WORDS OR PHRASES, AND THE RESULTS COME BACK QUICKLY.

THERE ARE MANY OTHER ONLINE ENCYCLOPEDIAS.

WIKIPEDIA, FOR INSTANCE, HAS AN INTERACTIVE FACILITY, ALLOWING USERS TO EDIT AND CONTRIBUTE TO THE SITE.

THERE'S ALSO *ONLINE ENCYCLOPEDIA*, WHICH IS AS PRECISE A NAME AS YOU'D WISH. *INFORMATIONSPHERE* IS ANOTHER, AND *ENCYCLOPEDIA BRITANNICA* ONLINE IS ANOTHER GREAT FREE ACCESS SITE (MAYBE NOT AS POWERFUL AS THE RETAIL PACKAGE, BUT STILL GOOD).

ALL OF THESE ARE GENERAL REFERENCE SITES, USUALLY OFFERING A BRIEF ESSAY ON EACH SUBJECT.

IF YOU JUST WANT A DICTIONARY OR THESAURUS (YOUR WORD PROCESSING PACKAGE IS LIKELY TO COME WITH ONE OF THOSE, BUT IT WON'T BE SO POWERFUL),

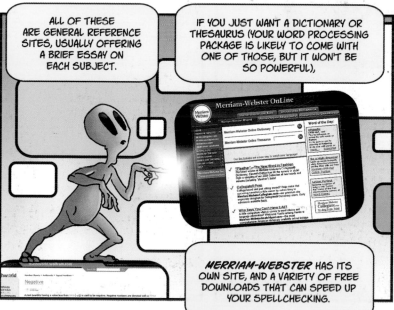

MERRIAM-WEBSTER HAS ITS OWN SITE, AND A VARIETY OF FREE DOWNLOADS THAT CAN SPEED UP YOUR SPELLCHECKING.

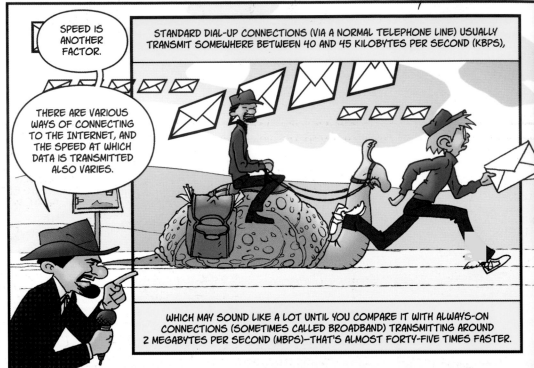
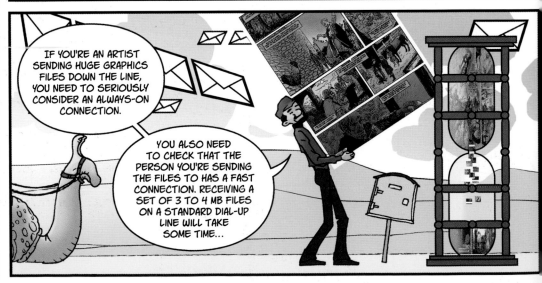

ANOTHER CONSIDERATION IS COMPATIBILITY.

THERE'S NO GUARANTEE YOU'RE GOING TO BE USING THE SAME SOFTWARE, OR EVEN SOFTWARE THAT'S TOTALLY COMPATIBLE.

OLDER VERSIONS OF THE SAME SOFTWARE PROBABLY WON'T BE ABLE TO READ FILES CREATED BY NEWER VERSIONS;

AND SOMETIMES MORE RECENT VERSIONS HAVE PROBLEMS WITH OLDER FILES (THEY SHOULDN'T, BUT IT HAPPENS).

ALTHOUGH IT'S A CLICHÉ THAT WRITERS WORK ON PCS AND ARTISTS ON MACS, THERE'S SOME TRUTH IN IT.

YOU GET THE SAME PROBLEM WITH AGE:

CHECK FIRST.

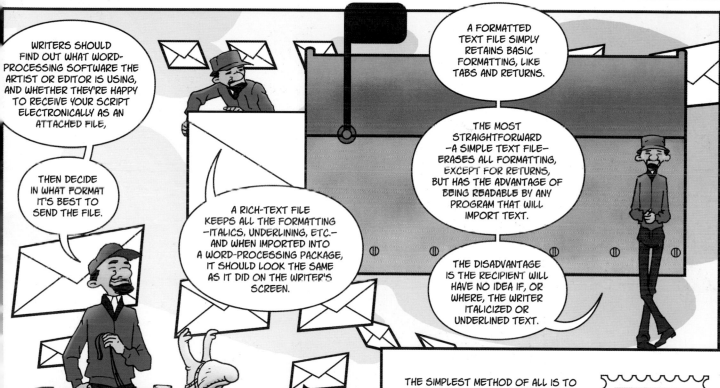

WRITERS SHOULD FIND OUT WHAT WORD-PROCESSING SOFTWARE THE ARTIST OR EDITOR IS USING, AND WHETHER THEY'RE HAPPY TO RECEIVE YOUR SCRIPT ELECTRONICALLY AS AN ATTACHED FILE,

THEN DECIDE IN WHAT FORMAT IT'S BEST TO SEND THE FILE.

A RICH-TEXT FILE KEEPS ALL THE FORMATTING —ITALICS, UNDERLINING, ETC.— AND WHEN IMPORTED INTO A WORD-PROCESSING PACKAGE, IT SHOULD LOOK THE SAME AS IT DID ON THE WRITER'S SCREEN.

A FORMATTED TEXT FILE SIMPLY RETAINS BASIC FORMATTING, LIKE TABS AND RETURNS.

THE MOST STRAIGHTFORWARD —A SIMPLE TEXT FILE— ERASES ALL FORMATTING, EXCEPT FOR RETURNS, BUT HAS THE ADVANTAGE OF BEING READABLE BY ANY PROGRAM THAT WILL IMPORT TEXT.

THE DISADVANTAGE IS THE RECIPIENT WILL HAVE NO IDEA IF, OR WHERE, THE WRITER ITALICIZED OR UNDERLINED TEXT.

THE SIMPLEST METHOD OF ALL IS TO INCORPORATE THE TEXT INTO THE BODY OF THE E-MAIL, JUST IN CASE THE ATTACHMENT WON'T OPEN.

AFTER SAVING THE MESSAGE AS A TEXT FILE, THE RECIPIENT IS FREE TO EDIT IT ANY WAY THEY LIKE.

WORD-CRUNCHING

THERE ARE A FEW CONVENTIONS TO REMEMBER WHEN IT COMES TO WRITING. NOT ONLY SCRIPTS, BUT SHORT STORIES, ARTICLES, NOVELS, WHATEVER.

THEY AREN'T RULES, EXACTLY, BUT STICKING TO THEM WILL MAKE YOU A LOT MORE POPULAR WITH WHOEVER HAS TO READ OR EDIT YOUR PAGES.

FIRST, PRINT OR WRITE ONLY ON ONE SIDE OF THE PAPER.

IT WON'T HELP YOUR RELATIONSHIP WITH TREES, ADMITTEDLY, BUT IT MAKES THINGS EASIER FOR READERS.

DOUBLE-SPACE YOUR LINES.

NOT ONLY DOES IT MAKE THE PAGES LOOK NEAT, BUT IT ALSO MAKES THEM EASIER TO READ, AND LEAVES SPACE FOR ANY EDITORIAL CHANGES OR CORRECTIONS TO BE MARKED IN.

ALTHOUGH YOU MAY HAVE SENT THE SCRIPT IN ELECTRONICALLY, CHANCES ARE THAT SOMEWHERE ALONG THE LINE IT'S GOING TO BE PRINTED OUT. NOT EVERYONE LIKES TO LINE-EDIT ON SCREEN.

ALWAYS LEAVE A MARGIN AROUND THE TEXT—AT LEAST ONE INCH (25MM)—AROUND THE TOP, BOTTOM, AND SIDES.

AGAIN, THIS MAKES IT LOOK NEAT AND ALLOWS SPACE FOR EDITORIAL MARKUPS.

NUMBERING THE PAGES IS ALSO IMPORTANT.

USE THE HEADER AND FOOTER OPTIONS OF YOUR WORD-PROCESSING PROGRAM TO ADD AN AUTOMATIC PAGE COUNT—PUTTING IT IN THE TOP-RIGHT CORNER IS USUALLY BEST.

MOST IMPORTANT OF ALL, WHEN YOU'RE WRITING YOUR SCRIPT, SAVE IT REGULARLY. SET UP YOUR WORD-PROCESSING SOFTWARE TO AUTOSAVE AT REGULAR INTERVALS. THEN, IF YOU SUFFER A COMPUTER CRASH, YOU WON'T LOSE ALL OF YOUR LAST HOUR'S WORK.

IT'S ALSO GOOD TO INCLUDE YOUR NAME (OR LAST NAME, AT LEAST), ALONG WITH AN ABBREVIATED FORM OF THE TITLE.

THEN, IF THE PRINTED PAGES GET SEPARATED, THERE'S A SIMPLE INDEXING SYSTEM TO IDENTIFY AUTHOR, DOCUMENT NAME, AND PAGE NUMBER.

QUIETUS/ On Earth.../ Chinn/p.1

QUIETUS

ON EARTH AS IT IS IN HEAVEN: PART ONE

Written by Mike Chinn

PAGE ONE:

1. An ancient laboratory – very much early 18th century style. Equipment is primitive - but still recognizable to modern readers. The walls are brick, encrusted with soot and detritus of centuries. Candles are the only source of illumination, and all are burned very low, dripping with cooling wax, suggesting they've been burning for a very long time.
We're looking down on high at a young student (Victor Frankenstein) bending over a crude wooden bench. It's not possible to see what he's doing, but his tailcoat is stained and blemished with blood, chemicals and sweat. The high collar of his coat hides his face so far. Surrounding him are jars, retorts, the paraphernalia familiar from any Hammer (in preference to Universal) movie. There's a vague feeling of unreality about the whole scene (exaggerate darkness beyond the candles, the size and shape of the vessels).

BLOCK: SHE HEARS THE SCRAPE OF STEEL ON BONE; FEELS THE PITILESS CHILL. EVEN THE ECHOES ARE SHARP AND COLD...

PAGE ONE (CONT): QUIETUS/ On Earth.../ Chinn/p.2

2. Closer in on Frankenstein. He's bending even lower over the bench – and what's lying on it. Although dishevelled and pallid, it's obvious that Frankenstein is handsome to an unusual degree. Whatever's there on the slab (and everyone will think they know) is shrouded in soiled cloth that clings suggestively to its outline. He's holding up an arm from under the wrappings – fingers wrapped around the wrist as though taking a pulse.

BLOCK: SHE WATCHES THE PALE STUDENT AS HE STOOPS LOW ACROSS HIS BENCH. SHE FEELS HIS ANTICIPATION... HIS DREAD—

FRANKENSTEIN: *BREATHE! BE VITAL!* LET THE HOT BLOOD COURSE THROUGH THE VEINS ONCE MORE!

BLOCK: —AND HIS HARSH, WHISPERED IMPRECATIONS...

3. The wrist in close up, dropping lifelessly back as Frankenstein releases it. The disappointment is clear on his face (middle-distance).

4. Frankenstein turning away from the slab in disgust or upset. His handsome features are made ugly by emotion. Behind him, just visible, there is the suggestion of movement under the sheet.

FRANKENSTEIN: I MUST SUCCEED! THE GATE *SHALL* BE OPENED. URYAMIEL HAS PROMISED IT! ALL THE SIGNS POINT THAT WAY!

BLOCK: SHE DOES NOT THINK HE IS SPEAKING ENGLISH – YET SHE UNDERSTANDS HIM WELL ENOUGH.

NOW SOME SCRIPTWRITING SPECIFICS.

A COMIC SCRIPT IS SIMILAR TO A MOVIE OR TV SCRIPT, WITH DIALOGUE AND SET DIRECTIONS (IN THIS CASE, A BRIEF DESCRIPTION OF EACH PANEL) ALONG WITH NARRATIVE.

EACH PANEL SHOULD BE CLEARLY NUMBERED, WITH EACH SCENE–OR VIGNETTE–DESCRIBED, FOLLOWED BY ANY DIALOGUE AND NARRATIVE.

THE PANEL NUMBER, ALONG WITH THE DIALOGUE AND NARRATIVE TEXT, SHOULD BE IN CAPITALS TO DISTINGUISH IT FROM THE DESCRIPTIVE TEXT, WHICH IS BEST LEFT IN LOWER-CASE.

PUT EXTRA LINE SPACES BETWEEN EACH PANEL DESCRIPTION. YOU DON'T WANT ANYONE GETTING CONFUSED ABOUT WHERE ONE PANEL'S DESCRIPTION ENDS AND THE NEXT BEGINS.

A SIMPLE *PAGE #* AT THE START OF EACH SCRIPT SHEET WILL DO, WITH *PAGE # (CONT)* FOR EVERY SHEET THAT CONTINUES THAT PAGE. THEN START A NEW SHEET FOR THE NEXT PAGE.

THERE CAN BE UP TO FIVE PAGES OF SCRIPT FOR A SINGLE PAGE OF FINISHED ARTWORK, SO AS WELL AS NUMBERING YOUR SCRIPT PAGES, MAKE SURE IT'S ALWAYS CLEAR WHICH COMIC PAGE YOU'RE DESCRIBING.

FINALLY, A SCRIPT PAGE WILL OFTEN HAVE FEWER PANELS ON IT THAN A FINISHED COMICS PAGE–BECAUSE THE ARTIST MAY ADD PANELS.

BUT, ON THE OTHER HAND, IT MAY BE MUCH LONGER, DEPENDING ON HOW MUCH DETAIL YOU PUT IN.

QUIETUS/ On Earth.../ Chinn/p.5

PAGE THREE:

8. Elizabethan London. It's evening, and everything is murky and brown looking (even back then London suffered from pollution: i.e. smoke). An elderly figure in scholarly robes and long flowing white beard is walking through the narrow streets, preceded by a boy holding a lantern on a pole. This is Dr John Dee, magician, cryptologist, mathematician and philosopher. The year is 1588, which means Dee is 61 years old.

BLOCK: THE LONDON OF ELIZABETH TUDOR
BLOCK: THE VIRGIN QUEEN.

9. Dee and the boy passing through a tight alleyway. Water and other things splash under the soles of their shoes..

BLOCK: THE INHERITOR OF A SHAKY THRONE AND RULER OF A COUNTRY RIVEN BY RELIGIOUS INTOLERANCE.

10. They have reached a door – unremarkable, set back a little in a half-timbered building. The boy is reaching to open it, but Dee – looking around him to make sure they are unobserved – has a hand on his wrist, holding him back.

BLOCK: GOD WILLING, BY THE TIME OF HER PASSING, ENGLAND WILL BE A GREAT POWER. SPAIN'S EQUAL.

PAGE THREE (CONT): QUIETUS/ On Earth.../ Chinn/p.6

11. Walking down a black unlit corridor – the lamp the only illumination. It makes Dee and his escort stand out in sharp contrast – where the light cannot reach is as black as the surrounding corridor.

BLOCK: IT IS THE YEAR OF OUR LORD 1588. AND GOOD QUEEN BESS HAS FIFTEEN YEARS AHEAD OF HER YET –

12. The boy opening the door to a room lit with candles – but not too bright, least it draw attention to the men inside. There are five in all – one is Admiral Sir Francis Drake, another Edward Kelley, Dee's sidekick ... the other three are nameless. All standing around a circular table. They are all looking up expectantly at Dee's entrance. Expectant – but solemn.

BLOCK: —GOD WILLING...

13. Dee throwing the rolls of parchment onto the table. Drake is looking down at them – but Kelley is watching his master instead.

DEE: GENTLEMEN – I FEAR WHAT WE HAVE DREADED MOST IS UPON US.
DEE: THE APOCALYPSE IS NIGH–

DRAWING WITH SOFTWARE

I CAN'T TELL YOU HOW TO DRAW HERE, BUT I CAN GIVE YOU SOME TIPS ON THE KIND OF EQUIPMENT YOU'LL NEED TO BE ABLE TO BOTH SCAN WORK INTO THE COMPUTER, AND EDIT IT ONCE IT'S THERE.

YOU CAN ALSO DRAW DIRECTLY INTO THE COMPUTER IF YOU'VE GOT THE RIGHT TOOLS. ARTISTS NEED A LITTLE MORE EQUIPMENT THAN WRITERS, FOR WHOM A COMPUTER AND PRINTER WILL BE ADEQUATE.

FIRST OFF YOU NEED TO CONSIDER THE SIZE AND RESOLUTION OF YOUR SCREEN; YOU DON'T WANT TO RUIN YOUR EYESIGHT SQUINTING AT A TINY MONITOR.

SOMETHING LIKE A 17-INCH SCREEN SHOULD BE FINE, BUT THE BIGGER THE BETTER.

SOME PEOPLE EVEN HAVE TWO MONITORS, ONE TO DISPLAY THE ARTWORK AS LARGE AS POSSIBLE, AND THE OTHER FOR ALL THE PALETTES AND MENUS THAT THE SOFTWARE REQUIRES.

FLAT LCD SCREENS ARE RAPIDLY REPLACING THE OLD, HEAVY CRT MONITORS, BUT REMEMBER THAT COLOR REPRODUCTION ON LCD SCREENS IS NOT ALWAYS AS GOOD AS ON THE OLDER MONITORS, AND THEY CURRENTLY COST MORE.

THIS IS RAPIDLY CHANGING, THOUGH, AS THE TECHNOLOGY IMPROVES AND THE PRICES COME DOWN.

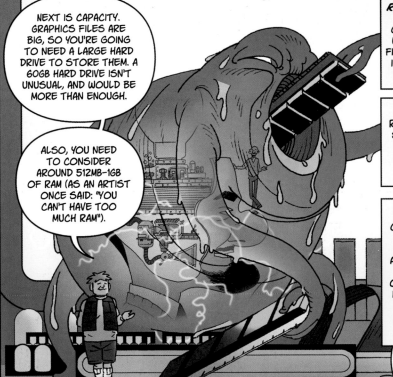

NEXT IS CAPACITY. GRAPHICS FILES ARE BIG, SO YOU'RE GOING TO NEED A LARGE HARD DRIVE TO STORE THEM. A 60GB HARD DRIVE ISN'T UNUSUAL, AND WOULD BE MORE THAN ENOUGH.

ALSO, YOU NEED TO CONSIDER AROUND 512MB-1GB OF RAM (AS AN ARTIST ONCE SAID: "YOU CAN'T HAVE TOO MUCH RAM").

RAM (RANDOM ACCESS MEMORY) IS THE COMPUTER'S HIGH-SPEED WORK SPACE, BUT IT CAN FILL UP QUICKLY, ESPECIALLY IF YOU HAVE A FEW LARGE IMAGES OPEN AT ONCE.

IF YOU RUN OUT OF RAM, YOUR COMPUTER WILL START TO USE THE HARD DRIVE TO COMPENSATE, AND THAT SLOWS EVERYTHING DOWN.

MOST COMPUTERS NOW COME WITH CD (650MB) OR DVD (4.7GB) READERS / WRITERS AS STANDARD, AND BLANK CDS ARE CHEAP AND EASY TO GET HOLD OF. IT'S ALWAYS BEST TO KEEP A BACKUP OF WORK ON A CD OR DVD IN CASE OF HARD DRIVE CRASHES OR OTHER ACCIDENTS.

NEXT UP IS A FLATBED SCANNER TO DIGITIZE ALL YOUR PENCILED AND INKED ARTWORK.

THE SIZE YOU BUY DEPENDS ON WHAT YOU'LL BE SCANNING (AND YOUR BUDGET). ULTIMATELY, YOU WANT SOMETHING THAT'S BIG ENOUGH TO SCAN A FULL PAGE OF ART,

BUT IF YOU DRAW BIG–OR HAVE A SMALL SCANNER–YOU CAN GET AWAY WITH SCANNING IN PIECES THEN COMBINING THEM IN PHOTOSHOP, THOUGH THIS IS NOT ALWAYS EASY.

YOU SHOULD ALSO MAKE SURE IT CAN SCAN AT A HIGH ENOUGH RESOLUTION. A TOTAL OF 600 DPI (THAT'S DOTS PER INCH, ALSO KNOWN AS PPI–PIXELS PER INCH, WHICH IS TECHNICALLY MORE ACCURATE) IS A DEFINITE MINIMUM.

THE OTHER TWO THINGS YOU NEED TO CHECK ARE THE NUMBER OF COLORS THAT CAN BE SCANNED–36-BIT COLOR IS QUITE COMMON, AND MORE THAN ENOUGH–AND THE SCANNER'S SPEED.

IF YOU HAVE A LOT OF WORK TO SCAN IN, IT MAKES SENSE TO GET IT DONE AS QUICKLY AS POSSIBLE.

DESKTOP INKJET PRINTERS ARE VERY CHEAP NOWADAYS, AND THEY'RE FINE IF YOU NEED ONE ONLY FOR EVERYDAY PRINTS AND THE ODD GLOSSY COLOR REPRODUCTION.

IF YOU DO A LOT OF PRINTING, OR NEED SOMETHING SUPER-HIGH QUALITY, THEN YOU MIGHT WANT TO LOOK INTO PROFESSIONAL INKJET OR COLOR LASER PRINTERS. BE WARNED THOUGH: THEY CAN BE EXPENSIVE.

FINALLY, YOU CAN GET A GRAPHICS TABLET FOR DIGITAL HAND-DRAWING.

THEY WORK LIKE AN ELECTRONIC PEN AND PAPER AND CAN HANDLE THINGS LIKE PEN PRESSURE OR ANGLE THAT A MOUSE JUST CAN'T DO.

YOU CAN ALSO PICK UP SMALL TABLETS RELATIVELY CHEAPLY THAT MIGHT BE FINE, DEPENDING ON YOUR DRAWING STYLE.

COLORING

WHERE ONCE A COLORIST WOULD USE A MARKER PEN OR BRUSH TO APPLY COLORED INKS TO THE BLACK-AND-WHITE ARTWORK, NOW IT'S MOSTLY DONE ELECTRONICALLY.

SOFTWARE PACKAGES SUCH AS COREL PAINT SHOP PRO AND ADOBE PHOTOSHOP ARE POPULAR BECAUSE THEY SHIP WITH A WIDE VARIETY OF TOOLS THAT ARE PERFECTLY SUITED TO THE TASK.

DIGITAL BRUSHES ARE ALSO MORE VERSATILE THAN THEIR COUNTERPARTS, AND IT'S A WHOLE LOT EASIER TO CORRECT YOUR MISTAKES.

ONE THING TO KEEP IN MIND WHEN COLORING DIGITALLY IS THAT IF YOU'RE WORKING FOR PRINT (AS OPPOSED TO JUST PUTTING ARTWORK ON THE WEB) THEN YOU'LL NEED TO ENSURE THAT YOU WORK IN CMYK MODE.

C M Y K

WE'LL EXPLAIN THIS IN MORE DETAIL LATER, BUT BASICALLY SOME COLORS THAT YOU CAN SEE ON-SCREEN CAN'T BE REPRODUCED IN PRINT, AND WORKING IN CMYK MODE WILL MAKE SURE THAT YOU NEVER USE THESE "IMPOSSIBLE" COLORS.

DIGITAL COLORING IS ALWAYS DONE USING LAYERS, KEEPING THE BLACK LINE ARTWORK AS A SEPARATE LAYER, AND THEN APPLYING COLOR ON LAYERS BENEATH.

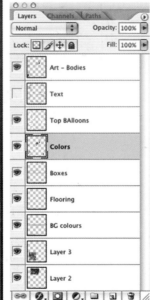

THE ONLY EXCEPTION TO THIS RULE IS WHEN YOU WANT TO CREATE SPECIAL EFFECTS, SUCH AS TRANSFORMING BLACK LINES INTO COLOR ONES TO SUGGEST BOLTS OF ENERGY.

IN ORDER TO PAINT UNDERNEATH YOUR ARTWORK, YOU HAVE TO MAKE THE WHITE AREAS TRANSPARENT AND THE BLACK AREAS A "SOLID" BLACK (THAT IS, 100%K IN CMYK MODE)

SO THAT WHEN YOU PRINT, YOU DO NOT GET ANY COLOR SHOWING THROUGH THE LINES.

IT'S A SIMPLE MATTER IN PHOTOSHOP TO SET THIS UP AS AN "ACTION" SO YOU CAN QUICKLY APPLY IT TO YOUR ARTWORK.

ALL LAYERS, EXCEPT FOR THE INITIAL BACKGROUND LAYER AND ANY IMPORTED IMAGES (SUCH AS BLACK-AND-WHITE ARTWORK) ARE BY THEIR NATURE TRANSPARENT,

SO YOU CAN PAINT ON THEM WITH WASHES OR SOLID COLOR AS YOU SEE FIT.

THE EASIEST WAY TO DO THIS, AT LEAST INITIALLY, IS BY SETTING THE ARTWORK LAYER TO *"MULTIPLY"* (WHICH TURNS WHITE TRANSPARENT, BUT KEEPS BLACK OPAQUE),

ALLOWING YOU TO IMPORT, COMBINE, AND EDIT OTHER PIECES OF BLACK LINE WORK INTO YOUR FILE WITHOUT HAVING TO REPEAT THE PROCESS OF GETTING ANOTHER SET OF BLACK LINES READY FOR PRINT.

MANY COLORISTS WORK INITIALLY BY *"FLATTING"* IN AREAS OF SOLID COLOR,

THEN SELECTING THESE AREAS AND MODIFYING THEM WITH COLOR WASHES, ON SEPARATE LAYERS.

THIS IS WHERE HAVING A LARGE HARD DISK AND PLENTY OF RAM IS VERY IMPORTANT.

History | **Actions**

055-Col-02.psd

Open
Move
Delete Layer
Delete Layer
Paint Bucket
Pencil
Pencil
Pencil
Pencil
Pencil
Layer Order

NOT ONLY DO MORE LAYERS MEAN LARGER FILES, BUT PHOTOSHOP WILL ALSO SAVE A NUMBER OF *"HISTORY STATES"* OF YOUR WORK SO YOU CAN STEP BACK AND FORWARD THROUGH THEM.

FOR THE ARTIST, THIS IS A VERY VALUABLE LITTLE TOOL, BUT IT RAPIDLY EATS UP YOUR COMPUTER'S MEMORY.

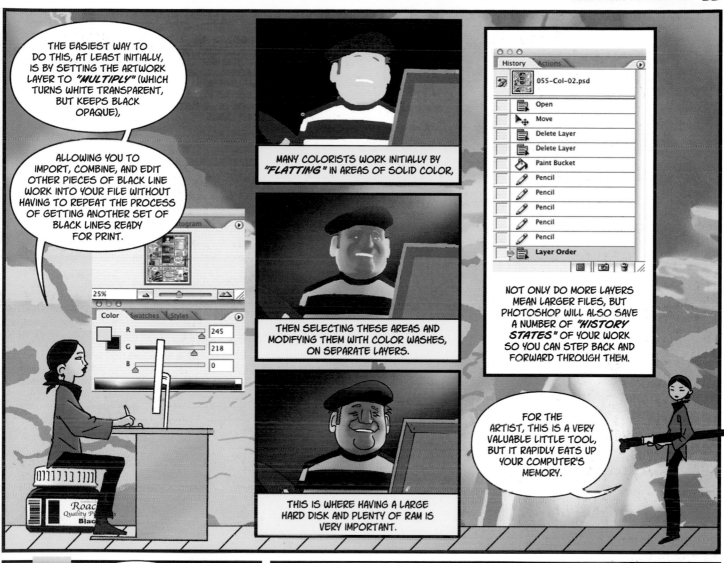

THERE'S MUCH MORE TO PHOTOSHOP THAN BRUSHES, THOUGH.

 OTHER USEFUL TOOLS INCLUDE THE *LASSO* AND *MAGIC WAND* FOR SELECTING AREAS OF ARTWORK,

 THE *GRADIENT* TOOL FOR... YOU CAN PROBABLY GUESS WHAT THAT ONE'S FOR,

 THE *PAINT BUCKET* FOR FILLING SELECTIONS,

 AND THE *EYEDROPPER* FOR PICKING UP COLOR FROM SOMEWHERE ELSE SO YOU CAN EXACTLY MATCH COLORS. AND THAT'S JUST SCRATCHING THE SURFACE.

FINALLY, THERE ARE MANY FILTERS AND EFFECTS (PLUG-INS) AVAILABLE: FLARES, TEXTURES, ETC.

ONCE AGAIN, THEY CAN BE VERY USEFUL, BUT DON'T OVERDO IT.

YOU DON'T NEED TO GET ALL OF THE TOYS OUT OF THE TOY BOX AT ONCE!

SAVING

SAVING YOUR WORK FREQUENTLY SHOULD BECOME AN AUTOMATIC PROCESS WHEN YOU'RE WRITING OR DRAWING.

IN FACT, IN MANY APPLICATIONS YOU CAN MAKE IT AUTOMATIC BY CHANGING A SETTING IN THE PROGRAM'S PREFERENCES WINDOW.

ON THE UPSIDE, THIS WILL PROTECT YOU FROM LOSING ALL OF YOUR WORK WHEN YOUR COMPUTER CRASHES, BUT ON THE DOWNSIDE, IT CAN SLOW DOWN THE PIECE OF SOFTWARE THAT YOU ARE USING.

TO BE HONEST, WITH THE SPEED OF COMPUTERS NOWADAYS, YOU CAN (AND SHOULD) ENABLE THIS FEATURE WITHOUT NOTICING ANY SLOWDOWN.

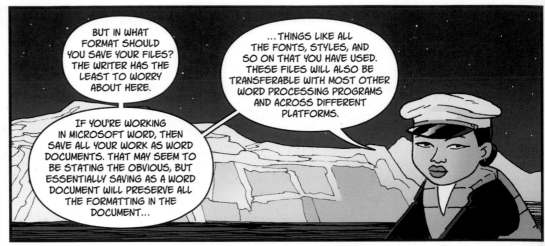

BUT IN WHAT FORMAT SHOULD YOU SAVE YOUR FILES? THE WRITER HAS THE LEAST TO WORRY ABOUT HERE.

...THINGS LIKE ALL THE FONTS, STYLES, AND SO ON THAT YOU HAVE USED. THESE FILES WILL ALSO BE TRANSFERABLE WITH MOST OTHER WORD PROCESSING PROGRAMS AND ACROSS DIFFERENT PLATFORMS.

IF YOU'RE WORKING IN MICROSOFT WORD, THEN SAVE ALL YOUR WORK AS WORD DOCUMENTS. THAT MAY SEEM TO BE STATING THE OBVIOUS, BUT ESSENTIALLY SAVING AS A WORD DOCUMENT WILL PRESERVE ALL THE FORMATTING IN THE DOCUMENT...

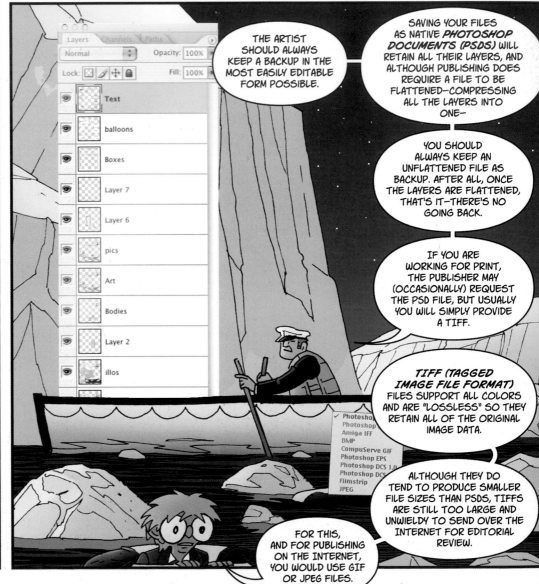

THE ARTIST SHOULD ALWAYS KEEP A BACKUP IN THE MOST EASILY EDITABLE FORM POSSIBLE.

SAVING YOUR FILES AS NATIVE *PHOTOSHOP DOCUMENTS (PSDS)* WILL RETAIN ALL THEIR LAYERS, AND ALTHOUGH PUBLISHING DOES REQUIRE A FILE TO BE FLATTENED—COMPRESSING ALL THE LAYERS INTO ONE—

YOU SHOULD ALWAYS KEEP AN UNFLATTENED FILE AS BACKUP. AFTER ALL, ONCE THE LAYERS ARE FLATTENED, THAT'S IT—THERE'S NO GOING BACK.

IF YOU ARE WORKING FOR PRINT, THE PUBLISHER MAY (OCCASIONALLY) REQUEST THE PSD FILE, BUT USUALLY YOU WILL SIMPLY PROVIDE A TIFF.

TIFF (TAGGED IMAGE FILE FORMAT) FILES SUPPORT ALL COLORS AND ARE "LOSSLESS" SO THEY RETAIN ALL OF THE ORIGINAL IMAGE DATA.

ALTHOUGH THEY DO TEND TO PRODUCE SMALLER FILE SIZES THAN PSDS, TIFFS ARE STILL TOO LARGE AND UNWIELDY TO SEND OVER THE INTERNET FOR EDITORIAL REVIEW.

FOR THIS, AND FOR PUBLISHING ON THE INTERNET, YOU WOULD USE GIF OR JPEG FILES.

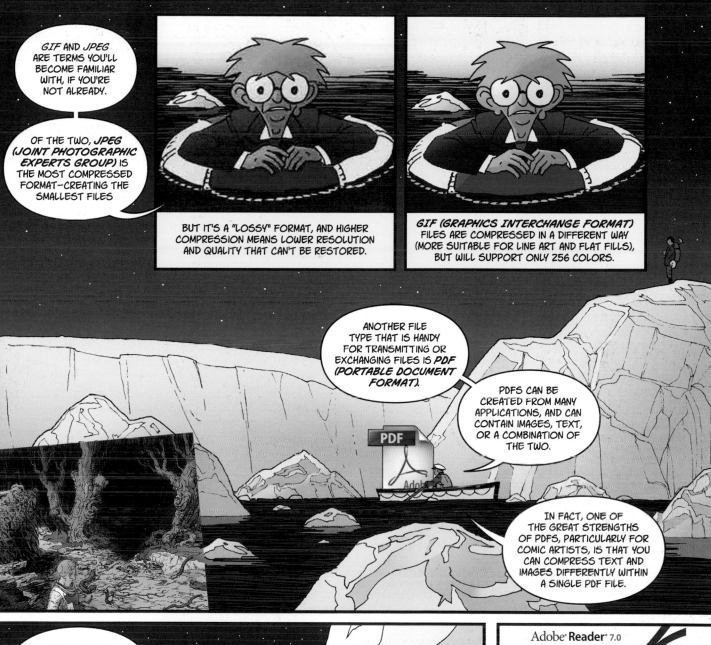

GIF AND JPEG ARE TERMS YOU'LL BECOME FAMILIAR WITH, IF YOU'RE NOT ALREADY.

OF THE TWO, *JPEG (JOINT PHOTOGRAPHIC EXPERTS GROUP)* IS THE MOST COMPRESSED FORMAT—CREATING THE SMALLEST FILES

BUT IT'S A "LOSSY" FORMAT, AND HIGHER COMPRESSION MEANS LOWER RESOLUTION AND QUALITY THAT CAN'T BE RESTORED.

GIF (GRAPHICS INTERCHANGE FORMAT) FILES ARE COMPRESSED IN A DIFFERENT WAY (MORE SUITABLE FOR LINE ART AND FLAT FILLS), BUT WILL SUPPORT ONLY 256 COLORS.

ANOTHER FILE TYPE THAT IS HANDY FOR TRANSMITTING OR EXCHANGING FILES IS *PDF (PORTABLE DOCUMENT FORMAT).*

PDFS CAN BE CREATED FROM MANY APPLICATIONS, AND CAN CONTAIN IMAGES, TEXT, OR A COMBINATION OF THE TWO.

IN FACT, ONE OF THE GREAT STRENGTHS OF PDFS, PARTICULARLY FOR COMIC ARTISTS, IS THAT YOU CAN COMPRESS TEXT AND IMAGES DIFFERENTLY WITHIN A SINGLE PDF FILE.

THIS MEANS YOU CAN SEND LOW-RESOLUTION PDFS TO CLIENTS, OR TO POST ON THE WEB, AND HAVE THE TEXT REMAIN ABSOLUTELY PIN-SHARP.

ANOTHER GOOD THING ABOUT PDFS IS THAT THEY ARE NOT EDITABLE, AND IT'S POSSIBLE TO "LOCK" THEM, SO THEY CAN'T BE COPIED OR PRINTED.

Adobe® Reader® 7.0

Version 7.0.7 (12/1/06 22:42)

Copyright 1984–2005 Adobe Systems Incorporated and its licensors. All rights reserved.

PDFS ARE READ THROUGH ADOBE ACROBAT AND READER SOFTWARE, BUT SINCE READER IS FREELY AVAILABLE, PDFS HAVE BECOME ALMOST UNIVERSAL.

PUBLISHING: PRINT OR WEB?

THE FILE FORMAT YOU CHOOSE OFTEN DEPENDS ON WHERE YOU INTEND THE FINISHED COMIC TO END UP—EITHER AT NEWSSTANDS AND BOOKSTORES, OR ON THE WEB—

AND THIS IS WHERE SIZE REALLY MATTERS.

FOR A PRINTED COMIC, THE FINISHED PAGE NEEDS TO HAVE THE BEST RESOLUTION AND QUALITY YOU CAN GIVE IT.

THE PUBLISHED BOOK WILL ONLY LOOK AS GOOD AS THE FINISHED ARTWORK; SKIMP ON THE QUALITY, AND IT'LL SHOW.

Image Size

Pixel Dimensions: 27.6M

Width: 2544 pixels
Height: 2839 pixels

OK
Cancel
Auto...

Document Size:

Width: 21.54 cm
Height: 24.04 cm
Resolution: 300 pixels/inch

☑ Scale Styles
☑ Constrain Proportions
☑ Resample Image: Bicubic

THIS MEANS YOU'RE GOING TO WANT A FILE THAT HAS A RESOLUTION OF AT LEAST 300 PPI (PIXELS PER INCH), AND BE IN CMYK COLOR MODE.

ALL OF THESE CONSIDERATIONS MEAN YOUR FILES ARE GOING TO BE FAIRLY BIG.

WHEN IT'S TIME TO SEND YOUR PAGES TO YOUR PUBLISHER, TIFFS ARE PROBABLY THE BEST FORMAT TO USE.

TIFF Options

Image Compression
○ NONE
◉ LZW
○ ZIP
○ JPEG

Quality: [] Maximum
small file large file

OK
Cancel

Pixel Order
◉ Interleaved (RGBRGB)
○ Per Channel (RRGGBB)

Byte Order
○ IBM PC
◉ Macintosh

☐ Save Image Pyramid
☐ Save Transparency
Layer Compression
○ RLE (faster saves, bigger files)
○ ZIP (slower saves, smaller files)
◉ Discard Layers and Save a Copy

TIFFS HAVE A BUILT-IN LOSSLESS COMPRESSION OPTION (LZW), AND THEY CAN BE INCORPORATED DIRECTLY INTO LAYOUT SOFTWARE SUCH AS QUARKXPRESS AND INDESIGN.

IF YOU'RE GOING TO PUBLISH ON THE WEB, HOWEVER, THERE'S ROOM FOR COMPROMISE.

FOR ONE THING, A COMPUTER SCREEN'S RESOLUTION ISN'T AS GOOD AS A PRINTED PAGE. THEREFORE, YOU CAN REDUCE THE IMAGE QUALITY (AND FILE SIZE) WITHOUT MAKING A DIFFERENCE TO THE IMAGE SEEN ON-SCREEN.

72 ppi

ALSO, BIG IMAGE FILES TAKE A LONG TIME TO DOWNLOAD—EVEN IN THESE DAYS OF 8MB BROADBAND—AND WEB USERS AREN'T KNOWN FOR THEIR PATIENCE.

ANOTHER PROBLEM WITH BIG FILES IS THAT *ISPS (INTERNET SERVICE PROVIDERS*—THE PEOPLE WHO HOST YOUR FILES ON THE WEB) OFTEN ALLOW ONLY A LIMITED AMOUNT OF FREE HOSTING SPACE, OFTEN ABOUT 10MB.

FILES FOR THE WEB CAN ALSO BE SAVED IN RGB MODE, BECAUSE THEY'RE GOING TO BE VIEWED ON A SCREEN, NOT ON A PRINTED SHEET.

WE'LL GO INTO COLOR MODES IN MORE DETAIL LATER, BUT THE GOOD NEWS IS RGB MODE USES LESS SPACE, SO AGAIN THE FILES ARE SMALLER.

IF YOU DON'T WANT TO HAVE TO START PAYING FOR EXTRA MEGABYTES, THEN MAKE SURE TO KEEP YOUR FILE SIZES DOWN.

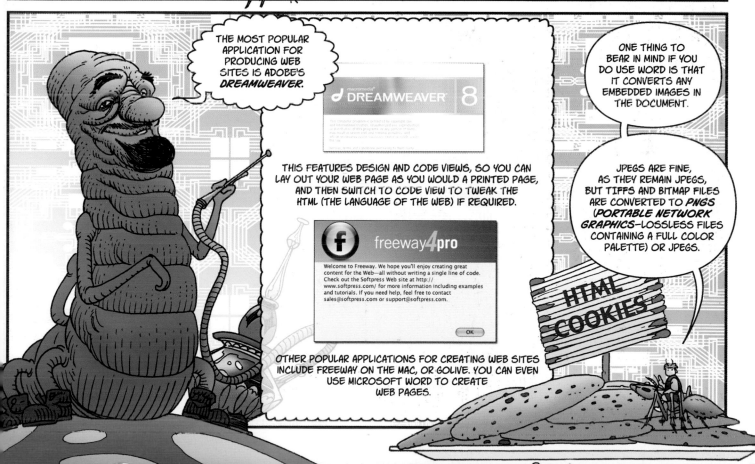

THE MOST POPULAR APPLICATION FOR PRODUCING WEB SITES IS ADOBE'S *DREAMWEAVER.*

ONE THING TO BEAR IN MIND IF YOU DO USE WORD IS THAT IT CONVERTS ANY EMBEDDED IMAGES IN THE DOCUMENT.

THIS FEATURES DESIGN AND CODE VIEWS, SO YOU CAN LAY OUT YOUR WEB PAGE AS YOU WOULD A PRINTED PAGE, AND THEN SWITCH TO CODE VIEW TO TWEAK THE HTML (THE LANGUAGE OF THE WEB) IF REQUIRED.

JPEGS ARE FINE, AS THEY REMAIN JPEGS, BUT TIFFS AND BITMAP FILES ARE CONVERTED TO *PNGS (PORTABLE NETWORK GRAPHICS*—LOSSLESS FILES CONTAINING A FULL COLOR PALETTE) OR JPEGS.

OTHER POPULAR APPLICATIONS FOR CREATING WEB SITES INCLUDE FREEWAY ON THE MAC, OR GOLIVE. YOU CAN EVEN USE MICROSOFT WORD TO CREATE WEB PAGES.

CHAPTER 4

INSPIRATION . 62
OBSERVING PEOPLE . 64
KEEPING NOTES AND RECORDS 66
DIGITAL CAMERAS . 68

INSPIRATION

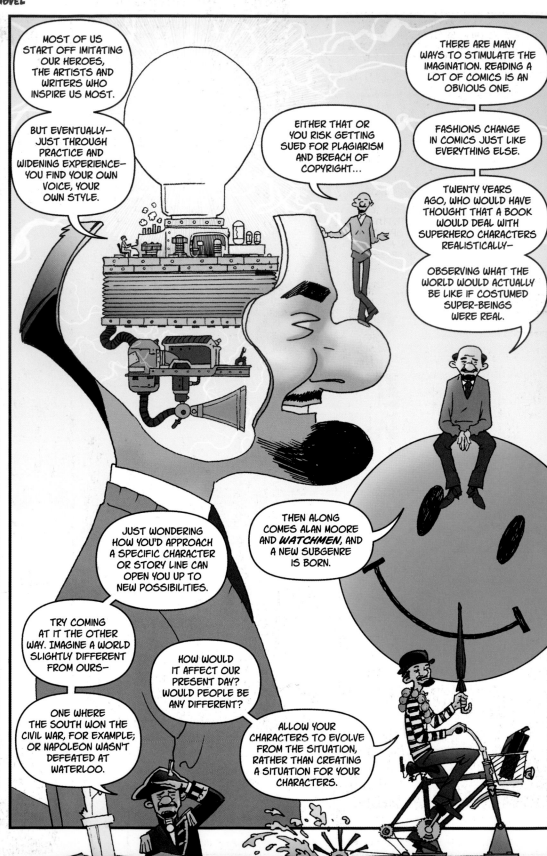

INSPIRATION'S A STRANGE THING. IT DOESN'T JUST LEAP UP AND BITE YOU—AT LEAST, NOT MOST OF THE TIME.

IT NEEDS HELP, CULTIVATION, AND A GOOD HARD KICK ONCE IN A WHILE.

OCCASIONALLY, SOMETHING WILL LEAP OUT AT YOU—BE LITERALLY DREAMT UP—BUT DON'T COUNT ON IT HAPPENING TOO OFTEN.

MOST OF US START OFF IMITATING OUR HEROES, THE ARTISTS AND WRITERS WHO INSPIRE US MOST.

BUT EVENTUALLY—JUST THROUGH PRACTICE AND WIDENING EXPERIENCE—YOU FIND YOUR OWN VOICE, YOUR OWN STYLE.

EITHER THAT OR YOU RISK GETTING SUED FOR PLAGIARISM AND BREACH OF COPYRIGHT...

THERE ARE MANY WAYS TO STIMULATE THE IMAGINATION. READING A LOT OF COMICS IS AN OBVIOUS ONE.

FASHIONS CHANGE IN COMICS JUST LIKE EVERYTHING ELSE.

TWENTY YEARS AGO, WHO WOULD HAVE THOUGHT THAT A BOOK WOULD DEAL WITH SUPERHERO CHARACTERS REALISTICALLY—

OBSERVING WHAT THE WORLD WOULD ACTUALLY BE LIKE IF COSTUMED SUPER-BEINGS WERE REAL.

JUST WONDERING HOW YOU'D APPROACH A SPECIFIC CHARACTER OR STORY LINE CAN OPEN YOU UP TO NEW POSSIBILITIES.

THEN ALONG COMES ALAN MOORE AND *WATCHMEN*, AND A NEW SUBGENRE IS BORN.

TRY COMING AT IT THE OTHER WAY. IMAGINE A WORLD SLIGHTLY DIFFERENT FROM OURS—

ONE WHERE THE SOUTH WON THE CIVIL WAR, FOR EXAMPLE; OR NAPOLEON WASN'T DEFEATED AT WATERLOO.

HOW WOULD IT AFFECT OUR PRESENT DAY? WOULD PEOPLE BE ANY DIFFERENT?

ALLOW YOUR CHARACTERS TO EVOLVE FROM THE SITUATION, RATHER THAN CREATING A SITUATION FOR YOUR CHARACTERS.

MOVIES AND TV ARE ANOTHER OBVIOUS EXAMPLE. NOTHING BEATS A BAD MOVIE FOR GETTING YOU TO LEAP UP IN FRUSTRATION AND SHOUT "I CAN DO BETTER THAN THAT!"

WELL, CAN YOU? PROVE IT. PUT YOUR OWN SPIN ON A FAMILIAR MOVIE OR TV SERIES.

CHANCES ARE U WON'T BE ABLE SELL YOUR OWN VERSION OF A *BUFFY* COMIC,

BUT YOU CAN AT LEAST GET SOME IDEA OF PACING, SCENE-SETTING, AND CHARACTERIZATION.

THE SAME GOES FOR VIDEO AND ARCADE GAMES.

TAKE A CHARACTER AND GIVE HIM HIS OWN STORY; OR REDESIGN A CHARACTER AROUND YOUR OWN CRITERIA.

OR HOW ABOUT AN ADAPTATION OF A CONVENTIONAL BOOK?

CLASSICS ILLUSTRATED WAS A LONG-RUNNING COMIC BOOK LINE OF LITERARY ADAPTATIONS AND IT WORKED FOR THEM.

HOW WOULD YOU TRANSFER A NOVEL INTO A COMIC STRIP? WHAT CHANGES WOULD YOU NEED TO MAKE FOR IT TO WORK GRAPHICALLY?

IN *THE LEAGUE OF EXTRAORDINARY GENTLEMEN*, ALAN MOORE AND KEVIN O'NEILL TOOK A COLLECTION OF CHARACTERS THAT ALREADY HAD A RECOGNIZED LITERARY HERITAGE AND UNITED THEM.

EVEN MORE LEFT FIELD, DC/VERTIGO HAS PUBLISHED FICTIONALIZED LIVES OF TWO HORROR SUPREMOS—*HP LOVECRAFT* AND *EDGAR ALLAN POE*.

HOW ABOUT A SIMILAR TREATMENT FOR YOUR OWN LITERARY HERO?

AND FINALLY, THERE'S THE OLD-FASHIONED, SIT DOWN AND SWEAT IT OUT METHOD.

HOW CAN YOU BRING SOMETHING FRESH AND NEW TO THE TABLE?

YOU WANT TO WRITE A SPECIFIC TYPE OF STORY, BE IT SUPERHERO, PRIVATE DETECTIVE, OR VAMPIRE, SO YOU NEED TO CONSIDER WHAT'S ALREADY BEEN DONE.

WILLIAM MOULTON MARSTON—WHO ALSO INVENTED THE LIE DETECTOR—CREATED *WONDER WOMAN* IN 1942 AS A DELIBERATELY FEMALE VERSION OF *SUPERMAN*.

AT A TIME WHEN WOMEN WERE SUDDENLY DOING WHAT HAD BEEN TRADITIONALLY MEN'S WORK BECAUSE OF WORLD WAR II, HE SAW AN OBVIOUS NICHE.

GO FIND YOURS.

OBSERVING PEOPLE

SOMETHING YOU NEED TO START DOING IS WATCHING AND LISTENING TO REAL PEOPLE.

CAREFUL YOU DON'T WATCH TOO CLOSE, THOUGH, YOU MIGHT WIND UP PENNING YOUR NEXT SCRIPT FROM BEHIND BARS!

BECAUSE, AFTER ALL, PEOPLE ARE WEIRD (IN THE NICEST WAY...). THEY SAY FUNNY THINGS.

THEY GET THEIR WORDS MIXED UP AND WHAT THEY WANT TO SAY COMES OUT AS SOMETHING ALTOGETHER DIFFERENT.

A CRAZY PHRASE CAN QUITE EASILY SPARK OFF A WHOLE TRAIN OF THOUGHT, AND QUITE A FEW WRITERS MAKE A HABIT OF LISTENING FOR BIZARRE PHRASES AND MANGLED SENTENCES.

AND IF YOU LISTEN TO PEOPLE TALKING, NO ONE REALLY TALKS IN THE ORDERED AND COHERENT WAY THEY DO IN THE MOVIES AND ON TV.

FOR INSTANCE, KEV AND I SOMEHOW GOT INTO THIS GAG THING ABOUT A GUY WITH A COUGH. I DON'T KNOW HOW IT STARTED, BUT IT ENDED UP BEING ABOUT AN EVIL COUGH-INFESTED GENIUS.

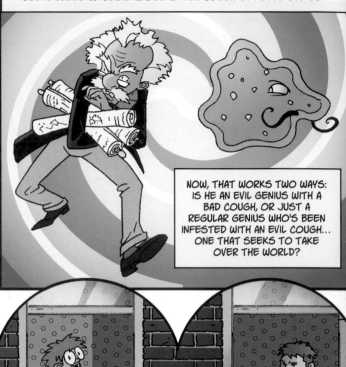

NOW, THAT WORKS TWO WAYS: IS HE AN EVIL GENIUS WITH A BAD COUGH, OR JUST A REGULAR GENIUS WHO'S BEEN INFESTED WITH AN EVIL COUGH... ONE THAT SEEKS TO TAKE OVER THE WORLD?

YOU DECIDE....

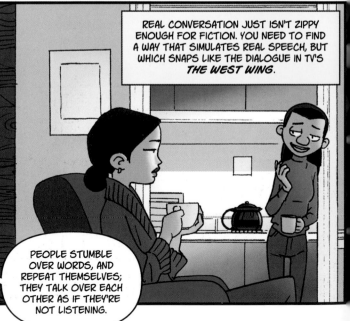

REAL CONVERSATION JUST ISN'T ZIPPY ENOUGH FOR FICTION. YOU NEED TO FIND A WAY THAT SIMULATES REAL SPEECH, BUT WHICH SNAPS LIKE THE DIALOGUE IN TV'S *THE WEST WING*.

PEOPLE STUMBLE OVER WORDS, AND REPEAT THEMSELVES; THEY TALK OVER EACH OTHER AS IF THEY'RE NOT LISTENING.

COMICS HAVE A UNIQUE POSITION HERE. WITH SPEECH BALLOONS YOU CAN OVERLAP AND WEAVE DIALOGUE IN A WAY THAT NO OTHER PRINTED MEDIUM CAN.

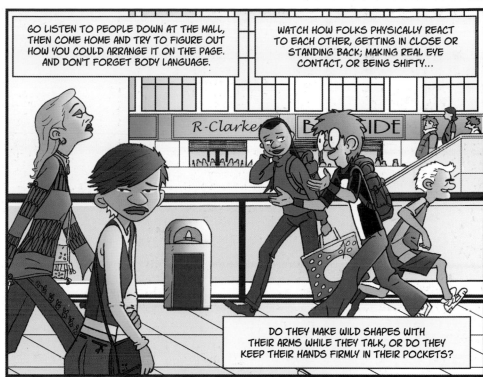

GO LISTEN TO PEOPLE DOWN AT THE MALL, THEN COME HOME AND TRY TO FIGURE OUT HOW YOU COULD ARRANGE IT ON THE PAGE. AND DON'T FORGET BODY LANGUAGE.

WATCH HOW FOLKS PHYSICALLY REACT TO EACH OTHER, GETTING IN CLOSE OR STANDING BACK; MAKING REAL EYE CONTACT, OR BEING SHIFTY...

DO THEY MAKE WILD SHAPES WITH THEIR ARMS WHILE THEY TALK, OR DO THEY KEEP THEIR HANDS FIRMLY IN THEIR POCKETS?

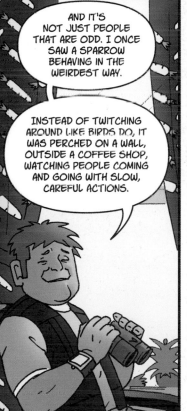

AND IT'S NOT JUST PEOPLE THAT ARE ODD. I ONCE SAW A SPARROW BEHAVING IN THE WEIRDEST WAY.

INSTEAD OF TWITCHING AROUND LIKE BIRDS DO, IT WAS PERCHED ON A WALL, OUTSIDE A COFFEE SHOP, WATCHING PEOPLE COMING AND GOING WITH SLOW, CAREFUL ACTIONS.

IT SEEMED TO BE CONSIDERING EVERYTHING; ALMOST AS THOUGH IT WAS WATCHING FOR SOMETHING—OR SOMEONE—IN PARTICULAR. MORE LIKE A PERSON THAN AN ANIMAL.

I DON'T KNOW WHY IT WAS BEHAVING LIKE THAT, MAYBE IT WAS SICK. OR MAYBE IT WASN'T REALLY A BIRD? MAYBE IT WAS A THOUGHT PROJECTION CONCEALING ITS REAL ALIEN FORM?

WHATEVER, IT ENDED UP IN THE NEXT ISSUE OF LOS BROS AS *MELVIN THE WERESPARROW.*

KEEPING NOTES AND RECORDS

ALWAYS TAKE NOTES OF ONE KIND OR ANOTHER,

OTHERWISE WHEN THAT MOMENT OF INSPIRATION COMES YOU'LL FORGET IT. TRUST ME—NEVER RELY ON JUST MEMORY.

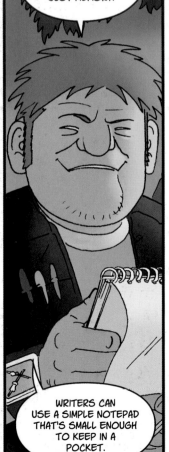

WRITERS CAN USE A SIMPLE NOTEPAD THAT'S SMALL ENOUGH TO KEEP IN A POCKET.

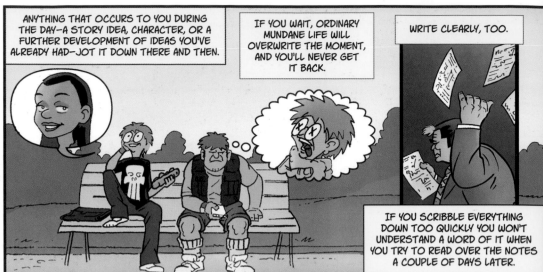

ANYTHING THAT OCCURS TO YOU DURING THE DAY—A STORY IDEA, CHARACTER, OR A FURTHER DEVELOPMENT OF IDEAS YOU'VE ALREADY HAD—JOT IT DOWN THERE AND THEN.

IF YOU WAIT, ORDINARY MUNDANE LIFE WILL OVERWRITE THE MOMENT, AND YOU'LL NEVER GET IT BACK.

WRITE CLEARLY, TOO.

IF YOU SCRIBBLE EVERYTHING DOWN TOO QUICKLY YOU WON'T UNDERSTAND A WORD OF IT WHEN YOU TRY TO READ OVER THE NOTES A COUPLE OF DAYS LATER.

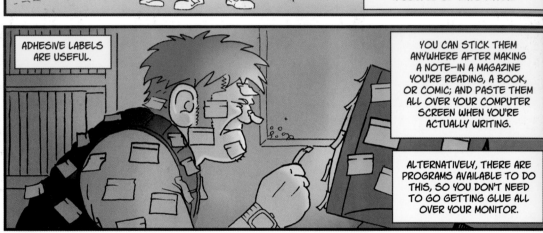

ADHESIVE LABELS ARE USEFUL.

YOU CAN STICK THEM ANYWHERE AFTER MAKING A NOTE—IN A MAGAZINE YOU'RE READING, A BOOK, OR COMIC; AND PASTE THEM ALL OVER YOUR COMPUTER SCREEN WHEN YOU'RE ACTUALLY WRITING.

ALTERNATIVELY, THERE ARE PROGRAMS AVAILABLE TO DO THIS, SO YOU DON'T NEED TO GO GETTING GLUE ALL OVER YOUR MONITOR.

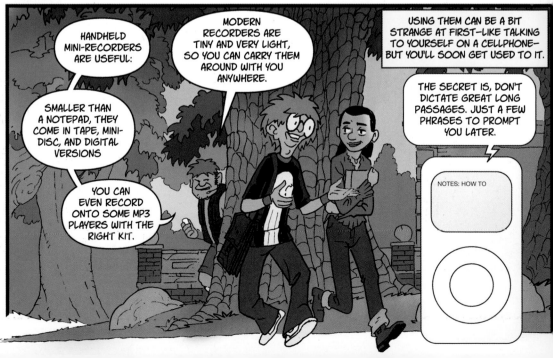

HANDHELD MINI-RECORDERS ARE USEFUL:

MODERN RECORDERS ARE TINY AND VERY LIGHT, SO YOU CAN CARRY THEM AROUND WITH YOU ANYWHERE.

USING THEM CAN BE A BIT STRANGE AT FIRST—LIKE TALKING TO YOURSELF ON A CELLPHONE—BUT YOU'LL SOON GET USED TO IT.

SMALLER THAN A NOTEPAD, THEY COME IN TAPE, MINI-DISC, AND DIGITAL VERSIONS

YOU CAN EVEN RECORD ONTO SOME MP3 PLAYERS WITH THE RIGHT KIT.

THE SECRET IS, DON'T DICTATE GREAT LONG PASSAGES. JUST A FEW PHRASES TO PROMPT YOU LATER.

NOTES: HOW TO

ARTISTS SHOULD ALWAYS CARRY A SKETCHPAD— BUT AGAIN, NOTHING TOO BIG. LIKE A WRITER, A STENOGRAPHER'S PAD WILL PROBABLY DO, UNLESS YOU WANT LARGE SKETCHES.

IF YOUR SUBJECT'S NOT LIKELY TO GET UP AND WALK AWAY IN A COUPLE OF SECONDS, MAYBE COME BACK WITH A BIGGER PAD LATER.

OR, IF YOUR PAD IS RING-BOUND, OPENING IT OUT WILL DOUBLE THE AMOUNT OF SPACE YOU HAVE TO WORK WITH.

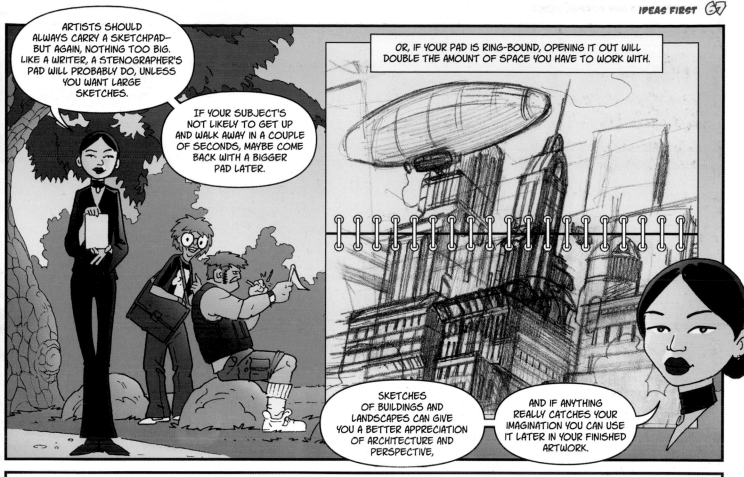

SKETCHES OF BUILDINGS AND LANDSCAPES CAN GIVE YOU A BETTER APPRECIATION OF ARCHITECTURE AND PERSPECTIVE,

AND IF ANYTHING REALLY CATCHES YOUR IMAGINATION YOU CAN USE IT LATER IN YOUR FINISHED ARTWORK.

TRY SKETCHING A FEW FACES—ESPECIALLY THE MORE UNUSUAL ONES.

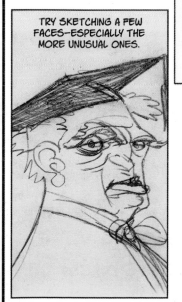

IF YOU DON'T HAVE THE NERVE TO TRY THIS OUT IN THE STREET, TALK YOUR FRIENDS OR RELATIVES INTO POSING. NOT ONLY WILL IT HELP IMPROVE YOUR UNDERSTANDING OF HOW A FACE WORKS, BUT YOU'LL ALSO BE CREATING A PORTFOLIO OF FACES AND EXPRESSIONS.

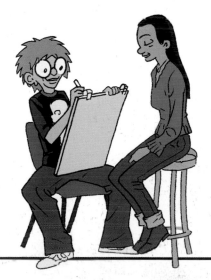

AND YOU HAVE A PRECEDENT: MANY COMIC ARTISTS, LIKE ALEX ROSS AND P. CRAIG RUSSELL, ACTUALLY USE LIVE MODELS FOR THEIR WORK.

IT DOESN'T MATTER WHAT KIND OF STYLE YOU'RE GOING FOR—PHOTO-REALISM OR CARICATURE—YOU NEED TO KNOW WHAT THE RULES ARE BEFORE YOU CAN BREAK THEM.

DIGITAL CAMERAS

DIGITAL STILL CAMERAS AND VIDEO RECORDERS ARE PERFECT FOR RECORDING IMAGES INSTANTLY.

THEY ALLOW YOU TO GET AROUND THE POTENTIAL EMBARRASSMENT OF STANDING IN THE STREET, DRAWING—YOU JUST POINT AND SHOOT.

IF YOU DON'T LIKE THE PICTURE, DELETE IT AND TAKE ANOTHER.

MOST MODERN DIGITAL VIDEO RECORDERS WILL ALSO TAKE STILL IMAGES,

(AND SOME STILL CAMERAS WILL TAKE SHORT VIDEOS...),

ALL THAT LIMITS YOU IS THE AMOUNT OF STORAGE SPACE ON THE MEMORY CARD.

GET THE BIGGEST CARDS YOU CAN, AND CARRY SPARES.

THE REASON WHY YOU WANT THE PICTURES—FOR SIMPLE REFERENCE OR SOMETHING TO BE INCLUDED IN YOUR BOOK AS PART OF THE ARTWORK—WILL DETERMINE THE RESOLUTION OF YOUR CAMERA.

6 MEGAPIXELS IS BECOMING STANDARD, BUT 4 OR 4.5 MEGAPIXELS SHOULD BE FINE.

AS WITH SCANNED ARTWORK, THE BIGGER THE RESOLUTION, THE BETTER. DON'T IMAGINE YOU'RE GOING TO GET A DECENT IMAGE FROM A CELLPHONE WITH A BUILT-IN CAMERA.

THE BEST RESOLUTION YOU'RE LIKELY TO GET AT THE MOMENT IS 1 OR 2 MEGAPIXELS— FINE FOR A SIMPLE REFERENCE SHOT, BUT NO GOOD AS PART OF A STRIP

UNLESS YOU'RE ACTUALLY GOING FOR THE PIXELATED LOOK, OF COURSE...

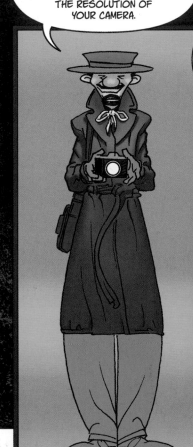

THE IMAGES YOU'VE SNAPPED CAN BE DOWNLOADED ONTO YOUR COMPUTER—EITHER THROUGH A DOCK OR A USB (UNIVERSAL SERIAL BUS) OR FIREWIRE CONNECTION.

IT'S NOT A BAD IDEA TO KEEP AN ORGANIZED BACKUP LIBRARY OF IMAGES ON CD OR DVD FOR LATER REFERENCE. YOU NEVER KNOW WHEN YOU'LL NEED THEM, AND IT'S BETTER THAN HAVING THEM TAKE UP YOUR ENTIRE HARD DRIVE.

THE BEST PLACE TO MANIPULATE YOUR IMAGES IS IN A PROGRAM LIKE ADOBE *PHOTOSHOP.*

PHOTOSHOP ELEMENTS—THE CHEAPER, CUT-DOWN VERSION OF PHOTOSHOP—CONTAINS ALL THE EDITING TOOLS YOU'LL REQUIRE, BUT IS MISSING SOME CRITICAL PRINT TOOLS (SUCH AS A CMYK MODE).

THERE ARE OTHER, LESS POWERFUL SOFTWARE ITEMS AVAILABLE, SUCH AS MICROSOFT *PHOTO EDITOR* AND COREL *PAINT SHOP PRO,*

BUT AGAIN THESE ARE MORE CONCERNED WITH BASIC PHOTOGRAPHIC MANIPULATION AND THEY DON'T HAVE THE BEST RANGE OF TOOLS AT THEIR DISPOSAL.

THAT SAID, THEY'RE FINE FOR SIMPLE MANIPULATION, AND ARE QUICK AND EASY TO USE.

Adobe®Photoshop®CS2

Version 9.0

© 1990–2005 Adobe Systems Incorporated. All rights reserved. Adobe, the Adobe logo and Photoshop are either registered trademarks or trademarks of Adobe Systems Incorporated in the United States and/or other countries.

ONCE YOU'VE IMPORTED YOUR DIGITAL SNAPS INTO PHOTOSHOP, YOU CAN TWEAK THEM IN MANY WAYS—FROM SIMPLE COLOR OR CONTRAST ADJUSTMENTS TO INCREDIBLY COMPLEX MULTILAYERED MONTAGES.

PHOTOSHOP ALSO WORKS WELL WITH ILLUSTRATOR—A POPULAR DIGITAL DRAWING PROGRAM—SO IT'S EASY TO COMBINE PHOTOGRAPHIC IMAGES WITH YOUR DRAWN OR SCANNED ARTWORK.

SOME WONDERFULLY EVOCATIVE COMIC ART HAS BEEN PRODUCED USING A COMBINATION OF CAMERAWORK AND DRAWING—SUCH AS *I, PAPARAZZI* AND *PROMETHEA*

AND IT'S WORTH EXPERIMENTING TO SEE WHAT YOU CAN DO WITH THE STYLE.

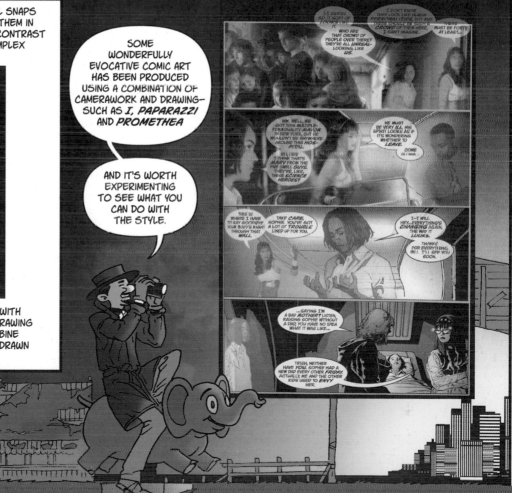

CHAPTER 5

WRITING STYLES . 72

FULL SCRIPT VERSUS PLOT METHODS 74

ONLINE COLLABORATION 76

PACE . 78

CHARACTER DEVELOPMENT 80

SETTING . 82

USE OF MOVIE TECHNIQUES84

RESEARCH . 86

WRITING A BRIEF AND SYNOPSIS 88

WRITING STYLES

IT SHOULD GO WITHOUT SAYING THAT ALL DIFFERENT GENRES AND SUBGENRES TEND TO HAVE THEIR OWN STYLE.

WRITERS ALSO HAVE THEIR OWN INDIVIDUAL STYLES, BUT THAT'S NOT SOMETHING YOU CAN BE TAUGHT. IT JUST COMES WITH EXPERIENCE.

SCIENCE FICTION, FOR INSTANCE, OFTEN HAS PASSAGES OF MIND-JARRING SCIENCE—AND NOT ALWAYS VERY GOOD SCIENCE.

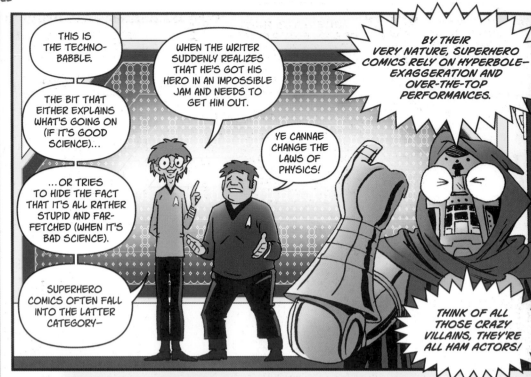

THIS IS THE TECHNO-BABBLE.

THE BIT THAT EITHER EXPLAINS WHAT'S GOING ON (IF IT'S GOOD SCIENCE)...

...OR TRIES TO HIDE THE FACT THAT IT'S ALL RATHER STUPID AND FAR-FETCHED (WHEN IT'S BAD SCIENCE).

SUPERHERO COMICS OFTEN FALL INTO THE LATTER CATEGORY—

WHEN THE WRITER SUDDENLY REALIZES THAT HE'S GOT HIS HERO IN AN IMPOSSIBLE JAM AND NEEDS TO GET HIM OUT.

YE CANNAE CHANGE THE LAWS OF PHYSICS!

BY THEIR VERY NATURE, SUPERHERO COMICS RELY ON HYPERBOLE—EXAGGERATION AND OVER-THE-TOP PERFORMANCES.

THINK OF ALL THOSE CRAZY VILLAINS, THEY'RE ALL HAM ACTORS!

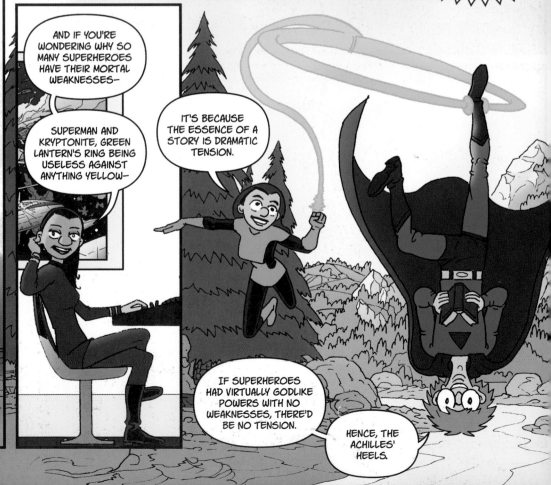

AND IF YOU'RE WONDERING WHY SO MANY SUPERHEROES HAVE THEIR MORTAL WEAKNESSES—

SUPERMAN AND KRYPTONITE, GREEN LANTERN'S RING BEING USELESS AGAINST ANYTHING YELLOW—

IT'S BECAUSE THE ESSENCE OF A STORY IS DRAMATIC TENSION.

IF SUPERHEROES HAD VIRTUALLY GODLIKE POWERS WITH NO WEAKNESSES, THERE'D BE NO TENSION.

HENCE, THE ACHILLES' HEELS.

LET'S USE A CRIME STORY AS AN EXAMPLE. WHAT SORT OF WRITING STYLE WOULD FIT IT?

LIGHT AND FLUFFY, OR HARD-EDGED AND HYPERREAL?

IS THERE ANY ROOM FOR HUMOR?

WHAT KIND OF PACE SHOULD THE STORY HAVE?

WHILE THERE'S PLENTY OF ROOM FOR HUMOR IN ANY STORY, REGARDLESS OF THE GENRE (IF WE'RE NOT TREATING HUMOR AS A GENRE IN ITS OWN RIGHT!), LIGHT AND FLUFFY CRIME STORIES JUST WON'T DO.

THE CLOSEST YOU'LL PROBABLY GET IS BLACK HUMOR—THINK OF THE MOVIE *ARSENIC AND OLD LACE*, WHERE TWO DEAR OLD LADIES ARE POISONING THEIR MALE GUESTS. CUTE.

FOR CRIME YOU CAN EITHER GO FOR SOCIAL REALISM, SUCH AS *STRAY BULLETS* BY DAVID LAPHAM, OR THE ÜBER-VIOLENCE OF THE *100 BULLETS* BOOKS (OR SOMEWHERE IN BETWEEN).

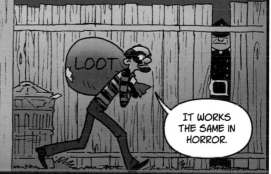

ALTHOUGH BOTH OF THESE EXAMPLES AREN'T KNOWN FOR THEIR GAGS, OCCASIONAL SPOTS OF HUMOR ARE RECOGNIZED AS A WAY OF DEFUSING TENSION.

WANTED

LOOT

IT WORKS THE SAME IN HORROR.

PACE IS ALL-IMPORTANT. NOT ONLY DO YOU WANT YOUR STORY ROLLING ALONG AT A SPEED THAT'LL KEEP THE READERS INTERESTED, YOU ALSO NEED TO PITCH IT RIGHT.

CRIME AND HORROR FAVOR A SLOW BEGINNING, GIVING THE READER TIME TO GET TO KNOW THE CHARACTERS, THEN BUILDING UP TO A CRESCENDO.

FANTASY OFTEN RATTLES ALONG LIKE AN EXPRESS TRAIN (AT LEAST, THE OLD-FASHIONED CONAN-STYLE FANTASY DOES);

AS DOES SPACE OPERA AND THE SUPERHERO STRIP.

BUT EVEN HERE YOU NEED QUIETER PERIODS—FOR MOMENTS OF EXPLANATION, OR CHARACTER INTERACTION.

OR EVEN JUST FOR THE READERS TO GET THEIR BREATH BACK.

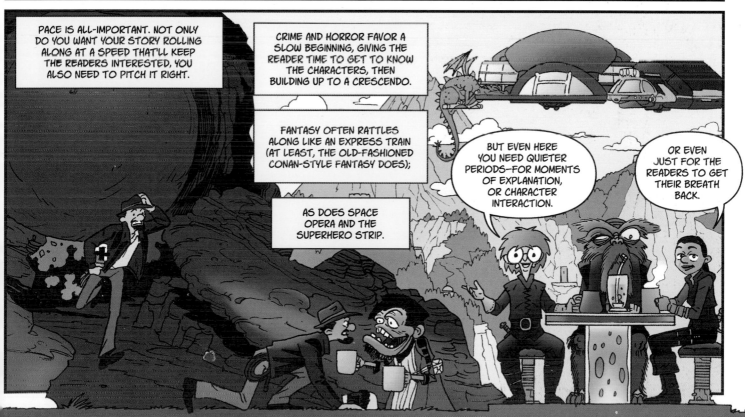

FULL SCRIPT VERSUS PLOT METHODS

ALTHOUGH THERE ARE MANY WAYS TO WRITE A COMIC SCRIPT, THE MAIN TWO ARE "FULL SCRIPT" AND "PLOT FIRST." FROM THEIR NAMES YOU CAN PRETTY MUCH GUESS HOW THEY WORK, BUT LET'S TAKE A LOOK AT THEM.

FIRST, FULL SCRIPT. THIS IS THE TRADITIONAL WAY OF PRESENTING A SCRIPT, AND SHARES MANY THINGS IN COMMON WITH A SHOOTING SCRIPT FOR A MOVIE OR TV SHOW.

THE WRITER DESCRIBES EVERYTHING: THE SCENE, NARRATIVE, AND DIALOGUE EXACTLY AS IT SHOULD HAPPEN ON THE FINISHED COMIC PAGE.

EACH PANEL (ALWAYS NUMBERED IN SEQUENCE, REMEMBER) IS DESCRIBED AS FULLY AS THE WRITER WISHES.

SOME AUTHORS —ALAN MOORE IS ONE OF THEM—GO INTO INCREDIBLE DETAIL ABOUT EXACTLY HOW THEY SEE THE PANELS AND HOW THEY WILL BE ARRANGED ON THE PAGE,

WHILE OTHERS ARE HAPPY TO LEAVE IT TO THE ARTIST.

THIS EXTRACT FROM *THE ORIGINALS* BY DAVE GIBBONS IS A TYPICAL FULL SCRIPT.

```
                    LEL
          Maybe sell some Zebs for
          Ronnie. Big money in them.

3. SAME SHOT. BOK HASN'T MOVED.
LEL CLOSES HIS EYES. A SHADOW
ENTERS THE PANEL AND WARREN'S
BALLOON COMES FROM OFF.

                  WARREN (O.P)
          Where did you two go last
          night?

4. SAME SHOT. BOK HASN'T MOVED. NOR
LEL. WARREN HAS WALKED INTO SHOT.

                  WARREN
          I said where --

PAGE FORTY THREE

1. AT LEL'S HOUSE. HE WALKS IN THE
DOOR, TIRED AND DISHEVELED FROM
THE NIGHT BEFORE. HIS MOTHER, AT
THE SINK, LOOKS ROUND CONCERNED.
HIS FATHER GLOWERS ANGRILY OVER HIS
MORNING NEWSPAPER AND HIS FOURTEEN
YEAR OLD SISTER GLANCES NEUTRALLY
IN HIS DIRECTION. THE HOUSE IS A
LITTLE SHABBY AND CLUTTERED.

                    TEXT
          Home was always a comedown,
          too.
```

EACH NARRATIVE BOX AND PIECE OF CHARACTER DIALOGUE THEN FOLLOWS IN THE ORDER THE AUTHOR IMAGINES.

YOU'VE SEEN HOW PANELS OFTEN HAVE SEVERAL NARRATIVE BOXES AND DIALOGUE BALLOONS SPACED ABOUT THEM.

IF THIS IS WHAT YOU WANT, YOU NEED TO WRITE IT THAT WAY.

AGAIN, THAT'S NOT NECESSARILY HOW IT'LL HAPPEN—BUT YOU NEED TO START WITH A FIRM IDEA OF WHAT YOU WANT.

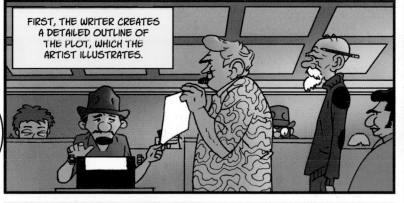

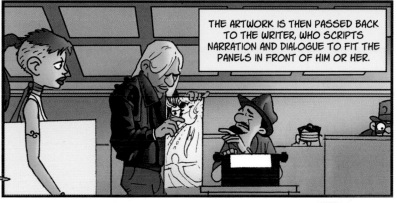

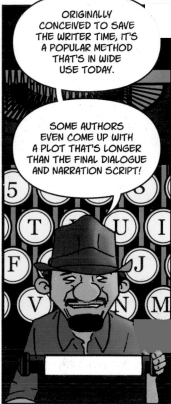

ANY FINAL SCRIPT PRODUCED IN THIS MANNER WILL OBVIOUSLY BE SIMPLER THAN A FULL SCRIPT. THERE AREN'T ANY SCENES TO DESCRIBE, AFTER ALL! ALL THAT'S REQUIRED ARE THE WORDS TO FIT THAT SCENE. BUT KEEP THOSE PANELS NUMBERED!

Mike Chinn, How To Make Your Own Graphic Novel / p. 75

Panel 1
Naz: Plot first is sometimes also called the Marvel method

Naz (cont) It's a way to produce a comic quickly and effectively —especially if the writer is busy on several comics at the same time.

Panel 2
Box: First, the writer creates a detailed outline of the plot which the artist illustrates.

Panel 3.
Box: The artwork is then passed back to the writer, who scripts narration and dialogue to fit the panels in front of him or her

Panel 4.
Prof: originally conceived to save the writer time, it's a popular method widely in use today.

SIMILAR TO A MOVIE SCRIPT, START WITH A CHARACTER'S NAME IF THEY'RE SPEAKING (E.G., "FRED:"), OR START WITH "BOX:" IF YOU WANT THE TEXT TO GO IN A NARRATIVE BOX. AS BEFORE, INSERT BOXES AND SPEECH WHEREVER YOU THINK THEY SHOULD GO. JUST DON'T OVERDO IT. THE ARTWORK'S IMPORTANT, TOO.

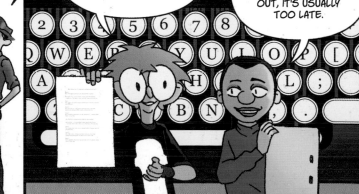

ONLINE COLLABORATION

IF YOU'RE IN THE GREAT POSITION OF WORKING CLOSELY WITH AN ARTIST, IT MAKES SENSE TO BOUNCE IDEAS OFF EACH OTHER.

USING E-MAIL, YOU CAN EASILY SEND IDEAS, BITS OF SCRIPT, AND EVEN ROUGH SKETCHES BACK AND FORTH.

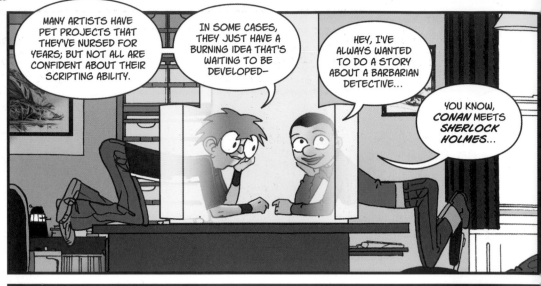

MANY ARTISTS HAVE PET PROJECTS THAT THEY'VE NURSED FOR YEARS; BUT NOT ALL ARE CONFIDENT ABOUT THEIR SCRIPTING ABILITY.

IN SOME CASES, THEY JUST HAVE A BURNING IDEA THAT'S WAITING TO BE DEVELOPED—

HEY, I'VE ALWAYS WANTED TO DO A STORY ABOUT A BARBARIAN DETECTIVE...

YOU KNOW, *CONAN* MEETS *SHERLOCK HOLMES*...

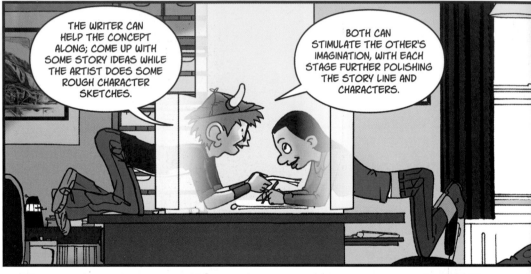

THE WRITER CAN HELP THE CONCEPT ALONG; COME UP WITH SOME STORY IDEAS WHILE THE ARTIST DOES SOME ROUGH CHARACTER SKETCHES.

BOTH CAN STIMULATE THE OTHER'S IMAGINATION, WITH EACH STAGE FURTHER POLISHING THE STORY LINE AND CHARACTERS.

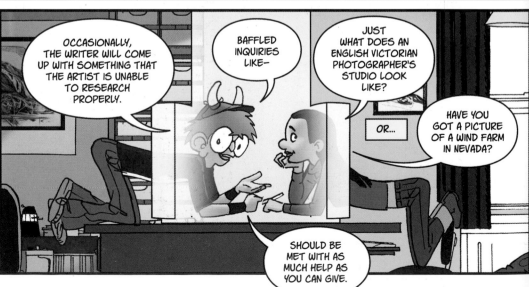

OCCASIONALLY, THE WRITER WILL COME UP WITH SOMETHING THAT THE ARTIST IS UNABLE TO RESEARCH PROPERLY.

BAFFLED INQUIRIES LIKE—

JUST WHAT DOES AN ENGLISH VICTORIAN PHOTOGRAPHER'S STUDIO LOOK LIKE?

OR...

HAVE YOU GOT A PICTURE OF A WIND FARM IN NEVADA?

SHOULD BE MET WITH AS MUCH HELP AS YOU CAN GIVE.

IT'S NOT UNCOMMON TO WORK ON A CHARACTER BRIEF: A DESCRIPTION OF THE CHARACTERS IN THE STORY.

Name:	?
Age:	43
Height:	6' 5"
Build:	Well-muscled/ Heroic
Eye color:	Hazel
Hair color:	Light brown with gray highlights
Clothing:	Barbarian chic
Address:	No fixed abode

NSED TO DETECT SINCE 320

THE WRITER SUPPLIES DETAILS OF EACH CHARACTER—NAME, AGE, HAIR AND EYE COLOR, CLOTHING, AND SO ON—AND THE ARTIST TAKES IT FROM THERE.

THE BRIEF SHOULD ALSO INCLUDE DETAILS THAT THE READER MAY NEVER GET TO KNOW ABOUT, LIKE PAST INJURIES THAT MIGHT AFFECT THE WAY A CHARACTER STANDS OR WALKS.

THESE TIDBITS OF INFORMATION ARE ALL THERE FOR THE ARTIST TO GET A PROPER FEEL FOR THE CHARACTERS.

IF WRITER AND ARTIST CAN'T PERSUADE THEMSELVES THAT THE PEOPLE POPULATING THE BOOK ARE REAL, THREE-DIMENSIONAL CHARACTERS, THEN THEY'RE NEVER GOING TO CONVINCE THE READERS.

THE ARTIST WILL DEVELOP HIS OR HER OWN IDEAS OF HOW THE CHARACTERS WILL LOOK AND REACT, AND THESE WILL BE REFLECTED IN THE CHARACTER SKETCHES THAT HE OR SHE CAN SHOW TO THE WRITER FOR REACTIONS AND COMMENTS.

FINALLY, THE ARTIST MIGHT COME UP WITH AN IDEA THAT WILL CHANGE THE STORY LINE, AND IT'S IMPORTANT TO LET THE ARTIST RAISE IT.

"TWO HEADS ARE BETTER THAN ONE" MIGHT BE A CLICHÉ, BUT IT'S ALSO TRUE. A PROPER EDITORIAL SESSION—WITH IDEAS TOSSED AROUND FREELY—CAN BE VERY CONSTRUCTIVE.

NO WRITER SHOULD GET TOO POSSESSIVE OF A STORY. THE ARTIST IS AN EQUAL PARTNER.

PACE

PACING YOUR STORY APPROPRIATELY IS IMPORTANT. TOO SLOW, AND YOU LOSE THE READER'S ATTENTION; TOO FRANTIC, AND YOU MIGHT JUST DRIVE READERS AWAY IN CONFUSION.

AND YOU CAN'T JUST STAY AT THE SAME PACE ALL THE WAY THROUGH—DIFFERENT SITUATIONS CALL FOR DIFFERENT RHYTHMS.

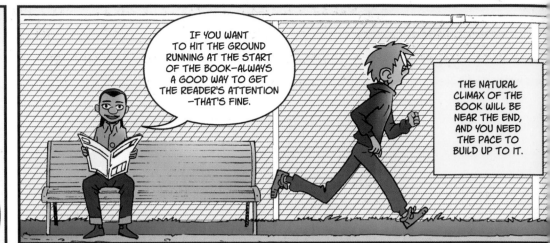

IF YOU WANT TO HIT THE GROUND RUNNING AT THE START OF THE BOOK—ALWAYS A GOOD WAY TO GET THE READER'S ATTENTION —THAT'S FINE.

THE NATURAL CLIMAX OF THE BOOK WILL BE NEAR THE END, AND YOU NEED THE PACE TO BUILD UP TO IT.

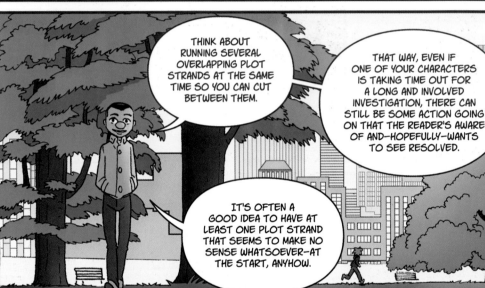

THINK ABOUT RUNNING SEVERAL OVERLAPPING PLOT STRANDS AT THE SAME TIME SO YOU CAN CUT BETWEEN THEM.

THAT WAY, EVEN IF ONE OF YOUR CHARACTERS IS TAKING TIME OUT FOR A LONG AND INVOLVED INVESTIGATION, THERE CAN STILL BE SOME ACTION GOING ON THAT THE READER'S AWARE OF AND—HOPEFULLY—WANTS TO SEE RESOLVED.

IT'S OFTEN A GOOD IDEA TO HAVE AT LEAST ONE PLOT STRAND THAT SEEMS TO MAKE NO SENSE WHATSOEVER—AT THE START, ANYHOW.

THEN YOU CAN GIVE YOUR READERS THE SATISFACTION OF SEEING ALL THOSE DANGLY LOOSE ENDS TIED UP NEATLY AT THE CONCLUSION.

WHEN YOU'RE GOING FOR SLOWER MOMENTS, YOUR SCENES SHOULD BE LONGER. CHARACTERS CAN TALK A LITTLE MORE, TOO.

PANELS SHOULD MOSTLY BE LONG AND WIDE SHOTS (WE'LL TALK ABOUT THESE IN MORE DETAIL LATER), NOTHING TOO CLOSE.

EVERYTHING SHOULD WORK TOGETHER TO CREATE A FEELING OF EASE.

PLOT TWISTS ARE ESSENTIAL. RAYMOND CHANDLER—CREATOR OF PRIVATE EYE *PHILIP MARLOWE* —FAMOUSLY SAID THAT WHENEVER HE FELT A STORY WAS SLOWING DOWN, HE'D WRITE IN A MAN WITH A GUN ENTERING THE ROOM.

THAT'S OVER-SIMPLIFYING, BUT YOU GET THE IDEA.

DISORIENT YOUR READERS; TAKE THEM DOWN A ROUTE THEY THINK THEY'VE BEEN BEFORE, THEN LOSE THEM.

CONFOUND THEIR EXPECTATIONS: KILL OFF A CHARACTER THAT LOOKED CERTAIN TO MAKE IT TO THE END. THAT SHOULD GET THEIR ATTENTION.

AS TENSION BUILDS, YOU CAN CREATE A SENSE OF URGENCY BY USING SHORTER SCENES AND BRIEF AND TO-THE-POINT DIALOGUE.

SHOW CHARACTERS IN CLOSE-UP SO WE CAN SEE THEIR EXPRESSIONS (TENSE, ANGRY, HURT…).

LITERALLY, MORE IN YOUR FACE.

CUTTING BACK AND FORTH BETWEEN SHORT SCENES ALSO WORKS.

IMAGINE A COUPLE OF PAGES OF ARTWORK THAT ARE NOTHING BUT A SUCCESSION OF PANELS OF TWO CHARACTERS HURRYING THROUGH THE NIGHT.

YOU'RE IMITATING THE FAST-CUTTING TECHNIQUE OF MOVIES FOR EXACTLY THE SAME PURPOSE: TO CREATE TENSION—

DRAGGING YOUR CHARACTERS INTO CONFRONTATION, AND PULLING THE READERS ALONG WITH THEM.

THEY ALTERNATE PANELS, CUTTING BACK AND FORTH LIKE A METRONOME. MAYBE ONE DOWN THE LEFT OF THE PAGE, THE OTHER DOWN THE RIGHT. AT THE BOTTOM OF THE LAST PAGE—IN A SINGLE PANEL—THEY MEET FACE TO FACE.

CHARACTER DEVELOPMENT

CECI N'EST PAS UNE PIPE

CHARACTERIZATION, SADLY, NEVER USED TO BE COMICS' STRONG POINT.

THE HERO WAS SIMPLY THE HERO (FIGHTING FOR TRUTH, JUSTICE, AND THE AMERICAN WAY), AND THE VILLAINS WERE VILLAINS BECAUSE THEY OPPOSED THE HERO. NO MOTIVE SEEMED TO BE NECESSARY.

HAPPILY, THINGS HAVE CHANGED A LITTLE.

WHILE NO ONE EXPECTS DOSTOYEVSKIAN LEVELS OF MOTIVATION AND ANGST, IT'S ALWAYS A GOOD IDEA TO HAVE REASONS WHY YOUR CHARACTERS BEHAVE THE WAY THEY DO—AND TO SHOW THEM.

DUE TO THE DUAL NATURE OF COMICS —GRAPHICS AND WORDS COMBINED—IT'S POSSIBLE TO DEMONSTRATE CHARACTER TRAITS IN A VARIETY OF WAYS.

NOT ONLY WHAT A CHARACTER SAYS AND THINKS—ALONG WITH WHATEVER INSIGHTS THE NARRATIVE CAN GIVE—BUT ALSO WHAT THEY'RE SEEN TO DO.

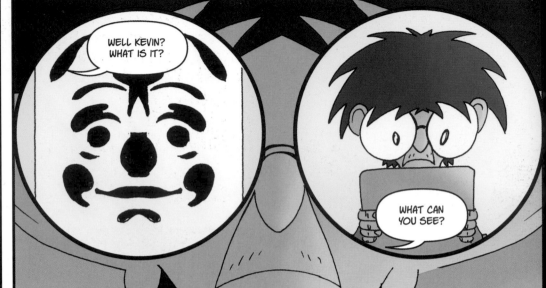

WELL KEVIN? WHAT IS IT?

WHAT CAN YOU SEE?

CONFLICT MAKES FOR INTEREST—DRAMATIC TENSION, REMEMBER—SO YOUR CHARACTERS SHOULD NEVER BE WHOLLY BLACK OR WHITE.

A PRETTY BUTTERFLY.

EVEN THE GREATEST HERO HAS A DARK SECRET SOMEWHERE, AND THE WORST VILLAIN WILL HAVE AT LEAST ONE REDEEMING CHARACTERISTIC.

TAKE BATMAN'S ARCHRIVAL THE JOKER AS AN EXAMPLE. HE'S ALWAYS BEEN A LITTLE TWO-DIMENSIONAL, WITH NO BACKGROUND OR HISTORY.

IN *THE KILLING JOKE*, ALAN MOORE ATTEMPTED TO FILL THIS GAP:

A FAMILY AND POVERTY-STRICKEN BACKGROUND THAT LED HIM, INEVITABLY, TO CRIME, AND A CHEMICAL DISFIGUREMENT THAT ALSO DESTROYED HIS MIND.

ALTHOUGH THE JOKER REMAINS A MONSTER, HE BECOMES A LITTLE MORE SYMPATHETIC: MORE HUMAN.

PSYCHIATRIC HELP 5¢

THE DOCTOR IS: IN

YOU'LL NEED TO PROVIDE YOUR CHARACTERS WITH MOTIVES OF ONE SORT OR ANOTHER. NO ONE ACTS OUT OF THE BLUE; SOMEWHERE, THERE'S A REASON FOR WHAT THEY'RE DOING, BE IT FOR GOOD OR EVIL.

AND OFTEN ALL THE EMOTIONAL BAGGAGE OF YOUR CHARACTER'S PAST WILL BE THE PRIME MOVER OF THAT MOTIVE.

SO WHAT ARE THE MAIN THINGS THAT MOTIVATE PEOPLE?

DESIRE, FEAR, HUNGER, HATRED, GUILT, AND OCCASIONALLY MORE ALTRUISTIC FEELINGS, LIKE WANTING TO HELP YOUR FELLOW MAN.

BUT EVEN HERE YOU CAN SLIP IN WASHES OF GRAY:

JUST WHAT MAKES SOMEONE WANT TO HELP?

GUILT, AGAIN? THE GUILT THE WEALTHY CAN SOMETIMES FEEL?

OR MAYBE SURVIVOR GUILT—BEING THE ONLY ONE TO WALK FREE FROM A TRAIN WRECK.

REVENGE IS A COMMON MOTIVE, ALTHOUGH IT DOESN'T HAVE TO BE SO OBVIOUS.

IN *THE CROW*, ERIC DRAVEN IS CLEARLY OUT TO PUNISH THOSE WHO KILLED HIM;

WHILE ON A MORE SUBCONSCIOUS LEVEL, BRUCE WAYNE IS ENDLESSLY DRIVEN TO AVENGE THE MURDER OF HIS PARENTS.

THOUGH I SUSPECT THE BATMAN WOULD BE THE FIRST TO DENY IT.

THE MORE LAYERS THAT CHARACTERS HAVE, THE MORE INTERESTING—AND REALISTIC—THEY BECOME.

ONE THING TO REMEMBER: IF YOU'RE WRITING A GRAPHIC NOVEL —A STAND-ALONE STORY, NOT A CHAPTER IN AN ONGOING SERIES—

AT THE END OF THE BOOK, THERE WILL HAVE BEEN CHANGES. ALL OF THE CAST WILL HAVE BEEN MARKED IN SOME WAY BY THE PASSAGE OF THE PLOT.

YOU'RE TELLING THE STORY OF THE WAY THOSE CHANGES CAME ABOUT, AND ONE OF THE BIGGEST CHANGES WILL BE IN CHARACTER.

SETTING

THE SETTING IS AS MUCH A CHARACTER IN THE BOOK AS THE HUMAN CAST.

IMAGINE *DRACULA* WITHOUT THE ANCIENT, MOLDERING CASTLE; OR *STAR WARS* WITHOUT THE VARIOUS PLANETS AND WEIRD INHABITANTS. THEY WOULDN'T BE THE SAME.

IF YOUR BOOK IS A SPACE OPERA, THEN THE CHOICE IS OBVIOUS;

IT SHOULD BE SET IN THE VASTNESS OF SPACE, WHERE THERE ARE PLENTY OF BIG STARSHIPS, ALIENS, AND CATACLYSMIC BATTLES.

THE GREAT THING ABOUT THE FUTURE IS THAT NOBODY KNOWS WHAT IT WILL HOLD.

ALTHOUGH THE *STAR WARS* MOVIES ARE FAMOUSLY SET "IN A GALAXY FAR, FAR AWAY," THAT'S JUST TO EMPHASIZE THE FANTASY/FAIRYTALE ELEMENT. THEY MIGHT JUST AS WELL BE IN OUR FUTURE.

BUT SCIENCE FICTION DOESN'T NEED TO BE IN SPACE, OR THE FAR FUTURE.

WARREN ELLIS'S *TRANSMETROPOLITAN* IS SET IN A NEAR-FUTURE DYSTOPIA, AND VERY FIRMLY ON EARTH. THE IMPORTANT FACT HERE IS THAT IT IS A DYSTOPIA—A WORLD THAT'S FALLING APART.

THE USE OF FUTURE DYSTOPIAS—AS OPPOSED TO PERFECT, UTOPIAN WORLDS—IS A FAVORITE FOR SATIRE.

HORROR CAN JUST AS EASILY BE SET IN THE RUINED, HAUNTED CASTLES OF GOTHIC FICTION AS IT CAN BE IN THE MODERN WORLD.

THE GOTHIC APPROACH IS FUN, BUT MOST MODERN HORROR IS THE PRODUCT OF ANXIETY—WHETHER IT'S THE FEAR OF THE ATOM BOMB IN THE 1950S, OR MODERN FEARS OF TERRORISM.

TAKING THINGS OUT OF THEIR USUAL CONTEXT CAN ALSO ADD AN UNSETTLING EDGE TO A HORROR STORY...

TAKE YOUR MONSTER THAT PROWLED THE EVERGLADES 200 YEARS AGO, AND PUT IT ON THE STREETS OF MIAMI.

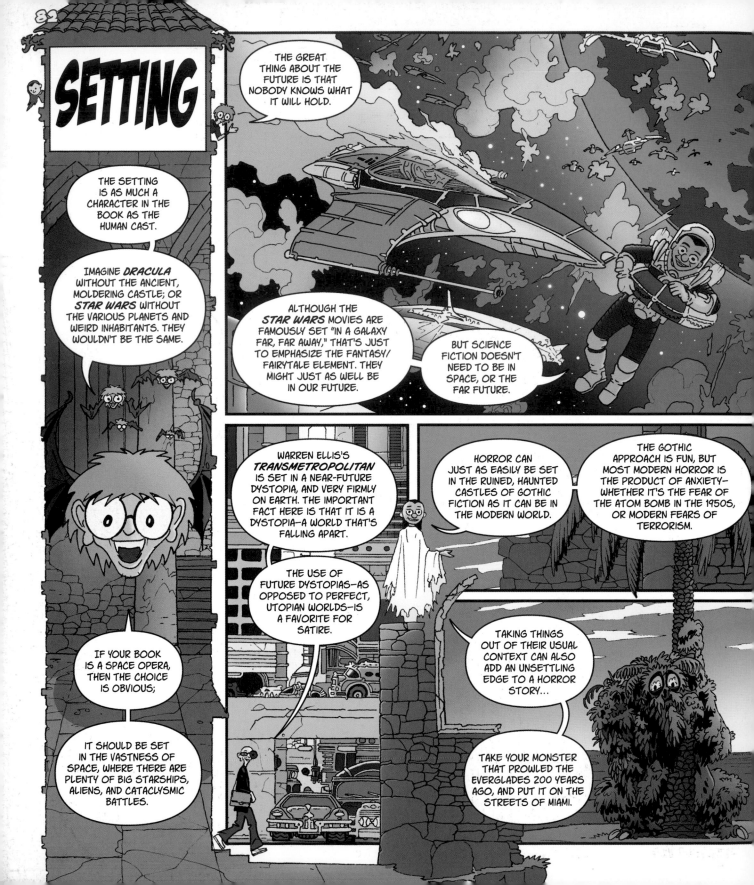

CRIME FICTION IS MOSTLY AT HOME IN A REAL-WORLD SETTING THAT READERS ARE FAMILIAR WITH (THOUGH THERE'S NOTHING TO SAY YOU CAN'T HAVE A SCIENCE FICTION BACKDROP, OR A FANTASY ONE).

THE OBVIOUS APPROACH, IF YOU'RE WRITING A PRIVATE EYE OR POLICE PROCEDURAL, IS TO SET IT AGAINST A SEEDY, MORALLY DECAYING PART OF THE CITY.

THE URBAN DECAY OF THIS SETTING MIRRORS THE CORRUPTION YOUR CHARACTERS WILL BE UP AGAINST AS THE STORY UNFOLDS.

VERY ATMOSPHERIC, BUT IT'S NOT THE ONLY OPTION.

NEIL GAIMAN'S *MURDER MYSTERIES* IS SET IN HEAVEN, AND TELLS THE TALE OF THE FIRST CRIME EVER COMMITTED.

FANTASY STORIES CAN TAKE ANY SETTING YOU WISH.

ALTHOUGH MOST WILL AUTOMATICALLY THINK OF THE MIDDLE EARTHS AND HYBOREAN AGES OF J.R.R. TOLKEIN AND ROBERT E. HOWARD, FANTASY IS MORE THAN SWORDS AND SORCERY.

BILL WILLINGHAM'S *FABLES* BOOKS TRANSPOSE THE FANTASY CHARACTERS FROM CHILDREN'S STORIES INTO MODERN DAY NEW YORK CITY.

LASTLY, OF COURSE, THERE ARE SUPERHEROES.

TRADITIONALLY, THEY RESIDE IN THE CONCRETE CANYONS OF THE BIG CITY, BUT THE CITIES THEMSELVES CAN HAVE COMPLETELY DIFFERENT CHARACTERS.

SPIDER-MAN'S HIGH-RISE MANHATTAN IS A WORLD AWAY FROM DAREDEVIL'S GRITTY HELL'S KITCHEN, EVEN THOUGH THEY'RE BOTH SET IN THE SAME CITY.

REMEMBER WHAT WE SAID AT THE BEGINNING: THE SETTING SHOULD BECOME ANOTHER CHARACTER IN YOUR STORY, ONE WITH A LIFE AND A PAST.

USE OF MOVIE TECHNIQUES

THERE'S QUITE A LOT OF TERMINOLOGY COMMON TO BOTH COMIC AND MOVIE SCRIPTS.

IT MAKES SENSE: IN BOTH CASES YOU'RE DETAILING WHAT PEOPLE WILL SEE IN YOUR FRAME—WHETHER IT'S A CINEMA SCREEN OR A COMIC PANEL.

THE MAIN DIFFERENCE, OF COURSE, IS THAT IN A COMIC YOU HAVE NO TRUE MOVEMENT (EXCEPT, PERHAPS, ON WEB SITES, WHICH WE'LL COME TO LATER). YOU HAVE TO FAKE IT.

HOW TO...
Take 84

EST: Int—Kevin's Apartment

WHEN YOU BEGIN A NEW SCENE, YOU START OFF WITH AN *ESTABLISHING SHOT*. THIS PANEL WILL CONTAIN A GENERAL VIEW, GIVING THE READER A DETAILED SNAPSHOT OF THE LOCATION AND WHO'S IN THAT PARTICULAR SCENE.

SO, IF THE SCENE IS IN AN APARTMENT, THE VIEW WILL BE OF THAT APARTMENT, EITHER WITH THE MAJOR PLAYERS ALREADY THERE, OR WITH THEM ABOUT TO ENTER IN THE NEXT PANEL.

APART FROM SCENE SETTING, THESE SHOTS CAN BE USED FOR PLACING YOUR CHARACTERS IN CONTEXT, AS A SMALL DOT AGAINST A VAST BACKGROUND, OR JUST ONE PERSON IN A TEEMING ROOM OR STREET.

LS: Kevin and Naz are sitting on Kevin's sofa

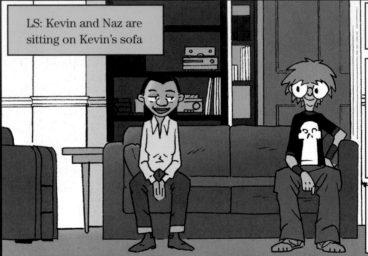

GETTING IN A LITTLE CLOSER, THERE'S THE *LONG SHOT*.

HERE, YOU STILL HAVE YOUR CHARACTERS PLACED AGAINST A BACKGROUND, BUT YOU'VE BROUGHT THEM NEARER, THEREFORE ALLOWING THE CHARACTERS TO BE SEEN IN GREATER DETAIL, AND SLIGHTLY INCREASING A SENSE OF INTIMACY.

YOU'RE SHOWING THE READER THAT THESE PEOPLE ARE CENTRAL TO THE SCENE, SO WHAT THEY HAVE TO SAY IS IMPORTANT.

MS: We move closer in on Kevin and Naz

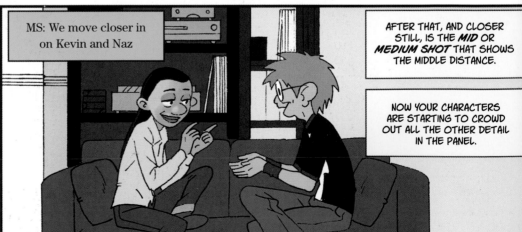

AFTER THAT, AND CLOSER STILL, IS THE *MID* OR *MEDIUM SHOT* THAT SHOWS THE MIDDLE DISTANCE.

NOW YOUR CHARACTERS ARE STARTING TO CROWD OUT ALL THE OTHER DETAIL IN THE PANEL.

CU: Kevin

CLOSER STILL, AND PRETTY OBVIOUS, IS THE **CLOSE-UP**. WHEN YOU WANT TO DRAW PARTICULAR ATTENTION TO ONE CHARACTER—OR SOME OTHER OBJECT—YOU ZOOM IN. THE PANEL IS DOMINATED BY THE ONE SINGLE CHARACTER OR OBJECT.

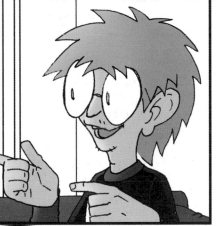

ECU: Naz

AFTER THAT COMES THE **EXTREME CLOSE-UP**—MOVING CLOSER STILL TO A CHARACTER'S FACE, AND CENTERING ON A PARTICULAR FEATURE, PERHAPS THE EYES OR MOUTH. THIS IS THE MOST INTIMATE MOMENT—YOU'RE VIRTUALLY PRIVY TO HER THOUGHTS.

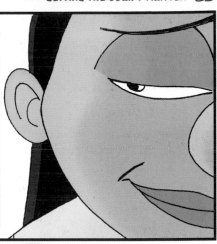

SOME OF THESE CAN BE MIXED IN THE SAME PANEL, OF COURSE.

ONE CHARACTER CAN BE IN CLOSE-UP, OTHERS IN THE MIDDLE DISTANCE, OR IN LONG SHOT.

IT'S A WAY OF ESTABLISHING A BRIEF HIERARCHY…

IN THE NEXT PANEL, IT CAN ALL BE REVERSED, WITH WHOEVER HAD BEEN IN THE BACKGROUND NOW IN CLOSE-UP.

…WHOEVER'S IN CLOSE-UP IS THE MOST IMPORTANT CHARACTER. MAYBE THEY'RE EXPLAINING A MAJOR PART OF THE STORY, OR MAYBE WE'RE SEEING THEIR PERSPECTIVE OF THE EVENTS IN THE BACKGROUND.

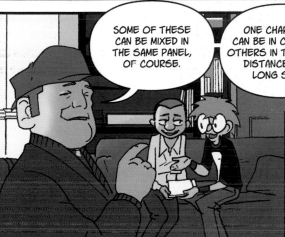
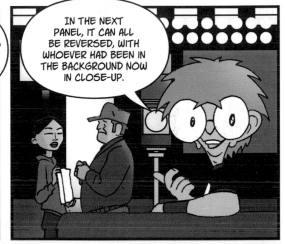

OTHER TECHNIQUES TO SIMULATE MOVEMENT ARE **TRACKING** AND **PANNING SHOTS**.

TRACKING MOVES THE VIEWPOINT PARALLEL TO THE BACKGROUND (SUCH AS FOLLOWING A CHARACTER DOWN A STREET),

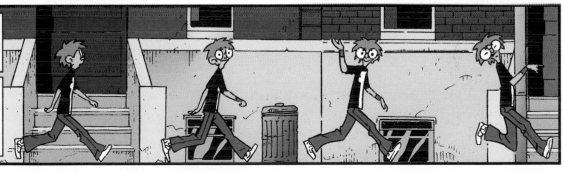

AND PANNING IS ROTATING THE VIEWPOINT AROUND ITS AXIS.

THIS IS NORMALLY HANDLED IN COMICS BY SPLITTING THE SHOT ACROSS THREE OR MORE PANELS TO GIVE THE IMPRESSION OF VIRTUAL CAMERA MOVEMENT.

RESEARCH

THERE COMES A POINT IN EVERY WRITER'S LIFE WHEN YOU HAVE TO DO SOME RESEARCH.

DOESN'T MATTER WHAT YOUR SUBJECT IS —EVEN IF IT'S SOMETHING THAT'S A PERSONAL FAVORITE, AND YOU THINK YOU KNOW EVERYTHING THERE IS TO KNOW—YOU'LL SUDDENLY HIT A WALL, A GAP IN YOUR KNOWLEDGE, AND GRIND TO A HALT.

SO WHERE DO YOU GO TO PLUG THAT GAP?

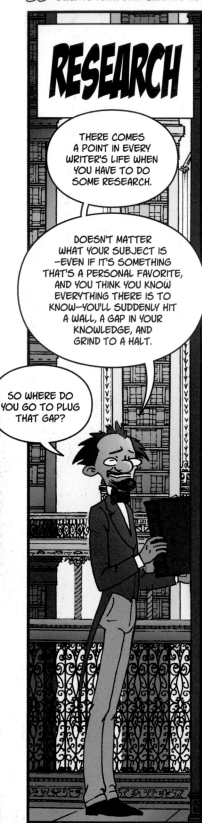

MOST PEOPLE WOULD HEAD STRAIGHT FOR THE INTERNET, FIRST OFF.

BUT, AS WE'VE ALREADY MENTIONED, THE INTERNET ISN'T THE REPOSITORY OF ALL HUMAN KNOWLEDGE. IT CAN ONLY REPORT ON WHAT'S BEEN UPLOADED.

YOU ALSO NEED TO BE PRETTY SPECIFIC IN YOUR SEARCHES.

IF YOU'RE TRYING TO FIND OUT DETAILS OF BALL AND CAP REVOLVERS FROM THE MID 19TH CENTURY BUT JUST ENTER "REVOLVERS" INTO THE SEARCH BOX, YOU'RE GOING TO GET HUNDREDS, IF NOT THOUSANDS, OF SITES THAT ARE OF NO USE TO YOU WHATSOEVER.

ENTERING "COLT" WOULD BE JUST AS FRUSTRATING: HISTORIES OF SAMUEL COLT, SITES ABOUT HORSES, AS WELL AS THE SPECIFIC SITES GIVING YOU THE INFORMATION YOU WANT.

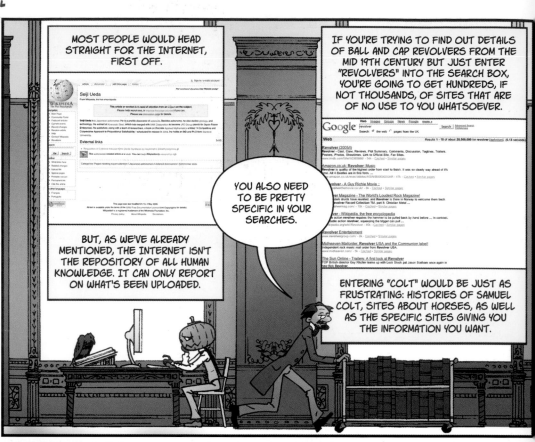

THE NEXT STOP IS THE PUBLIC LIBRARY.

AN AVERAGE LIBRARY MIGHT NOT HAVE THE RESOURCES OF THE INTERNET (THOUGH THERE'LL BE COMPUTER ACCESS), BUT AT LEAST THERE'LL BE STAFF ON HAND TO POINT YOU IN THE RIGHT DIRECTION.

YOU MIGHT HAVE TO TAKE OUT A FEW BOOKS, BUT WHO KNOWS WHERE THAT MIGHT LEAD?

DIGGING OUT A FEW FACTS COULD NUDGE YOUR IMAGINATION IN WILD NEW DIRECTIONS, IDEAS YOU'D NEVER EVEN CONSIDERED BEFORE.

AND WHAT ABOUT THE ARTIST?

WE'VE ALREADY COVERED ON-LINE COLLABORATION, SO WHY NOT ASK HIM FOR HIS INPUT. HE MAY, OR MAY NOT, KNOW THE ANSWER,

BUT HE COULD HAVE A BETTER IDEA OF WHERE TO LOOK.

THERE ARE ALSO MANY DIVERSE SPECIAL PUBLICATIONS AND SOCIETIES. THEIR JOURNALS MAY NOT BE FREELY AVAILABLE IN BOOKSTORES,

BUT THE INTERNET SHOULD BE ABLE TO HELP YOU THERE.

GOOGLE ALLOWS THE OPTION OF SEARCHING "GROUPS" TO FIND LISTS OF SOCIETIES AND NEWSGROUPS THAT MIGHT BE OF SOME HELP, OR "IMAGES" TO PROVIDE A SELECTION OF IMAGES FROM WEB SITES THAT ROUGHLY MATCH YOUR SEARCH CRITERIA.

THERE ARE ALSO COMMERCIAL PICTURE RESEARCH LIBRARIES THAT CAN SUPPLY ARCHIVED IMAGES, AS LONG AS YOU KNOW SPECIFICALLY WHAT YOU'RE LOOKING FOR, AND ARE WILLING TO PAY FOR THEM.

FINALLY, READ WIDELY.

MAGAZINES SUCH AS *NATIONAL GEOGRAPHIC*, *SCIENTIFIC AMERICAN*, AND *NEW SCIENTIST* PROVIDE ARTICLES AND NEWS ON THE MODERN WORLD AND SCIENTIFIC ADVANCES IN TERMS THAT ARE ACCESSIBLE EVEN TO THOSE WITHOUT A DEGREE IN ASTROPHYSICS.

PUBLICATIONS SUCH AS THE *WRITER'S HANDBOOK* AND *THE WRITERS' + ARTISTS' YEARBOOK* LIST MANY OF THEM.

KEEPING BACK ISSUES—IF YOU CAN FIND THE SPACE FOR THEM—WILL PROVIDE YOU WITH YOUR OWN REFERENCE LIBRARY.

WRITING A BRIEF AND SYNOPSIS

WE'VE ALREADY MENTIONED THE *CHARACTER BRIEF:* A DESCRIPTION OF THE CENTRAL PROTAGONISTS IN YOUR STORY THAT THE ARTIST CAN USE TO DEVELOP A CHARACTER SKETCH.

ALTHOUGH IT'S NOT UNUSUAL TO DESCRIBE THE CHARACTERS IN THE SCRIPT AS AND WHEN THEY APPEAR, A DETAILED WRITTEN BRIEF CAN BE MORE USEFUL.

THE FIRST THING THAT ANY BRIEF NEEDS IS A DESCRIPTION OF THE CHARACTER'S PHYSICAL TRAITS AND APPEARANCE—A COMMON SHORTCUT FOR THIS IS TO MENTION A WELL-KNOWN CELEBRITY THAT THEY RESEMBLE.

A BIT LIKE A HEROIC JOHNNO BUT WITH KIRK DOUGLAS'S CHIN.

THE NEXT THING IS TO MENTION NOT JUST THE CLOTHING THAT THE CHARACTER WEARS, BUT ALSO IF THE CLOTHING ITSELF HAS ANY PARTICULAR CHARACTERISTICS.

IF THE CHARACTER WEARS A CAPE, IS IT ALWAYS BILLOWING IN AN IMAGINARY WIND?

THIS KIND OF THING IS OFTEN JUST DONE FOR EFFECT, BUT IT'S THESE SMALL DETAILS THAT YOU SHOULD COVER IN THE BRIEF. CONSIDER HOW THE ENTIRE COSTUME OF TODD MCFARLANE'S *SPAWN* SEEMS TO BE ALIVE, AND EVERY PANEL HAS A SENSE OF MOVEMENT.

THIS IS SOMETHING FOR THE BRIEF, YOU DON'T NEED TO KEEP MENTIONING IT IN THE FINAL SCRIPT.

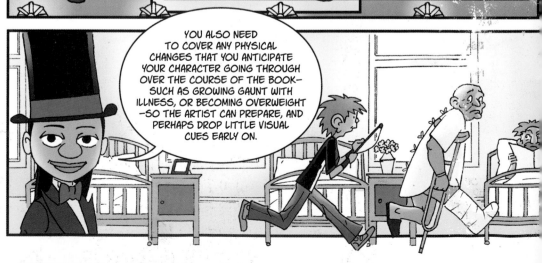

YOU ALSO NEED TO COVER ANY PHYSICAL CHANGES THAT YOU ANTICIPATE YOUR CHARACTER GOING THROUGH OVER THE COURSE OF THE BOOK—SUCH AS GROWING GAUNT WITH ILLNESS, OR BECOMING OVERWEIGHT—SO THE ARTIST CAN PREPARE, AND PERHAPS DROP LITTLE VISUAL CUES EARLY ON.

THE FINAL THING IS TO TRY TO KEEP IT SHORT— A COUPLE HUNDRED WORDS—AND KEEP AN OPEN MIND.

TRUST THE ARTIST, AND LISTEN TO (AND LOOK AT) HER INTERPRETATION OF YOUR CHARACTERS.

SIMILARLY, A SYNOPSIS IS A BRIEF OUTLINE OF THE BOOK ITSELF—THE BARE BONES PLOT AND STORY LINE TOLD IN UP TO A THOUSAND WORDS.

FOR A SINGLE ISSUE, THE SYNOPSIS WOULD NORMALLY BE AROUND A PAGE IN LENGTH, BUT FOR YOUR MINI-SERIES OR GRAPHIC NOVEL, YOU SHOULD BE THINKING AROUND TWO TO FIVE PAGES.

YOU'LL NEED TO TELL THE WHOLE STORY, WITH A BEGINNING, MIDDLE, AND PROPER CONCLUSION.

YOUR SYNOPSIS SHOULD SAY WHAT HAPPENS, WHY, AND HOW, NOTING CHARACTER SPECIFICS AND IMPORTANT PLOT POINTS.

ADDITIONALLY, IF YOUR STORY IS A MINI-SERIES SPREAD OVER SEVERAL ISSUES, THEN YOU'LL NEED TO INDICATE WHERE EACH ISSUE STARTS AND ENDS.

FINALLY, THERE ARE SOME LAST-MINUTE CHECKS BEFORE SENDING THE SYNOPSIS AWAY.

ARE THE CHARACTERS BELIEVABLE, AND DO THEY BEHAVE CONSISTENTLY THROUGHOUT THE STORY?

HAVE YOU DESCRIBED THE PLOT CLEARLY AND IS IT EASY TO FOLLOW?

DOES THE STORY SOUND EXCITING AND INTERESTING?

IN OTHER WORDS, HAVE YOU INJECTED ENOUGH ENTHUSIASM INTO THE SYNOPSIS?

IF READING IT BACK TO YOURSELF IS EMBARRASSING, JUST THINK OF THE EFFECT IT'S GOING TO HAVE ON THE EDITOR!

BUT WITH ALL THAT IN MIND... BE POSITIVE!

GETTING THE
SCRIPT DRAWN

CHAPTER 6

ARTISTIC STYLES . 92

ARTISTS' TECHNIQUES . 94

BITMAP AND VECTOR SOFTWARE 96

MAC OR PC? . 98

WORKING FROM A BRIEF 100

WORKING FROM A SCRIPT102

MOOD . 104

STYLES OF ARTWORK .106

PANEL LAYOUTS . 108

FRAMING DEVICES AND CROPS 110

SCANNING IN HAND-DRAWN ARTWORK 112

USE OF LAYERS . 114

RGB OR CMYK? . 116

CREATING BALLOONS AND LETTERING 118

PLACING TYPOGRAPHY120

ARTISTIC STYLES

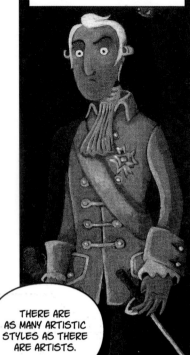

MANY ARTISTS EXPERIMENT FOR YEARS WITH DIFFERING TECHNIQUES BEFORE SETTLING ON ONE THEY FEEL MORE COMFORTABLE WITH...

...OTHERS RELISH THE CONSTANT CHALLENGE OF TRYING OUT NEW WAYS OF DRAWING, USING A VARIETY OF BRUSHES, PENS, PAPERS, AND COMPUTER TECHNIQUES.

DAVID MAZZUCCHELLI IS AN ARTIST WHOSE STYLE HAS RADICALLY CHANGED OVER THE YEARS.

HE ORIGINALLY STARTED OUT DRAWING FAIRLY PROSAIC SUPERHERO COMICS LIKE *DAREDEVIL: BORN AGAIN* AND *BATMAN: YEAR ONE*.

HOWEVER, WHEN HE STARTED SELF-PUBLISHING *RUBBER BLANKET* HE EXPERIMENTED WITH MORE CARTOONY AND ILLUSTRATIVE STYLES OF DRAWING.

THERE ARE AS MANY ARTISTIC STYLES AS THERE ARE ARTISTS.

OFTEN, THOSE ARTISTS THAT REMAIN FLEXIBLE GET MORE WORK BECAUSE THEY CAN ADAPT TO THE WRITER AND PUBLISHER'S DEMANDS—SO TRY NOT TO GET LOCKED INTO ONE STYLE TOO EARLY ON.

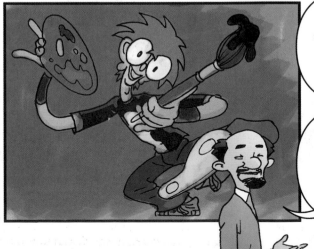

HAVING SAID THAT, DON'T GO CHANGING STYLES MIDWAY THROUGH YOUR GRAPHIC NOVEL UNLESS THE SCRIPT REQUESTS IT, SUCH AS IN A FLASHBACK.

A GOOD EXAMPLE OF WHERE VARIOUS STYLES WORK WELL TOGETHER IS BILL SIENKIEWICZ'S ARTWORK IN *ELEKTRA: ASSASSIN*, WRITTEN BY FRANK MILLER.

IT'S WHAT MAKES YOUR WORK UNIQUE, A VISUAL SIGNATURE, IF YOU WILL.

DAVE SIM + GERHARD'S WORK ON *CEREBUS THE AARDVARK* MADE EXCELLENT USE OF LETRATONE TO GIVE A DISTINCTIVE LOOK AND MADE THE MOST OF THE COMIC'S BLACK-AND-WHITE LIMITATIONS.

GERHARD'S INTENSELY DETAILED BACKGROUNDS AND SIM'S CARICATURES JUXTAPOSED NICELY, AND HELPED MAKE THE CAST LEAP OFF THE PAGE.

BRYAN TALBOT USES A DIFFERENT TECHNIQUE TO MAKE HIS CHARACTERS STAND OUT. IN *THE TALE OF ONE BAD RAT* HE DREW THICK LINES AROUND THE CENTRAL PROTAGONIST, HELEN.

THIS HAS THE JOINT EFFECT OF MAKING HER STAND OUT FROM THE BACKGROUNDS AND ALSO HIGHLIGHTS THE ISOLATION AND LONELINESS THE CHARACTER FEELS.

MOVING AWAY FROM THE RICH COLORS AND FLUID LINES OF TALBOT'S WORK WE HAVE MIKE MIGNOLA'S CREATION *HELLBOY*.

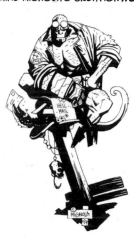

HERE, MIGNOLA USES SHARP, ANGULAR LINES AND HEAVY SPOT BLACKS TO CREATE A GOTHIC FEEL OF MENACE AND SUPPRESSION,

WHICH, EVEN WHEN COLORED, SUGGESTS THAT THINGS AREN'T ALL THAT THEY APPEAR TO BE.

OF COURSE, WITH TODAY'S COMPUTER TECHNOLOGY IT'S POSSIBLE TO DO A FULLY PAINTED GRAPHIC NOVEL

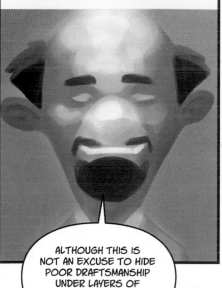

ALTHOUGH THIS IS NOT AN EXCUSE TO HIDE POOR DRAFTSMANSHIP UNDER LAYERS OF PAINT (VIRTUAL OR OTHERWISE).

A FINE EXAMPLE OF GOOD COMIC PAINTING IS BRENT ANDERSON'S COVER FOR THE CULT HIT, *SOMERSET HOLMES*.

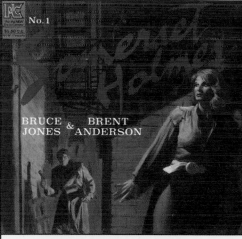

HERE THE ARTIST HAS MANAGED TO CONVEY FEAR AND TENSION THROUGH THE COLOR PALETTE, THE COMPOSITION, AND THE USE OF NOIR-LIKE SHADOWS.

SO WHATEVER YOUR PERSONAL STYLISTIC PREFERENCE IS AT THE MOMENT, WHETHER BLACK-AND-WHITE LINE WORK, CARICATURE, FULLY PAINTED, LIFE LIKE, OR A MULTIMEDIA MONTAGE, DON'T BE AFRAID TO BRANCH OUT AND TRY SOMETHING NEW.

YOU MAY DISCOVER A WHOLE NEW WAY OF WORKING THAT'S JUST RIGHT FOR YOU.

ARTISTS' TECHNIQUES

THE VERY FIRST COMIC STRIPS WERE IN BLACK AND WHITE, MAINLY BECAUSE NEWSPAPERS WERE THEIR ORIGINAL HOME.

TODAY, JUST ABOUT EVERYONE EXPECTS COMIC BOOKS TO BE IN COLOR, BUT BLACK AND WHITE IS STILL VERY POPULAR.

THE MAJORITY OF MANGA TITLES, THE HERNANDEZ BROTHERS' *LOVE AND ROCKETS*, ALAN MOORE'S *FROM HELL*, FRANK MILLER'S *SIN CITY* BOOKS, CHARLES BURNS'S *BLACK HOLE*...

WHETHER FOR ARTISTIC REASONS, OR SIMPLY TO CUT COSTS, ARE ALL EXCELLENT EXAMPLES OF MODERN BLACK-AND-WHITE COMICS THAT WOULD PROBABLY GAIN NOTHING FROM BEING IN FULL COLOR.

IN FACT, THEY MIGHT WELL LOSE SOMETHING.

ANYONE WITH AN INTEREST IN COMICS KNOWS THAT THE ARTWORK BEGINS AS "PENCILS," BUT THAT TERM IS NOW TAKEN TO MEAN A GENERAL ROUGH STAGE BECAUSE SOME ARTISTS NOW SKETCH DIRECTLY ON THE COMPUTER.

TAKING THE FINISHED SCRIPT, THE ARTIST TRIES OUT VARIOUS ROUGH SKETCHES AND LAYOUTS UNTIL HE OR SHE IS HAPPY.

ESSENTIALLY, THIS MEANS RE-DRAWING THE ROUGH SKETCHES AS CLEAN, FINISHED LINE ART.

INKING IS THE PROCESS OF GOING OVER THE FINAL PENCIL LINES IN BLACK INK, FILLING IN ANY *SPOT BLACK* AREAS IN THE ARTWORK, TO ADD CLARITY AND COHESION TO THE PENCILS.

THE SHADING TECHNIQUE IS, AGAIN, DOWN TO THE ARTIST.

SOME ARTISTS, SUCH AS *BRIAN BOLLAND*, PREFER TO DO ALL OF THEIR SHADING AND HATCHING AT THE PENCIL STAGE, LEAVING THE INKER TO TRACE OVER THIS.

OTHER ARTISTS, SUCH AS *CHARLIE ADLARD*, HAVE ONLY OUTLINES AT THE FINAL PENCILS STAGE, AND LEAVE ALL OF THE SHADING AND FILLING TO THE INK STAGE.

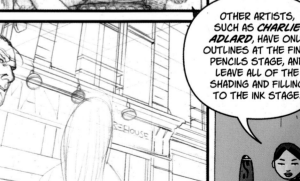

TODAY, WITH THE USE OF SCANNERS, GRAPHICS TABLETS, AND APPROPRIATE SOFTWARE, IT'S POSSIBLE TO SKIP THE INKING STAGE ALTOGETHER AND GO STRAIGHT TO THE COLORING PROCESS.

AGAIN, THERE ARE A FEW METHODS FOR THIS.

THE FIRST IS TO SCAN THE FINAL PENCILS INTO THE COMPUTER AND THEN ALTER THE COLOR BALANCE SO THAT THE PENCIL LINES BECOME BLACK.

HOWEVER, YOU NEED A CERTAIN LEVEL OF SKILL FOR THIS. THE PENCIL LINES WILL HAVE TO BE CLEANED UP AND SHARPENED, AND YOU'LL HAVE TO CAREFULLY GO OVER THE FILES AFTERWARD TO REMOVE ANY SMUDGES OR MISTAKES.

ANOTHER METHOD IS TO SCAN THE PENCIL ROUGHS INTO THE COMPUTER, AND THEN DIGITALLY TRACE OVER THESE ON A SEPARATE LAYER, CREATING YOUR FINAL PENCILS/INKS ON THE COMPUTER.

THE THIRD METHOD IS TO DRAW DIRECTLY INTO THE COMPUTER FROM THE OUTSET, USING A GRAPHICS TABLET AND SOFTWARE SUCH AS *ADOBE ILLUSTRATOR* OR *COREL PAINTER*.

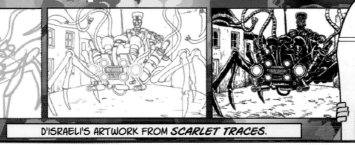

D'ISRAELI'S ARTWORK FROM *SCARLET TRACES*.

IF YOU'RE COMFORTABLE WITH THIS WAY OF WORKING, THEN IT CUTS OUT ALL OF THE SCANNING, ENABLING YOU TO INK AND COLOR AS YOU GO. IT'S A DIFFERENT DISCIPLINE, BUT WORTH TRYING.

YET ANOTHER METHOD THAT SOME ARTISTS USE IS TO OMIT THE INK STAGE ALTOGETHER AND COLOR THEIR PENCILS, SUCH AS ANDY KUBERT AND RICHARD ISANOVE'S ARTWORK IN *1602*.

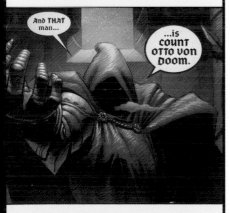

And THAT man...

...is COUNT OTTO VON DOOM.

THIS TECHNIQUE PRODUCES A VERY DIFFERENT STYLE OF ARTWORK, MORE PAINTERLY THAN TRADITIONAL COMIC ART.

DURING COLORING, THERE ARE MANY METHODS THAT CAN BE USED TO ENHANCE THE ORIGINAL ON THE WAY TO THE FINISHED PAGE.

DIFFERENT SHADES OF THE SAME TONE (COLOR) CAN BE USED TO DEPICT BOTH SHADING AND DISTANCE: THE MORE DISTANT AN OBJECT IS, THE PALER IT BECOMES; UP CLOSE, IT'S DARKER. AND, OBVIOUSLY, A COLOR WILL BE LIGHTER WHERE THE LIGHT CATCHES IT, AND DARKER IN SHADOW.

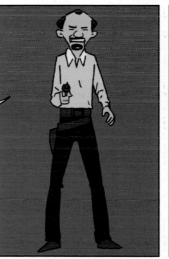

CERTAIN COLORS—PARTICULARLY FROM THE "WARM" (RED) OR "COLD" (BLUE) PARTS OF THE SPECTRUM—CAN CREATE MOOD. THE SAME PIECE OF ARTWORK—COLORED EITHER IN CHEERFUL REDS, ORANGES, AND YELLOWS, OR GREENS, BLUES, AND VIOLETS—WILL HAVE AN ENTIRELY DIFFERENT EMOTIONAL IMPACT ON THE READER.

BITMAP AND VECTOR SOFTWARE

THERE ARE TWO TYPES OF GRAPHIC FILES: *BITMAP* AND *VECTOR*.

BITMAPS ARE COMPOSED OF PIXELS, THOSE LITTLE SQUARES OF DIFFERENT COLOR YOU SEE WHEN YOU MAGNIFY A DIGITAL IMAGE TOO MUCH (CALLED PIXELATION, OR BITMAPPING).

THEY ARE BEST USED FOR IMAGES WITH IRREGULAR EDGES—SUCH AS PHOTOGRAPHS AND ARTWORK—BUT THEY DO TAKE UP A LOT OF MEMORY.

SCANNED ARTWORK WILL BE IN BITMAP MODE; AND BITMAP FILES ARE USED IN COLORING. ADOBE PHOTOSHOP IS A GOOD EXAMPLE OF SOFTWARE THAT'S USED TO EDIT BITMAPS.

VECTOR SOFTWARE PACKAGES INCLUDE ADOBE *ILLUSTRATOR* (WHICH WILL FEEL FAMILIAR TO ANYONE USED TO WORKING WITH PHOTOSHOP), MACROMEDIA *FREEHAND*, *CORELDRAW*, AND DENEBA *CANVAS*.

VECTOR FILES USE LINES INSTEAD OF DOTS, AND SO ARE BEST FOR IMAGES WITH SHARP, WELL-DEFINED EDGES. LOGOS, DIAGRAMS, PLANS, THINGS LIKE THAT.

COMPARED TO BITMAPS, VECTOR FILES ARE OFTEN A LOT SMALLER.

WE'VE ALREADY TALKED A LITTLE ABOUT SCANNING IN VARIOUS TYPES OF ARTWORK AT 300 PPI OR 600 PPI.

THE GREATER THE CONCENTRATION OF PIXELS, OR RESOLUTION, THE SMOOTHER THE IMAGE WILL BE. BUT A LOT DEPENDS ON THE VIEWING MEDIUM, TOO.

THE RESOLUTION OF A MONITOR IS ONLY 72 PPI SO ANY IMAGE ULTIMATELY DESTINED FOR SCREEN NEEDN'T HAVE A RESOLUTION ANY HIGHER THAN THAT.

PRINTED IMAGES, BLACK-AND-WHITE PHOTOGRAPHS (GRAYSCALE), AND COLOR PICTURES SHOULD BE 300 PPI, WHILE BLACK-AND-WHITE LINE DRAWINGS SHOULD BE 600 PPI.

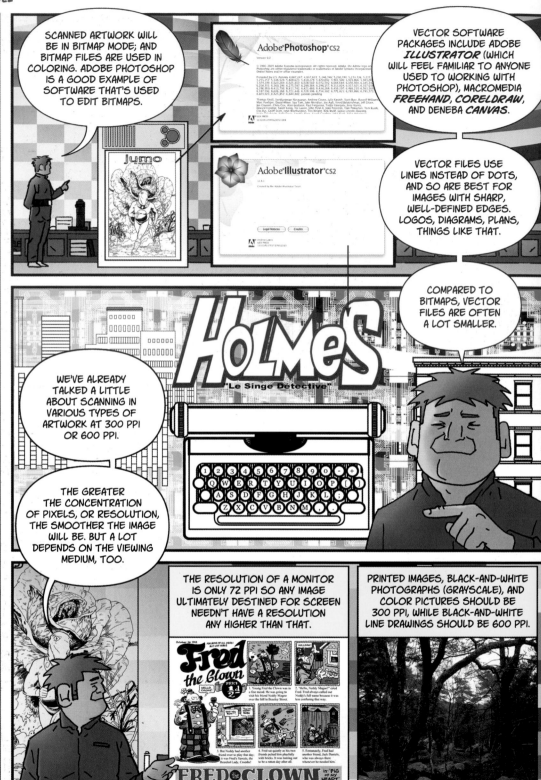

THIS IS SIMPLY BECAUSE COLOR IMAGES AND BLACK-AND-WHITE PHOTOGRAPHS CONTAIN GRADUATED SHADES THAT FOOL THE EYE INTO SEEING A SMOOTHER IMAGE. BLACK-AND-WHITE LINE ART NEEDS SMALLER AND MORE NUMEROUS PIXELS TO CREATE SMOOTH LINES.

SO ALTHOUGH YOU WANT AS HIGH A RESOLUTION AS POSSIBLE TO GET THE BEST IMAGE, REMEMBER THAT THE HIGHER THE RESOLUTION, THE MORE INFORMATION THE FILE REQUIRES; AND THE MORE INFORMATION, THE BIGGER THE FILE SIZE.

NOW YOU KNOW WHY YOUR HARD DRIVE NEEDS TO BE PRETTY BIG...

VECTOR SOFTWARE DOESN'T HAVE THIS RESOLUTION PROBLEM. BECAUSE THE IMAGES ARE CREATED WITH LINES, THEY CAN BE INCREASED IN SIZE WITHOUT ANY BITMAPPING.

IF YOU CONSIDER HOW FONTS CAN BE RESIZED WITHOUT LOSING RESOLUTION, IT'S OBVIOUS THEY'RE MADE UP OF VECTORS. VECTORS ARE ALSO IDEAL FOR CREATING SPEECH BALLOONS AND THE LETTERING THAT GOES IN THEM.

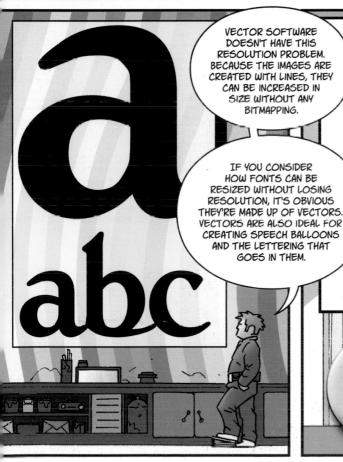

VECTOR LINES (CALLED PATHS) ARE USUALLY CREATED WITH A PEN TOOL.

AT EACH END OF A LINE, AND AT ANY POINT WHERE A LINE CHANGES DIRECTION, YOU WILL FIND AN ***ANCHOR POINT***. ANCHOR POINTS DO WHAT THEY SAY: FIX THE LINE TO THAT POINT.

THE FIRST AND LAST ANCHOR POINTS ARE KNOWN AS ***ENDPOINTS***.

THERE ARE TWO TYPES OF PATH: AN ***OPEN PATH***, WHICH HAS DISTINCT ENDS, AND A CLOSED PATH, WHICH HAS NO END (SUCH AS A CIRCLE OR BOX).

WITH PRACTICE, IT'S POSSIBLE TO CREATE AS MANY DIFFERENT TEXT BOXES AND BALLOONS AS YOU NEED, WITH VARIOUS 3D AND SHADING EFFECTS TO ADD VARIETY.

MAC OR PC?

WE'VE ALREADY MENTIONED THAT WRITERS SEEM TO PREFER PCS, WHILE ARTISTS GO FOR MACS. WHY IS THIS?

IS IT JUST A CASE OF STICKING WITH WHAT YOU'RE USED TO, OR IS THERE A GENUINE REASON?

TO BE HONEST, NOWADAYS THERE IS VERY LITTLE DIFFERENCE BETWEEN THEM.

BASICALLY, YOUR CHOICE DEPENDS ON WHICH OPERATING SYSTEM YOU PREFER.

MAC USERS WILL TELL YOU THAT *OS X* IS THE MOST USER-FRIENDLY,

AND PC USERS WILL TELL YOU THAT *WINDOWS* OFFERS THE BEST SOFTWARE.

LINUX USERS WILL TELL YOU THEY'RE BOTH WRONG, BUT WE WON'T WORRY ABOUT THEM FOR NOW.

IMPORTANTLY, THE MOST POPULAR SOFTWARE PACKAGES ARE AVAILABLE ON BOTH OPERATING SYSTEMS, AND MOST FILES ARE COMPATIBLE BETWEEN THE TWO.

SO, WHICHEVER YOU CHOOSE, YOU SHOULD STILL BE ABLE TO WORK WITH THE OTHER PEOPLE YOU NEED TO.

HISTORICALLY, MACS HAD BETTER GRAPHICS CARDS AND MONITORS, SO WERE PREFERRED BY DESIGNERS AND ARTISTS.

OUT OF THE BOX, A BASIC MAC PROBABLY STILL DOES HAVE BETTER GRAPHICS CAPABILITIES THAN A BASIC PC, BUT YOU HAVE TO PAY FOR THE PRIVILEGE,

AND IT'S STILL CHEAPER TO BUY A PC WITH SIMILAR SPECIFICATIONS AND UPGRADE THE GRAPHICS CARD THAN TO PURCHASE ITS MAC EQUIVALENT.

THAT'S ANOTHER THING: PCS ARE HUGELY UPGRADABLE, AND YOU CAN CHOP AND CHANGE THE VARIOUS PARTS AS YOU SEE FIT.

BUT THAT STRENGTH IS ALSO A WEAKNESS, BECAUSE A HUGE VARIETY OF COMPONENTS MEANS A HUGE VARIETY OF DRIVERS (PIECES OF SOFTWARE THAT MAKE THE NEW HARDWARE WORK WITH YOUR COMPUTER), WHICH CAN CAUSE CONFLICTS AND CRASHES IF THEY'RE NOT PROPERLY INSTALLED AND MAINTAINED.

MACS, WITH THEIR MORE LIMITED RANGE OF SYSTEM SPECS AND UPGRADES, ARE MUCH LESS PRONE TO THESE PROBLEMS.

VIRUSES ARE ALSO A COMMON CAUSE OF CONCERN. MOST VIRUSES SEEM TO BE AIMED AT MICROSOFT SOFTWARE, SIMPLY BECAUSE IT'S A BIG TARGET WORLDWIDE.

CONSEQUENTLY, MAC USERS FIND THEY'RE NOT AS TROUBLED BY INTERNET INFECTIONS AS THEIR PC COLLEAGUES.

THE SOLUTION IS TO BUY A PIECE OF REPUTABLE ANTI-VIRUS SOFTWARE AND KEEP IT UP TO DATE.

NOWADAYS, HOME USERS ARE MUCH MORE LIKELY TO BE TROUBLED BY E-MAIL SPAM THAN VIRUSES, AND THAT AFFECTS BOTH PC AND MAC USERS EQUALLY.

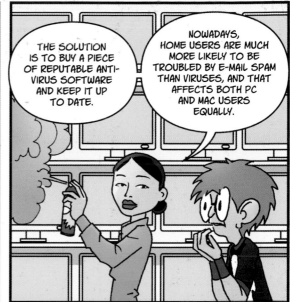

AS MENTIONED EARLIER, MACS HAVE TRADITIONALLY BEEN KNOWN FOR THEIR BETTER GRAPHICS CAPABILITIES, AND A FACTOR OF THIS WAS THEIR BUILT-IN *GAMMA CORRECTION SOFTWARE**

PCS STILL DON'T HAVE THIS AS STANDARD, BUT PHOTOSHOP COMES WITH ITS OWN CALIBRATION SOFTWARE, AND MOST GRAPHICS CARDS ALSO COME WITH SIMILAR SOFTWARE.

*THE BRIGHTNESS OF THE IMAGE IS AFFECTED BY THE MONITOR'S GAMMA VALUE.

BY FAR THE BIGGEST INFLUENCE ON WHICH SYSTEM YOU CHOOSE IS ALWAYS GOING TO BE WHAT YOU'RE USED TO, AND WHAT YOU'RE COMFORTABLE WITH.

YOU'RE THE ONE WHO'LL BE SLAVING IN FRONT OF THE COMPUTER DAY AND NIGHT, SO YOU NEED TO MAKE SURE YOU'RE HAPPY WITH IT, AND THAT THERE'S AS LITTLE BARRIER AS POSSIBLE BETWEEN GETTING YOUR VISION FROM YOUR HEAD TO THE SCREEN.

REMEMBER, IF YOU'RE AN ARTIST BUYING A COMPUTER, THE GRAPHICS CARD AND MONITOR ARE PARAMOUNT WHICHEVER OPERATING SYSTEM YOU GO FOR,

SO IT'S WORTH SPENDING A LITTLE EXTRA MONEY MAKING SURE YOU GET THE BEST YOU CAN.

WORKING FROM A BRIEF

IT MAY TAKE SEVERAL ROUGH SKETCHES BEFORE YOU HAVE A CLEAR IDEA OF WHAT THE CHARACTER LOOKS LIKE, OR IT MAY COME TO YOU INSTANTLY.

MANY WRITERS DON'T HAVE A PARTICULARLY VISUAL IMAGINATION. THEY MIGHT HEAR THEIR CHARACTERS TALKING IN THEIR HEADS—IT'S OKAY, WRITERS ARE ALLOWED TO HEAR VOICES—BUT THEY MAY NOT SEE THEM CLEARLY.

ONCE YOU'VE RECEIVED YOUR CHARACTER BRIEFS, YOU NEED TO WORK ON THEM IN YOUR OWN WAY. YOU CAN BE SURE THE WRITER'S DONE HIS OR HER OWN REWRITES AND REVISIONS TO GET TO THIS STAGE.

IF YOUR WRITER IS ONE OF THESE, YOU'RE GOING TO HAVE TO DO THE VISUALIZATION FOR HIM.

NOW IT'S YOUR TURN.

ON THE OTHER HAND, YOU MIGHT BE WORKING WITH A WRITER WHO HAS THE ENTIRE BOOK RUNNING IN FRONT OF HER LIKE A MOVIE. SHE IS LIKELY TO EXPLAIN TOO MUCH.

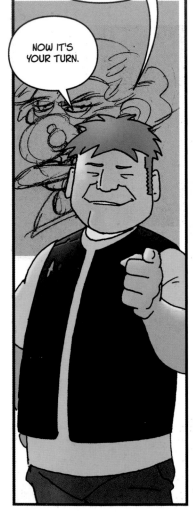

LIKE ANY PIECE OF ARTWORK, YOU'LL START WITH ROUGHS: PENCIL DRAWINGS, MAYBE EVEN QUICK OUTLINES WITH MARKER PENS.

EVEN BEFORE YOU GET AROUND TO TRYING OUT COLORS, YOU NEED TO NAIL THE FEATURES, POSTURE, AND ANY OTHER DETAILS THAT NEED ILLUSTRATING.

SCRIBBLE NOTES ON THE PAPER TO EXPLAIN WHAT YOU'RE DOING (OR EVEN JUST TO REMIND YOURSELF).

IT MAY SUDDENLY OCCUR TO YOU THAT THE CHARACTER SHOULD BE WEARING GLASSES—SMALL, SQUARE-FRAMED ONES WITH SLIGHT TINTS, FOR EXAMPLE—

FOR A VAGUELY MID-20TH CENTURY HIPPIE LOOK THAT YOU THINK FITS IN WITH WHAT YOU'VE BEEN TOLD ABOUT THE CHARACTER.

SINCE WE'VE ALREADY DECIDED THAT IT'S A GOOD IDEA TO KEEP IN CONTACT WITH THE WRITER (OR EDITOR, IF APPROPRIATE), YOUR NOTES WILL GIVE YOUR REASONING FOR THE ADDITION.

YOU'LL NEED TO TRY OUT THE CHARACTER IN DIFFERENT CLOTHING, TOO, UNLESS HE'S GOING TO BE SPENDING THE ENTIRE BOOK DRESSED IN THE SAME PANTS AND SWEATER.

EVEN IF THE CHARACTER DOES JUST HAVE THE ONE SUIT (WHICH HAPPENS MORE OFTEN THAN YOU'D THINK), YOU SHOULD STILL TRY DIFFERENT VARIATIONS ON IT SO THAT YOU AND THE WRITER CAN PICK THE BEST.

ONCE YOU'RE HAPPY WITH THE OVERALL LOOK OF THE CHARACTER, IT'S TIME TO TRY OUT SOME COLOR SCHEMES.

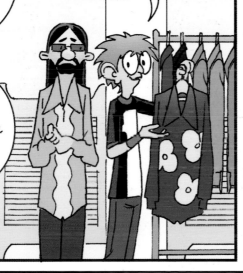

IS THERE AN OVERALL COLOR SCHEME THAT WILL AFFECT YOUR CHOICES, OR WILL THE CHARACTER BE COLORED TO STAND OUT?

SKETCHES ARE AS MUCH A PART OF CHARACTERIZATION AS ANY OF THE DIALOGUE OR ACTION SO YOU NEED TO GET THAT LOOK RIGHT.

AND FINALLY, BE PREPARED TO STAND YOUR GROUND. YOU'RE THE ARTIST, AND THE WRITER (AND EDITOR) SHOULD TRUST YOU TO DO THE BEST YOU CAN.

IF THERE'S ANYTHING IN THE SKETCHES THAT THEY'RE NOT HAPPY WITH, THEN EXPLAIN YOUR REASONS FOR ITS INCLUSION. THAT'S WHAT COMMUNICATION IS ALL ABOUT.

WORKING FROM A SCRIPT

ONCE AGAIN, YOU'LL PROBABLY MAKE SEVERAL ATTEMPTS AT PLANNING THE PAGES BEFORE YOU'RE HAPPY WITH THEM.

THE WRITER WILL HAVE SPECIFIED HOW MANY PANELS THERE ARE PER PAGE, BUT THEY WON'T HAVE SAID ANYTHING ABOUT HOW THE PAGE SHOULD BE LAID OUT (WELL, USUALLY...)

IT'S UP TO THE ARTIST TO FIGURE OUT HOW BEST TO LAY OUT EACH PAGE; HOW THE PANELS WILL INTERACT WITH EACH OTHER AND FLOW.

REMEMBER, THE ARTWORK IS TELLING THE STORY AS MUCH AS THE NARRATIVE AND DIALOGUE (MAYBE MORE SO, SINCE IT'S THE ARTWORK THE READER SEES FIRST), AND IT'S IMPORTANT TO KEEP THE READER'S EYES MOVING IN THE RIGHT DIRECTION.

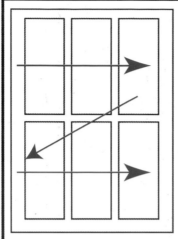
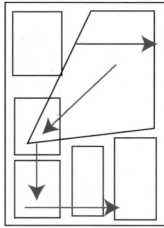

YOU DON'T NEED TO STICK TO A RIGID SYSTEM OF EQUAL-SIZED PANELS, ALL SEPARATED BY A NEAT GUTTER, BUT CONFUSING LAYOUTS THAT OBSCURE THE FLOW OF THE STORY DON'T HELP ANYONE.

YOU ALSO NEED TO CONSIDER WHERE THE NARRATIVE BOXES AND SPEECH BALLOONS ARE GOING TO FIT IN. IF YOU CROWD YOUR PANELS WITH ARTWORK, THEN SOME OF IT'S SIMPLY GOING TO GET OBSCURED, AND IT MIGHT END UP BEING AN IMPORTANT BIT.

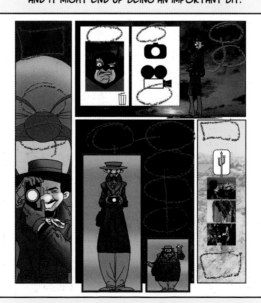

ALWAYS KEEP THIS IN MIND, AND MAKE SURE THAT THERE ARE SOME REDUNDANT AREAS ON THE PANEL WHERE THE BOXES AND BALLOONS CAN FIT HAPPILY.

IT'S ALSO POSSIBLE THAT, DURING THE PRELIMINARY SKETCHES, YOU'LL DISCOVER THAT THE WRITER'S POSITIONING OF A CHARACTER IN ONE OR MORE PANELS DOESN'T WORK PARTICULARLY WELL.

THE ANSWER IS SIMPLE; REDESIGN THE PANEL'S LAYOUT UNTIL YOU THINK IT DOES WORK.

ALSO, THINK ABOUT HOW THE TEXT SHOULD FLOW.

MAKE SURE THAT WHEN THE READER FINISHES PROCESSING THE INFORMATION IN ONE PANEL, SHE WILL BE LED NATURALLY TO THE NEXT ONE.

ONCE YOU'RE HAPPY WITH THE LAYOUT AND PANEL DESIGN, GO ON TO THE FINISHED PENCILS. THESE CAN BE AS LOOSE OR DETAILED AS YOU WISH, DEPENDING ON WHO'S DOING THE INKING.

IF YOU'RE INKING THE STORY YOURSELF, YOU CAN MAYBE CUT BACK ON THE DETAIL. IF A SEPARATE INKER IS INVOLVED, THOUGH, THE FINISHED PENCILS NEED TO BE AS COMPLETE AS YOU CAN MAKE THEM.

HOWEVER, TO CUT DOWN ON YOUR PENCIL BILL, YOU DON'T NEED TO FILL IN ANY LARGE AREAS OF BLACK—JUST WRITING IN A SIMPLE "X" IN EACH AREA WILL DO. THE INKER CAN FILL IN THE "SPOT BLACKS" LATER.

THE POINT OF INKING IS TO PROVIDE A CRISP, BLACK AND WHITE IMAGE FOR SCANNING IN.

BEFORE THE ADVENT OF DIGITAL TECHNOLOGY, THE CAMERAS USED FOR CAPTURING ARTWORK DIDN'T GET A PARTICULARLY CLEAN IMAGE FROM PENCILS

REMEMBER THE POOR REPRODUCTIONS YOU'D GET FROM A PHOTOCOPIER WITH ANYTHING THAT WASN'T PURE BLACK AND WHITE?

BUT AS WE SAW ON PAGE 95, IT'S NOW POSSIBLE TO SKIP THE INKING STAGE ALTOGETHER AND SCAN IN THE PENCILS.

WITH MODERN SCANNERS, YOU CAN CHOOSE WHETHER YOU WANT TO INK YOUR PENCILS BEFORE SCANNING THEM, OR TO SCAN THE PENCILS AND THEN "INK" DIGITALLY.

HOW YOU INK IS UP TO YOU: PENS OR BRUSHES, EVEN MARKER PENS OR A MOUSE IF YOU WANT.

THE MEDIUM DOESN'T MATTER AS LONG AS THE STORYTELLING IN THE FINISHED PRODUCT IS CLEAR AND UNDERSTANDABLE.

DON'T CONFUSE CLEAN INKS WITH CLEAN LINES:

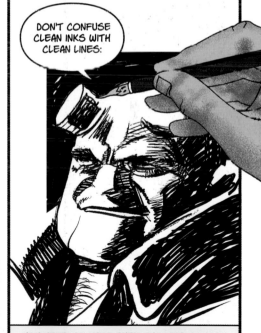

YOU NEED TO MAKE SURE THE INKS CONTAIN ONLY THE LINES THAT YOU WANT IN THE FINISHED PIECE, BUT THE LINE STYLE CAN BE AS "MESSY" AS YOU WANT—BILL SIENKIEWICZ'S ART IS A GOOD EXAMPLE.

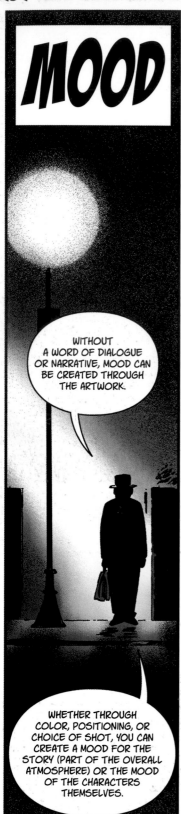

MOOD

WITHOUT A WORD OF DIALOGUE OR NARRATIVE, MOOD CAN BE CREATED THROUGH THE ARTWORK.

WHETHER THROUGH COLOR, POSITIONING, OR CHOICE OF SHOT, YOU CAN CREATE A MOOD FOR THE STORY (PART OF THE OVERALL ATMOSPHERE) OR THE MOOD OF THE CHARACTERS THEMSELVES.

WEATHER IS ALWAYS A GOOD MOOD SETTER.

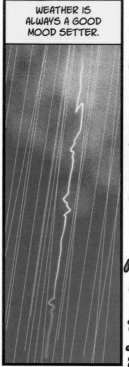

THUNDERSTORMS MIGHT BE CLICHÉD, BUT THEY'RE A KIND OF SHORTHAND THAT'S HARD-WIRED INTO HUMANS: THUNDER = BAD.

THEY ALSO PLAY AROUND WITH THE LIGHTING CONDITIONS.

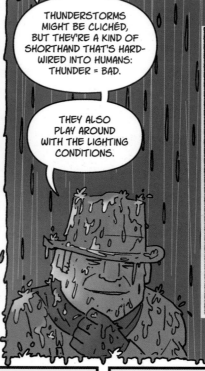

STORMS REDUCE THE AMOUNT OF AVAILABLE LIGHT, MAKING EVERYTHING GRAY AND DRAB.

CITIES BECOME GHOSTLY WITH REDUCED VISIBILITY AND WET GROUND REFLECTING SIGNS AND STREETLIGHTS.

AT NIGHT LIGHTNING ILLUMINATES SCENES IN SUDDEN, UNRELIABLE FLASHES.

WHO KNOWS WHAT MIGHT BE HIDING IN THE BLACKNESS BETWEEN FLASHES?

THE GENERAL LIGHTING CONDITIONS WILL ALWAYS AFFECT THE MOOD.

A SMALL DARK ROOM, LIT JUST A FEEBLE OR CANDLE, GIVE CLAUSTROPHO FEEL.

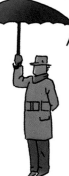

ON THE OTHER HAND, HARSH, BRIGHT LIGHT CAN GIVE A STERILE FEEL, LIKE IN AN OPERATING THEATER.

LIGHT ALSO CASTS SHADOWS, AND THE LENGTH AND POSITIONING OF THESE CAN SAY A LOT ABOUT A SCENE.

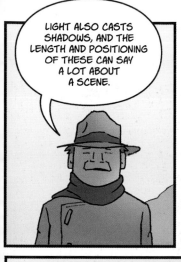

IF WE'RE OUTDOORS AND THE SHADOWS ARE SMALL AND HARSH, IT'LL BE CLOSE TO MIDDAY (AND PROBABLY IN A PART OF THE WORLD CLOSE TO THE EQUATOR).

LONG SHADOWS—SOMETIMES COMBINED WITH A RED TINGE TO THE LIGHT—WOULD INDICATE SUNDOWN. EQUALLY LONG SHADOWS CAN ALSO MEAN SUN-RISE.

WE'VE ALREADY MENTIONED WARM AND COLD COLOR. USING COLORS FROM THE RED END OF THE SPECTRUM (WARMER), GIVES A COSIER FEEL TO A SCENE,

WHILE THE BLUE/VIOLET END PRODUCES A CHILLIER FEEL.

UP ON SNOWY PEAKS OR ON ICE FIELDS, SHADING SHOULD BE PICKED OUT WITH PALE BLUES, EMPHASIZING THE COLDNESS OF THE SCENE.

ALTHOUGH, INTERESTINGLY ENOUGH, COMBINING WARM AND COLD COLORS CAN GIVE A HIGHER FEELING OF TENSION.

THINK OF A DARK CONTROL ROOM, FACES PICKED OUT BY BLUE AND GREEN SCREENS, THE ONLY HIGHLIGHTS ARE SPECKS OF RED AND YELLOW TELLTALES. SUDDENLY, RED IS NO LONGER A COZY COLOR; NOW IT MEANS DANGER.

A SENSE OF DESOLATION CAN BE CREATED WITH LONG AND WIDE-ANGLE SHOTS WHERE YOUR CHARACTER SEEMS TO BE THE ONLY PERSON IN THE ENTIRE LANDSCAPE.

IT COULD BE OUT IN THE DESERT, ON THE OCEAN, OR EVEN IN THE CENTER OF A BIG EMPTY CITY.

YOU GET THE VERY OPPOSITE EFFECT WHEN YOU OVERCROWD THE PANELS, ESPECIALLY IF YOU DRAW THE PANELS SMALLER THAN USUAL. FOR EXAMPLE, A CHARACTER FIGHTING HIS OR HER WAY THROUGH A CROWDED MARKET ALREADY CARRIES WITH IT A LOW LEVEL OF THREAT.

IF THE BUILDINGS IN THE BACKGROUND SEEM TO CROUCH AND LOOM OVER THE SCENE, YOU'VE CREATED A HEMMED-IN FEELING. INSTANTLY, THE TENSION GOES UP ANOTHER NOTCH.

STYLES OF ARTWORK

ALL COMIC ART IS STYLIZED, BUT THE DEGREE OF STYLIZATION VARIES WITH SUBJECT MATTER AND ARTISTIC TASTE (AND LICENSE).

COMICS CAN BE ANYTHING FROM PHOTO-REALISTIC TO DOWNRIGHT CARTOONY, AND THE CHOICE ISN'T ALWAYS AS OBVIOUS AS YOU'D THINK.

PHOTO-REALISM SPEAKS FOR ITSELF. MANY OF THE EARLY NEWSPAPER STRIPS EMPLOYED A REALISTIC STYLE—*STEVE CANYON*, *PRINCE VALIANT*, ETC.–THAT WAS FASHIONABLE AT THE TIME.

NOWADAYS, WITH THE ACCENT MORE ON SUPERHERO STRIPS, ANATOMICAL ACCURACY HAS GIVEN WAY TO MORE EXAGGERATED PHYSIQUES.

BUT THAT'S NOT TO SAY PHOTO-REALISM HAS DISAPPEARED ALTOGETHER.

ARTISTS SUCH AS P. CRAIG RUSSELL, ALEX ROSS, AND MATT BUSCH STILL USE PHOTOGRAPHED MODELS AS REFERENCE POINTS.

FIRST THING I REMEMBER WAS THE WORD.

AND THE WORD WAS GOD.

RUSSELL AND BUSCH THEN DRAW THEIR STRIPS IN THE OLD PEN-AND-INK WAY, WHILE ROSS PAINTS HIS ARTWORK–GIVING EVEN GREATER DEPTH.

ALL YOU NEED FOR YOUR REFERENCE IS A CAMERA AND A PILE OF FRIENDS WHO DON'T MIND POSING OR MAKING FUNNY FACES.

AS WE'VE SAID, TODAY'S SUPERHEROES ARE AS HUGE AS THEIR ADVENTURES.

BOTH MEN AND WOMEN ARE TALLER THAN USUAL—THE MEN MASSIVELY MUSCLED, WITH HUGE SHOULDERS;

THE WOMEN HAVING MORE CURVES THAN YOU'LL FIND INSIDE A PLASTIC SURGEON'S CATALOG, WITH LEGS THAT GO ON FOREVER.

IT'S A FAR CRY FROM THE 1960S AND MURPHY ANDERSON'S POSSIBLY STAID, BUT STILL ANATOMICALLY REASONABLE, PICTURES.

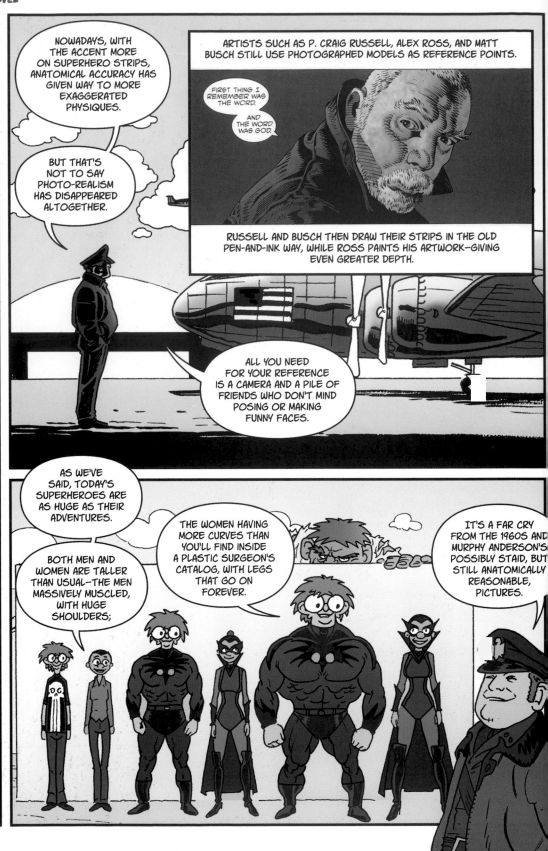

THE CARTOON STYLE IS PROBABLY ONE OF THE MOST RECOGNIZED.

STRIPS LIKE *PEANUTS* AND *GARFIELD* ARE FAMILIAR ACROSS THE WORLD, AND WHAT MAKES THEM SO RECOGNIZABLE IS THEIR PARTICULAR, SIMPLIFIED-YET-UNIQUE CARTOON STYLE.

AS LONG AS THERE HAVE BEEN NEWSPAPER STRIPS, THE CARTOON HAS BEEN A STAPLE. AND BOOKS LIKE *BONE* CONTINUE THE CARTOON LEGACY.

BUT IT'S NOT NECESSARY TO LIMIT THIS STYLE TO THE FUNNIES.

ALBION BY ALAN MOORE—ALONG WITH HIS DAUGHTER LEAH—IS A RETROSPECTIVE OF CHARACTERS FROM THE UNITED KINGDOM'S COMIC HISTORY. ALTHOUGH TOLD IN A CONVENTIONAL MANNER, OCCASIONAL PAGES THAT MIMIC THE BRITISH CARTOON STYLE ARE USED.

ONE CHARACTER'S SCHOOL LIFE—WHERE SHE ENDURED SYSTEMATIC CRUELTY FROM THE STAFF—IS DRAWN IN A *BASH STREET KIDS* STYLE THAT IS IRONIC AND ALSO MAKES THE UNDERSTATED CRUELTY EVEN MORE TERRIBLE.

ANOTHER INSTANTLY RECOGNIZABLE STYLE IS MANGA, AND IT'S A GROWING INFLUENCE ON WESTERN COMIC STYLES. EVEN SUCH ICONIC CHARACTERS AS BATMAN AND SPIDER-MAN HAVE BEEN AFFECTED.

IN THE SERIES *WAR DRUMS*, THE SEQUENCES DETAILING THE MISADVENTURES OF A WANNABE ROBIN—STEPHANIE BROWN—ARE DRAWN BY ARTIST DAMION SCOTT IN A STYLE THAT COMBINES A RECOGNIZABLE MANGA "LOOK" WITH MORE TRADITIONAL WESTERN ELEMENTS.

THE TALE OF ONE BAD RAT

by BRYAN TALBOT

A SIMILAR EXAMPLE IS BRYAN TALBOT'S *THE TALE OF ONE BAD RAT*. HERE, THE TITLE AND COVER ARTWORK ARE DESIGNED TO MIRROR THE STYLE OF BEATRIX POTTER'S FAMOUS TALES. AS WELL AS BEING DELIBERATE HOMAGES TO HISTORIC COMICS AND ILLUSTRATIONS, THESE PIECES ALSO JUXTAPOSE THE JUVENILE IMAGERY WITH ADULT THEMES.

MARVEL COMMISSIONED A GROUP OF ARTISTS AND WRITERS TO CREATE STORIES FOR THE *MARVEL MANGAVERSE*. THESE TALES RE-IMAGINED THE MARVEL HEROES IN A MANGA STYLE ALONG WITH TRADITIONAL MANGA THEMES SUCH AS GIANT ROBOTS AND GODZILLA-SIZED MONSTERS. THIS IMAGE FROM KAARE ANDREWS' *SPIDER SCROLL* SHOWS A MANGA SPIDER-MAN IN A TYPICAL WESTERN SUPER-HERO POSE.

I WILL HAVE MY VENGEANCE, DEMON, I'LL FOLLOW YOU TO THE PITS OF HELL AND BACK, IF I HAVE TO.

BUT NOT TODAY -- TODAY, I HAVE A CITY TO SAVE!

PANEL LAYOUTS

THESE PAGES FROM *THE STARDUST KID* BY MIKE PLOOG AND JM DEMATTEIS SHOW GREAT PANEL VARIATION.

IF YOU'VE ONLY TWO PANELS ON ONE PAGE, OBVIOUSLY THEY'LL BE BIGGER THAN ONES ON A PAGE WHERE THERE ARE SEVERAL, BUT THEY DON'T HAVE TO MATCH EACH OTHER.

WE'VE ALREADY TALKED ABOUT PANELS —HOW MANY PER PAGE, AND SO ON—BUT SO FAR, NOTHING MUCH ABOUT LAYING THEM OUT ON A PAGE.

PLACING YOUR FIVE TO SEVEN PANELS IN A RIGID GRID PATTERN MAY LOOK NEAT, BUT IT LACKS IMPACT.

ALTHOUGH PANELS STARTED OUT AS BASIC DEVICES TO CONTAIN A MOMENT OF ACTION, THEY'RE NOW PART OF THE OVERALL DESIGN.

ALTERING THE SIZE CREATES IMPACT, BECAUSE A BIGGER PANEL WILL DOMINATE A SMALLER ONE.

OVERLAYING PANELS IS QUITE COMMON, WHERE ONE PANEL WILL INTRUDE ON ANOTHER'S SPACE, OR SOMETIMES FLOAT OVER IT.

IT CAN BE A WAY OF CREATING A SENSE OF RAPID, STACCATO INSTANCES OF TIME, CHATTERING ONE AFTER THE OTHER.

YOU CAN ALSO IGNORE PANELS ALTOGETHER.

OR, IF YOUR PAGE IS A SINGLE PANEL WITH A PIVOTAL MOMENT CAPTURED IN IT, SMALLER, OVERLAID PANELS CAN ACT AS DETAILS FROM A BIGGER SCENE.

THE LATE WILL EISNER WAS QUITE FOND OF THIS TRICK, OFTEN FLOWING SCENES ONE INTO THE OTHER, GIVING AN ORGANIC FEELING TO THE ACTION.

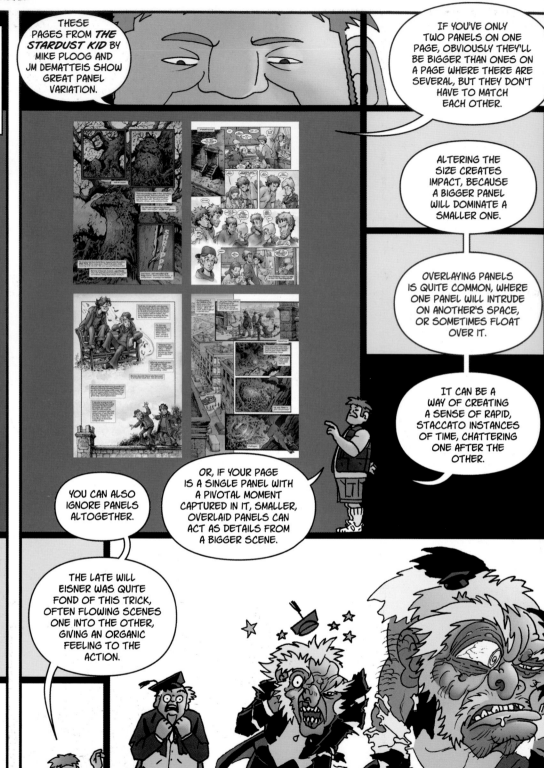

QUITE THE OPPOSITE EFFECT IS BREAK-UP, WHERE A SUCCESSION OF IMAGES ARE SCATTERED ACROSS THE PAGE.

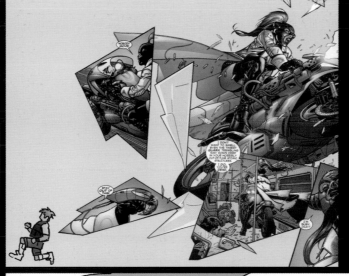

THIS IS A GOOD WAY OF HANDLING FLASHBACKS (OR EVEN FORWARDS), WITH PAST AND PRESENT COLLIDING IN A SUPERFICIALLY CHAOTIC WAY. BUT THIS APPROACH REQUIRES DISCIPLINE; OTHERWISE YOU'LL LOSE THE READER.

OFTEN THE BEST WAY IS TO USE THESE DIFFERENT FRAME LAYOUTS SPARINGLY, SO THEY SURPRISE THE READER AND LEND EVEN MORE EMPHASIS TO YOUR ILLUSTRATIONS.

AND ANYWAY, THERE ARE STILL PLENTY OF TRICKS THAT CAN BE PLAYED WITH THE STANDARD GRID.

DAVE GIBBONS OFTEN WORKS WITHIN A STRICT GRID, BUT USES IT IN INNOVATIVE WAYS, SUCH AS THIS SCENE FROM *BUTTERFLY* FROM THE MATRIX COMICS...

...GRIDS CAN ALSO BE SPLIT INTO THEIR CONSTITUENT ROWS AND COLUMNS FOR DIFFERENT EFFECTS,

HORIZONTAL ROWS GIVE A CINEMATIC FEEL, WHILE VERTICAL COLUMNS HAVE A CLAUSTROPHOBIC LOOK TO THEM.

FRAMING DEVICES AND CROPS

FRAMING DEVICES ARE BEST DESCRIBED AS KINDS OF VISUAL BRACKETS, AND SHOULDN'T BE CONFUSED WITH PANELS—THEY ARE A WAY OF ENCLOSING PART OF A PANEL, AND MAKING SURE THE EYE IS DRAWN TO IT.

THERE ARE SEVERAL WAYS OF DOING THIS.

A GROUP OF CHARACTERS STANDING AROUND LOOKING AT A SPECIFIC POINT IN THE PANEL IS A SIMPLE FRAMING DEVICE.

THEY'RE ENCLOSING THE ACTUAL PART OF THE PICTURE YOU WANT THE READER TO FOCUS ON, AND THEIR LINES OF SIGHT ACT AS POINTERS FOR THE READER'S OWN EYES.

YOU CAN CREATE THE SAME EFFECT WITH PERSPECTIVE—ROADS OR AVENUES OF TREES LEADING OFF INTO THE DISTANCE.

YOU CAN ALSO USE LINES—SUCH AS THE HORIZON, STREAKY CLOUDS, OR ROADS—GUIDE THE EYE THROUGH THE PANEL TO A SECONDARY FOCUS.

PANELS THEMSELVES CAN ACT AS FRAMING DEVICES BY TAKING ON THE FORM OF OBJECTS SUCH AS DOORWAYS OR WINDOWS.

ON THIS PAGE FROM SERGIO TOPPI'S *SHARAZ-DE* WE FIND A COMBINATION OF THESE TECHNIQUES.

BY USING THE SHAPE AND REFLECTION OF A SWORD AS AN IMPLIED PANEL, THE ARTWORK LEADS THE READER TO THE RIGHT, AND THE RISING CONTOUR LINES OF A HILL.

THIS THEN LEADS THE EYE TO THE NEXT PANEL TO FOCUS ON A HORSE HIGH UP ON THE HILLSIDE.

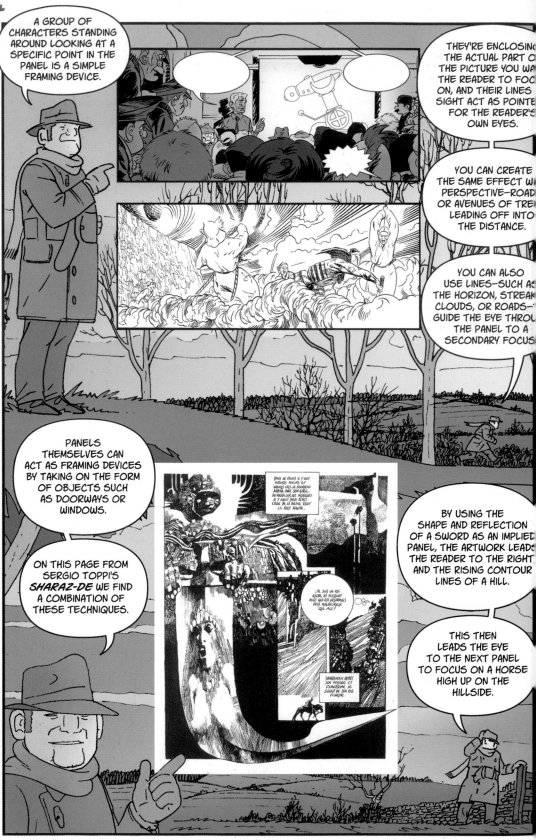

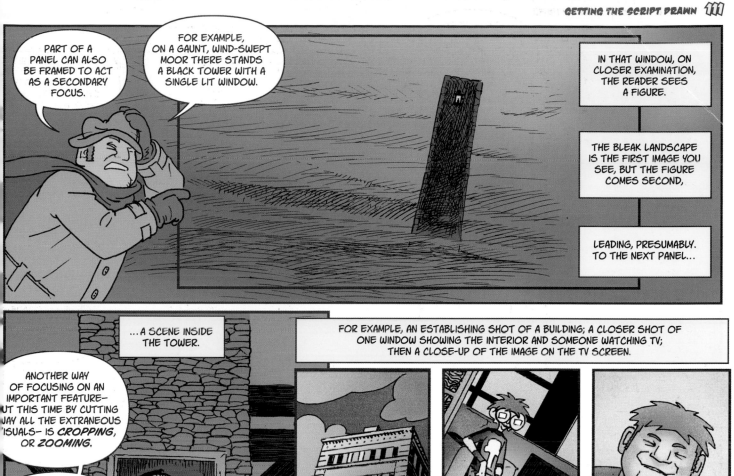

PART OF A PANEL CAN ALSO BE FRAMED TO ACT AS A SECONDARY FOCUS.

FOR EXAMPLE, ON A GAUNT, WIND-SWEPT MOOR THERE STANDS A BLACK TOWER WITH A SINGLE LIT WINDOW.

IN THAT WINDOW, ON CLOSER EXAMINATION, THE READER SEES A FIGURE.

THE BLEAK LANDSCAPE IS THE FIRST IMAGE YOU SEE, BUT THE FIGURE COMES SECOND,

LEADING, PRESUMABLY. TO THE NEXT PANEL...

...A SCENE INSIDE THE TOWER.

ANOTHER WAY OF FOCUSING ON AN IMPORTANT FEATURE— UT THIS TIME BY CUTTING AY ALL THE EXTRANEOUS ISUALS— IS *CROPPING*, OR *ZOOMING*.

ZOOMING IN TO AN EXTREME CLOSE-UP IS AN EFFECTIVE EANS OF CROPPING OUT BACKGROUND MATERIAL AND FOCUSING ON THE IMPORTANT ASPECTS ALONE.

THIS CAN BE DONE OVER A SERIES OF PANELS.

FOR EXAMPLE, AN ESTABLISHING SHOT OF A BUILDING; A CLOSER SHOT OF ONE WINDOW SHOWING THE INTERIOR AND SOMEONE WATCHING TV; THEN A CLOSE-UP OF THE IMAGE ON THE TV SCREEN.

OR JUST A SINGLE PANEL, SUCH AS A FINGER TAPPING A FACE IN A PHOTOGRAPH.

ILYA, IN *TIME WARP*, TIES THE ZOOM TOGETHER BY HAVING A SOUND INTRODUCED IN THE FIRST PANEL, AND THEN ZOOMING INTO THE PICTURE TO SHOW THE ORIGIN OF THAT SOUND.

SCANNING IN HAND-DRAWN ARTWORK

AT THE RISK OF STATING THE OBVIOUS, YOU'RE GOING TO NEED A GOOD SCANNER.

WE'VE ALREADY ESTABLISHED THAT YOU'RE PROBABLY GOING TO BE SCANNING IN YOUR LINE ART AT 600 PPI AT SOME POINT, SO YOUR SCANNER'S GOING TO NEED TO HAVE AT LEAST THAT RESOLUTION.

MOST SCANNERS ARE QUITE CAPABLE OF THAT TODAY, BUT DON'T BE FOOLED BY CHEAPER MACHINES CLAIMING A RESOLUTION OF 2400 PPI.

THAT'S NOT THE ACTUAL RESOLUTION OF THE SCANNER, BUT THE INTERPOLATED RESOLUTION, WHICH IS ARRIVED AT BY A MATHEMATICAL METHOD THAT ARTIFICIALLY INCREASES THE SCAN'S RESOLUTION (AT THE EXPENSE OF THE QUALITY).

WE'VE ALSO MENTIONED COLOR SPACE—THE NUMBER OF COLORS THAT CAN BE SCANNED. YOU'LL NEED AT LEAST 24-BIT, BUT MOST MODERN SCANNERS WILL HAVE 36-BIT COLOR ANYWAY.

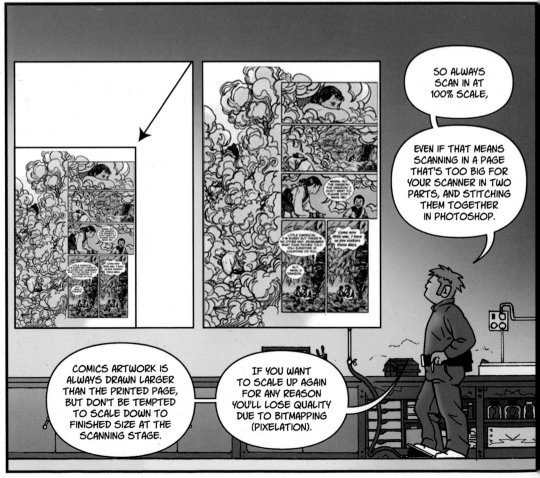

SO ALWAYS SCAN IN AT 100% SCALE,

EVEN IF THAT MEANS SCANNING IN A PAGE THAT'S TOO BIG FOR YOUR SCANNER IN TWO PARTS, AND STITCHING THEM TOGETHER IN PHOTOSHOP.

COMICS ARTWORK IS ALWAYS DRAWN LARGER THAN THE PRINTED PAGE, BUT DON'T BE TEMPTED TO SCALE DOWN TO FINISHED SIZE AT THE SCANNING STAGE.

IF YOU WANT TO SCALE UP AGAIN FOR ANY REASON YOU'LL LOSE QUALITY DUE TO BITMAPPING (PIXELATION).

LINE ART MODE IN PHOTOSHOP DOESN'T SUPPORT COLORS, SO BEFORE COLORING YOU WILL NEED TO CHANGE TO CMYK MODE AT (USUALLY) 300 PPI.

SOME ARTISTS ACTUALLY DO THE INITIAL SCAN IN GRAYSCALE, BUT LINE ART SCANS ARE CLEANER, SHARPER, AND DON'T NEED ANY ADJUSTMENTS FOR BRIGHTNESS AND CONTRAST.

PENCILS SHOULD BE SCANNED IN GRAYSCALE MODE.

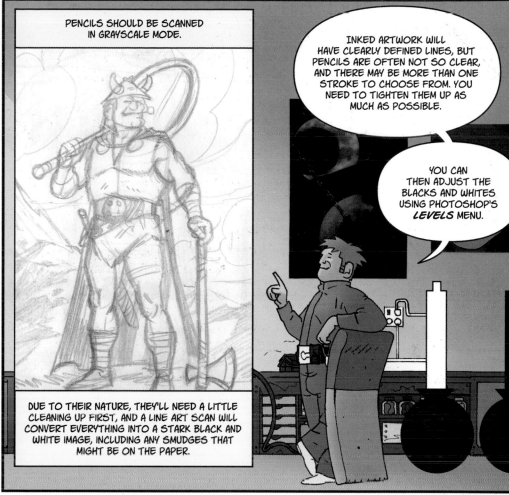

DUE TO THEIR NATURE, THEY'LL NEED A LITTLE CLEANING UP FIRST, AND A LINE ART SCAN WILL CONVERT EVERYTHING INTO A STARK BLACK AND WHITE IMAGE, INCLUDING ANY SMUDGES THAT MIGHT BE ON THE PAPER.

INKED ARTWORK WILL HAVE CLEARLY DEFINED LINES, BUT PENCILS ARE OFTEN NOT SO CLEAR, AND THERE MAY BE MORE THAN ONE STROKE TO CHOOSE FROM. YOU NEED TO TIGHTEN THEM UP AS MUCH AS POSSIBLE.

YOU CAN THEN ADJUST THE BLACKS AND WHITES USING PHOTOSHOP'S *LEVELS* MENU.

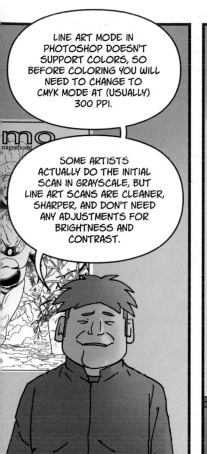

THERE'S A DIAGRAM—CALLED [H]ISTOGRAM—THAT [SH]OWS THE INTENSITY OF GRAYS WITH SPIKES.

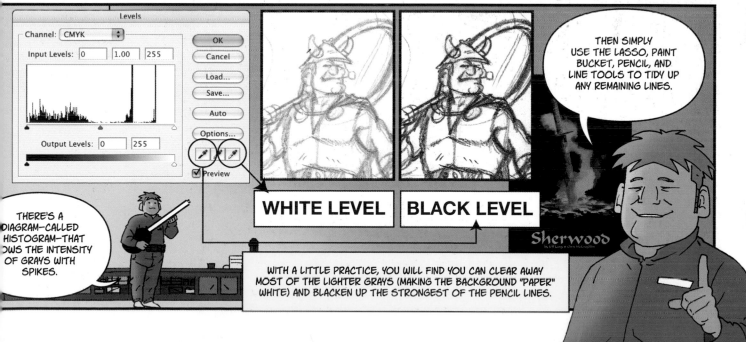

WHITE LEVEL

BLACK LEVEL

THEN SIMPLY USE THE LASSO, PAINT BUCKET, PENCIL, AND LINE TOOLS TO TIDY UP ANY REMAINING LINES.

WITH A LITTLE PRACTICE, YOU WILL FIND YOU CAN CLEAR AWAY MOST OF THE LIGHTER GRAYS (MAKING THE BACKGROUND "PAPER" WHITE) AND BLACKEN UP THE STRONGEST OF THE PENCIL LINES.

USE OF LAYERS

ONE WAY OF COLORING YOUR ARTWORK IS TO USE A "VIRTUAL BLUELINE." ESSENTIALLY, THIS IS A PALE-COLORED COPY OF YOUR LINE WORK THAT YOU CAN PAINT ONTO AND USE AS A BOUNDARY FOR FLOOD FILLS. THE FINAL BLACK LINE WORK IS THEN PLACED OVER THE TOP.

FIRST ENSURE THAT THE ARTWORK IS SET TO THE CORRECT RESOLUTION (USUALLY 300 PPI), THE MODE IS SET TO CMYK (FOR PRINT), AND THAT THE LINE ART IS THE CORRECT SIZE.

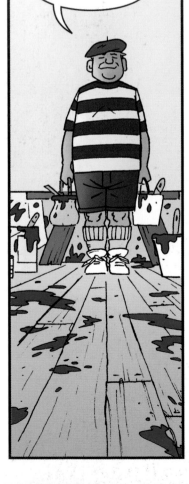

WITH YOUR ARTWORK OPEN, SELECT AND COPY THE ENTIRE LAYER, THEN CLICK ON THE *CHANNELS* TAB AND CREATE A NEW CHANNEL.

GIVE THE CHANNEL AN APPROPRIATE NAME—SUCH AS "OUTLINES"—AND PASTE THE COPIED ARTWORK INTO IT.

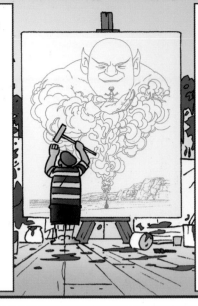

RETURN TO THE *LAYERS* PALETTE, AND CREATE A NEW LAYER. LOAD "OUTLINES" FROM YOUR CHANNELS BY GOING TO *SELECT > LOAD SELECTION*.

SET THE FOREGROUND COLOR TO 60C 40M 40Y 0K, AND FILL THE SELECTION WITH THIS COLOR. THIS IS YOUR "TRAPPING" LAYER.

FOR THE BLACK LINES OR "ARTWORK" LAYER, RELOAD THE "OUTLINES" FROM THE CHANNELS TO A NEW LAYER, AND AGAIN FLOOD THE SELECTION WITH THE *PAINT BUCKET* TOOL.

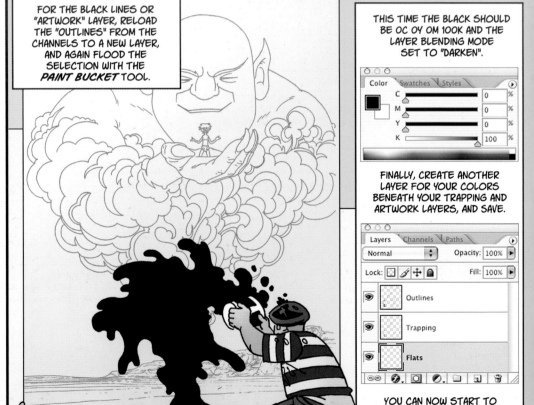

THIS TIME THE BLACK SHOULD BE 0C 0Y 0M 100K AND THE LAYER BLENDING MODE SET TO "DARKEN".

FINALLY, CREATE ANOTHER LAYER FOR YOUR COLORS BENEATH YOUR TRAPPING AND ARTWORK LAYERS, AND SAVE.

YOU CAN NOW START TO COLOR THE BASE LAYER.

USING THE *LASSO* TOOL, YOU CAN QUICKLY DRAW IN AREAS TO BE FILLED WITH THE *PAINT BUCKET*.

AS WITH A PAINTING, YOU BEGIN BY BLOCKING OUT ROUGH COLORS, ADDING ANY SHADING, HIGHLIGHTS, OR EVEN SPECIAL EFFECTS, LATER.

IT'S BETTER TO CREATE NEW LAYERS FOR EACH OF THESE, RATHER THAN APPLYING THEM ALL TO THE BASE LAYER.

THE FINAL COLORING LAYER WILL BE WHERE YOU ADD LIGHTING EFFECTS —LENS FLARE, METALLIC REFLECTIONS, ETC.—AS WELL AS DETAILS SUCH AS SMOKE, GHOSTLY PHENOMENA, AND THE LIKE.

AT THIS STAGE, YOU NEED TO DECIDE HOW TO SAVE THE FINISHED PRODUCT.

FLATTENING THE FILE WILL COMPRESS ALL THE LAYERS AND SEAL THEM AWAY FROM FURTHER MODIFICATION AS SURELY AS IF YOU'D LAMINATED THE PAGE IN PLASTIC.

FINE IF YOU'RE REALLY HAPPY WITH THE RESULT, OR YOUR DEADLINE'S UP, BUT IT IS LIMITING.

SAVING AS A PHOTOSHOP DOCUMENT WILL RETAIN ALL THE LAYERS AS THEY ARE, SO IF YOU'RE STILL WORKING ON A PAGE, ALWAYS SAVE AS A LAYERED PSD FILE.

RGB OR CMYK?

WE'VE THROWN THESE TERMS AROUND QUITE A BIT SO FAR, BUT WHAT EXACTLY DO THEY MEAN?

RGB IS RED, GREEN, AND BLUE: THE PRIMARY COLORS OF NORMAL WHITE LIGHT.

IF ALL THREE ARE MIXED, YOU GET WHITE; IF THEY'RE ABSENT, YOU GET BLACK (AS IN A SHADOW...).

WHAT HAPPENS IF YOU MIX RED, GREEN, AND BLUE PAINT OR INK ON A PAGE? IS THE RESULT WHITE? HARDLY.

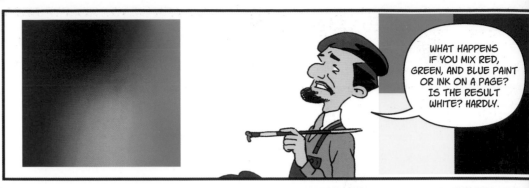

CMYK (CYAN, MAGENTA, YELLOW, BLACK) IS THE PRINTING EQUIVALENT. IT'S STILL ABLE TO CREATE ANY COLOR IN THE SPECTRUM, BUT THEY MIX IN THE OPPOSITE WAY FROM RGB.

IGNORING BLACK FOR THE TIME BEING, IF YOU DON'T ADD CYAN, YELLOW, OR MAGENTA TO A PIECE OF BLANK PAPER, YOU GET (UNSURPRISINGLY) WHITE.

MIX ALL THREE TOGETHER AND YOU GET... WELL, YOU GET A MUDDY COLOR, ACTUALLY,

SO BLACK IS ADDED AS A FOURTH COLOR (CALLED K, WHICH STANDS FOR *KEY PLATE*).

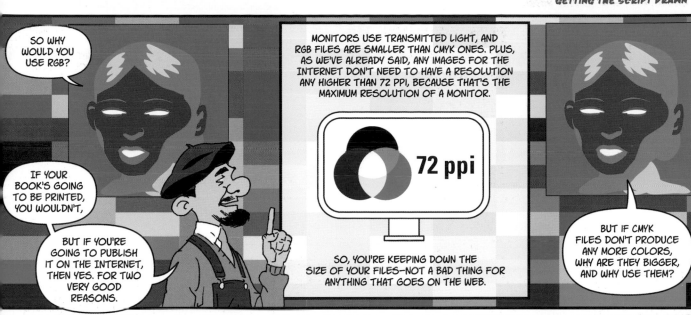

SO WHY WOULD YOU USE RGB?

MONITORS USE TRANSMITTED LIGHT, AND RGB FILES ARE SMALLER THAN CMYK ONES. PLUS, AS WE'VE ALREADY SAID, ANY IMAGES FOR THE INTERNET DON'T NEED TO HAVE A RESOLUTION ANY HIGHER THAN 72 PPI, BECAUSE THAT'S THE MAXIMUM RESOLUTION OF A MONITOR.

72 ppi

IF YOUR BOOK'S GOING TO BE PRINTED, YOU WOULDN'T,

BUT IF YOU'RE GOING TO PUBLISH IT ON THE INTERNET, THEN YES. FOR TWO VERY GOOD REASONS.

SO, YOU'RE KEEPING DOWN THE SIZE OF YOUR FILES—NOT A BAD THING FOR ANYTHING THAT GOES ON THE WEB.

BUT IF CMYK FILES DON'T PRODUCE ANY MORE COLORS, WHY ARE THEY BIGGER, AND WHY USE THEM?

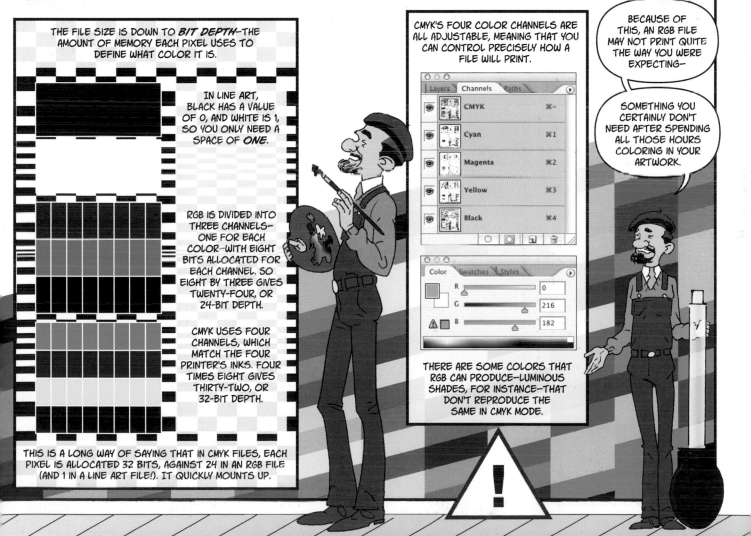

THE FILE SIZE IS DOWN TO *BIT DEPTH*—THE AMOUNT OF MEMORY EACH PIXEL USES TO DEFINE WHAT COLOR IT IS.

IN LINE ART, BLACK HAS A VALUE OF 0, AND WHITE IS 1, SO YOU ONLY NEED A SPACE OF *ONE*.

RGB IS DIVIDED INTO THREE CHANNELS—ONE FOR EACH COLOR—WITH EIGHT BITS ALLOCATED FOR EACH CHANNEL. SO EIGHT BY THREE GIVES TWENTY-FOUR, OR 24-BIT DEPTH.

CMYK USES FOUR CHANNELS, WHICH MATCH THE FOUR PRINTER'S INKS. FOUR TIMES EIGHT GIVES THIRTY-TWO, OR 32-BIT DEPTH.

THIS IS A LONG WAY OF SAYING THAT IN CMYK FILES, EACH PIXEL IS ALLOCATED 32 BITS, AGAINST 24 IN AN RGB FILE (AND 1 IN A LINE ART FILE!). IT QUICKLY MOUNTS UP.

CMYK'S FOUR COLOR CHANNELS ARE ALL ADJUSTABLE, MEANING THAT YOU CAN CONTROL PRECISELY HOW A FILE WILL PRINT.

Layers Channels Paths

CMYK ⌘~

Cyan ⌘1

Magenta ⌘2

Yellow ⌘3

Black ⌘4

Color Swatches Styles

R 0
G 216
B 182

THERE ARE SOME COLORS THAT RGB CAN PRODUCE—LUMINOUS SHADES, FOR INSTANCE—THAT DON'T REPRODUCE THE SAME IN CMYK MODE.

BECAUSE OF THIS, AN RGB FILE MAY NOT PRINT QUITE THE WAY YOU WERE EXPECTING—

SOMETHING YOU CERTAINLY DON'T NEED AFTER SPENDING ALL THOSE HOURS COLORING IN YOUR ARTWORK.

!

CREATING BALLOONS AND LETTERING

BALLOONS CAN BE CREATED USING VECTOR SOFTWARE SUCH AS ADOBE ILLUSTRATOR, OR CORELDRAW.

YOU CAN ALSO MAKE BALLOONS IN PHOTOSHOP, BUT IT'S NOT AS FLEXIBLE AS A DEDICATED VECTOR PROGRAM. WE'LL USE ILLUSTRATOR HERE.

BASICALLY, CREATING BALLOONS IS MUCH LIKE DRAWING CIRCLES AROUND TEXT THAT YOU'VE ALREADY POSITIONED.

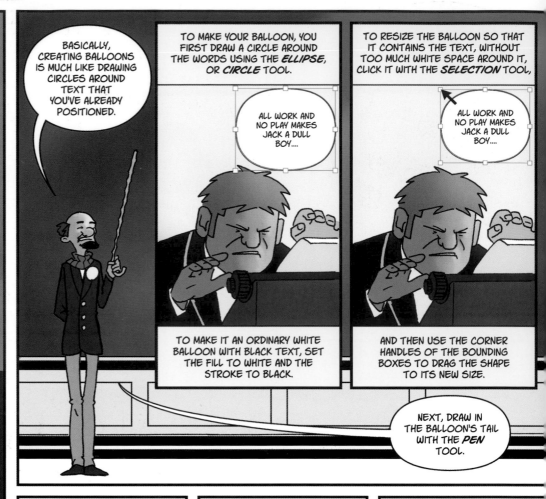

TO MAKE YOUR BALLOON, YOU FIRST DRAW A CIRCLE AROUND THE WORDS USING THE *ELLIPSE*, OR *CIRCLE* TOOL.

ALL WORK AND NO PLAY MAKES JACK A DULL BOY....

TO MAKE IT AN ORDINARY WHITE BALLOON WITH BLACK TEXT, SET THE FILL TO WHITE AND THE STROKE TO BLACK.

TO RESIZE THE BALLOON SO THAT IT CONTAINS THE TEXT, WITHOUT TOO MUCH WHITE SPACE AROUND IT, CLICK IT WITH THE *SELECTION* TOOL,

ALL WORK AND NO PLAY MAKES JACK A DULL BOY....

AND THEN USE THE CORNER HANDLES OF THE BOUNDING BOXES TO DRAG THE SHAPE TO ITS NEW SIZE.

NEXT, DRAW IN THE BALLOON'S TAIL WITH THE *PEN* TOOL.

CLICK ONCE ON THE BALLOON WHERE YOU WANT THE TAIL TO START FROM,

ALL WORK AND NO PLAY MAKES JACK A DULL BOY....

THEN MOVE THE MOUSE TO WHERE YOU WANT THE TAIL TO END—THIS IS UP TO YOU, BUT ABOUT HALFWAY TO THE SPEAKER'S MOUTH IS FINE.

TO CREATE A CURVED TAIL, CLICK AND HOLD THE MOUSE BUTTON, AND DRAG THE MOUSE DOWN TO CREATE A CURVE.

ALL WORK AND NO PLAY MAKES JACK A DULL BOY....

RELEASE THE MOUSE WHEN YOU'RE HAPPY. NEXT, ALT/OPTION-CLICK ON THE END POINT OF THE TAIL TO TURN IT INTO A CORNER POINT.

THEN CLICK BACK ON THE CIRCLE AGAIN, PERFORMING THE SAME HOLD AND DRAG MANEUVER TO CREATE A CURVE THAT MATCHES THE FIRST LINE.

ALL WORK AND NO PLAY MAKES JACK A DULL BOY....

WHEN THIS IS COMPLETE, SELECT BOTH THE CIRCLE AND THE TAIL AND CONVERT THEM INTO ONE OBJECT USING THE *PATHFINDER* PALETTE.

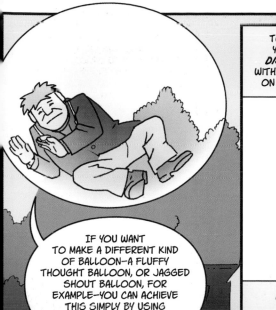

IF YOU WANT TO MAKE A DIFFERENT KIND OF BALLOON—A FLUFFY THOUGHT BALLOON, OR JAGGED SHOUT BALLOON, FOR EXAMPLE—YOU CAN ACHIEVE THIS SIMPLY BY USING ILLUSTRATOR'S FILTERS.

TO CREATE A JAGGED BALLOON, DRAW YOUR CIRCLE, THEN GO TO *FILTER > DISTORT > ZIG ZAG* AND EXPERIMENT WITH THE SETTINGS WITH *PREVIEW* TURNED ON UNTIL YOU'RE HAPPY WITH THE RESULT.

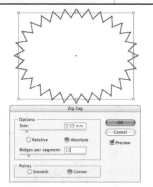

CREATING A THOUGHT BALLOON IS A VERY SIMILAR PROCESS.

FIRST RUN THE *ZIG ZAG* FILTER ON YOUR CIRCLE, BUT THIS TIME SET THE *SIZE* TO ZERO.

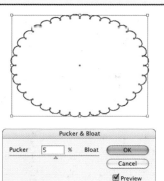

USE THE *RIDGES PER SEGMENT* SLIDER TO INDICATE HOW MANY LUMPS YOU'D LIKE ON YOUR CLOUD. NEXT, RUN THE *PUCKER AND BLOAT* FILTER, AND INCREASE THE *BLOAT* AMOUNT TO CREATE A CLOUD SHAPE.

FONTS FOR USE IN YOUR ARTWORK CAN COME FROM A VARIETY OF DIFFERENT SOURCES.

THERE ARE THE FONTS SUPPLIED WITH YOUR SOFTWARE, BUT GENERALLY, THESE AREN'T PARTICULARLY SUITABLE FOR LETTERING COMICS.

IF YOU ARE DOING A LOT OF LETTERING, IT MAKES SENSE TO GET HOLD OF SOME PROPER COMIC FONTS.

THERE ARE NUMEROUS SITES ON THE INTERNET AIMED SPECIFICALLY AT PROVIDING FONTS FOR COMICS. *BLAMBOT*, FOR EXAMPLE, PROVIDES FONTS DESIGNED VARIOUSLY FOR LETTERING, EFFECTS, AND TITLES.

IT DOES SUPPLY FREE FONTS FOR NON-PROFIT OR SELF-PUBLISHED COMICS, BUT YOU'LL HAVE TO PAY A LICENSE FEE IF YOU WANT TO USE THE FONTS FOR LARGE-SCALE COMMERCIAL PROJECTS.

ANOTHER SITE, *COMIC CRAFT*, NOT ONLY HAS A WIDE RANGE OF FONTS FOR SALE, BUT ALSO HAS NEWSGROUPS AND TUTORIALS AVAILABLE TO HELP YOU OUT WITH ANY PROBLEMS YOU MAY HAVE (SUCH AS CREATING SHADOWS AND STAGGERING THE LETTERING).

MANY OF THESE FONTS WERE ORIGINALLY CREATED WITH MACROMEDIA'S *FONTOGRAPHER*, SO IF YOU'RE FEELING ADVENTUROUS, YOU CAN ALWAYS TRY TO DESIGN YOUR OWN. AGAIN, BEING VECTOR BASED, THEY CAN BE RESIZED EASILY AND WITHOUT LOSING QUALITY.

PLACING TYPOGRAPHY

CREATING AND POSITIONING TYPOGRAPHY IS SIMILAR TO APPLYING COLOR TO YOUR SCANNED-IN ARTWORK.

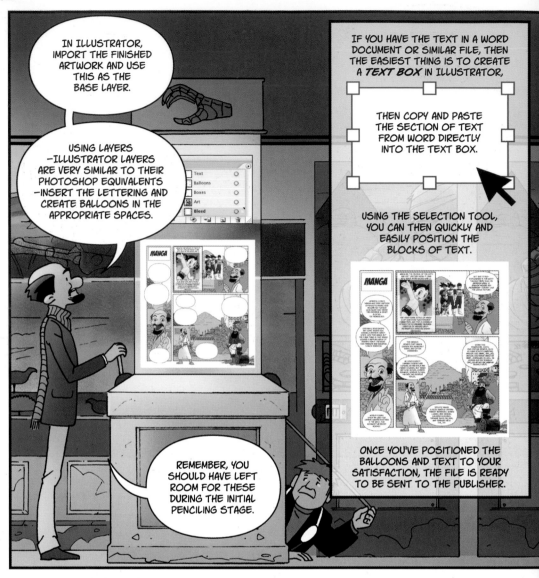

IN ILLUSTRATOR, IMPORT THE FINISHED ARTWORK AND USE THIS AS THE BASE LAYER.

USING LAYERS —ILLUSTRATOR LAYERS ARE VERY SIMILAR TO THEIR PHOTOSHOP EQUIVALENTS —INSERT THE LETTERING AND CREATE BALLOONS IN THE APPROPRIATE SPACES.

REMEMBER, YOU SHOULD HAVE LEFT ROOM FOR THESE DURING THE INITIAL PENCILING STAGE.

IF YOU HAVE THE TEXT IN A WORD DOCUMENT OR SIMILAR FILE, THEN THE EASIEST THING IS TO CREATE A *TEXT BOX* IN ILLUSTRATOR,

THEN COPY AND PASTE THE SECTION OF TEXT FROM WORD DIRECTLY INTO THE TEXT BOX.

USING THE SELECTION TOOL, YOU CAN THEN QUICKLY AND EASILY POSITION THE BLOCKS OF TEXT.

ONCE YOU'VE POSITIONED THE BALLOONS AND TEXT TO YOUR SATISFACTION, THE FILE IS READY TO BE SENT TO THE PUBLISHER.

IT'S USUALLY A GOOD IDEA TO KEEP THE TEXT AND ARTWORK SEPARATE, SO REMOVE THE BASE LAYER AND SAVE THE TEXT AND BALLOONS AS AN ILLUSTRATOR FILE.

THIS WAY, YOU GET TO KEEP YOUR ARTWORK UNMARKED, AND IF THE BOOK'S GOING TO BE PUBLISHED IN ANOTHER LANGUAGE, IT'LL NEED TO BE RE-LETTERED AFRESH, SO THE TEXT NEEDS TO BE KEPT EDITABLE.

FOR PROFESSIONAL PURPOSES YOU'D PROBABLY SEND IN THE LETTERING (AND THE SOUND EFFECTS) AS SEPARATE FILES, ANYWAY.

THEY WOULD THEN BE REASSEMBLED LATER.

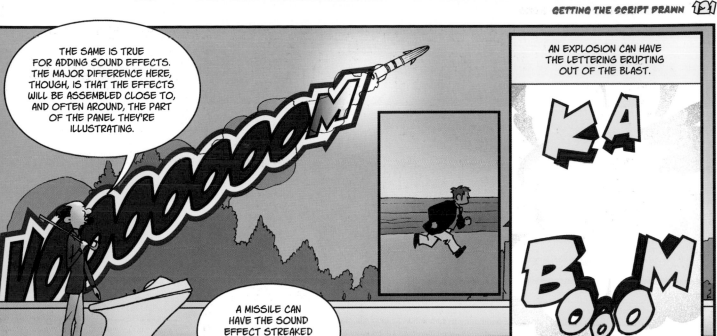

THE SAME IS TRUE FOR ADDING SOUND EFFECTS. THE MAJOR DIFFERENCE HERE, THOUGH, IS THAT THE EFFECTS WILL BE ASSEMBLED CLOSE TO, AND OFTEN AROUND, THE PART OF THE PANEL THEY'RE ILLUSTRATING.

A MISSILE CAN HAVE THE SOUND EFFECT STREAKED DOWN THE PATH OF THE EXHAUST.

AN EXPLOSION CAN HAVE THE LETTERING ERUPTING OUT OF THE BLAST.

TODAY, SOUND EFFECTS AREN'T THERE TO BE OBVIOUS—THE CAMP SENSIBILITIES OF THE OLD *BATMAN* TV SERIES ARE LONG OUT-OF-DATE—BUT THEY SHOULDN'T BE SO UNOBTRUSIVE THAT THE READER MISSES THEM ALTOGETHER.

THAT SAID, EFFECTS TYPOGRAPHY IS GENERALLY BRIGHTLY COLORED (OFTEN FROM THE WARM END OF THE SPECTRUM), COMPOSED FROM UNUSUAL FONTS, AND QUITE OFTEN GIVEN A THREE-DIMENSIONAL LOOK.

THE SIMPLEST METHOD OF CREATING AN OUTLINE IS TO GO TO *OBJECT > PATH > OFFSET PATH* IN ILLUSTRATOR, AND USE THE *OFFSET* VALUE TO CONTROL THE DISTANCE BETWEEN THE SHAPE AND ITS OUTLINE.

THE LETTERS CAN BE COLORED FROM THE *SWATCHES* PALETTE, THEN YOU CAN CREATE OUTLINES TO BE FILLED IN WITH BLACK OR A CONTRASTING COLOR.

IF YOU WANT TO USE THIS EFFECT ON TEXT, YOU'LL NEED TO FIRST CONVERT IT TO OUTLINES USING THE *TYPE > CREATE OUTLINES* COMMAND. NOTE THAT THIS WILL MEAN THAT THE TEXT ITSELF IS NO LONGER EDITABLE.

AS WITH EVERY OTHER ASPECT OF THE PAGE, THEY SHOULD SEEM TO SPRING NATURALLY, AND BE A PART OF THE STORYTELLING PROCESS.

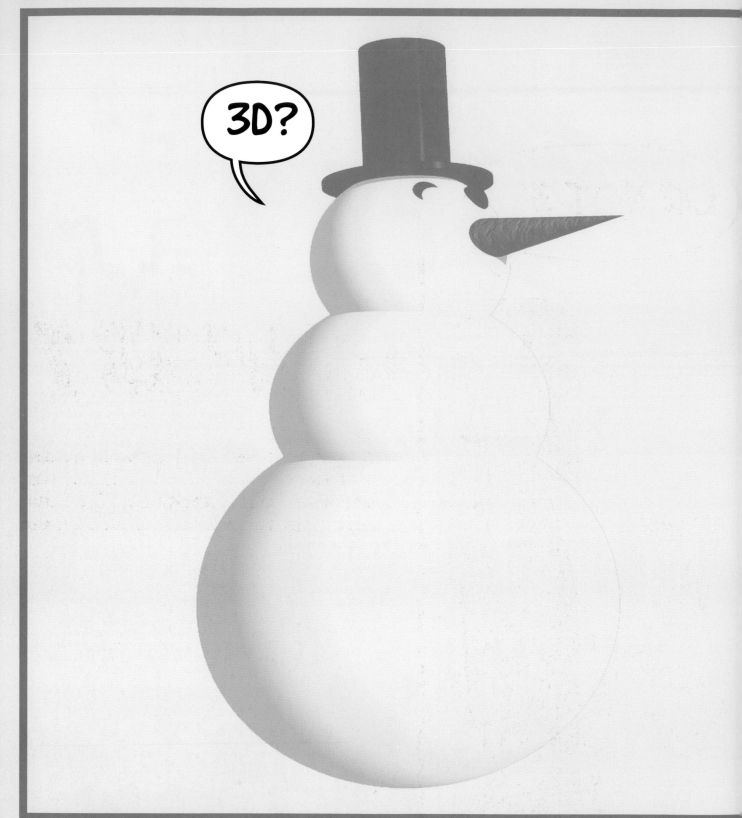

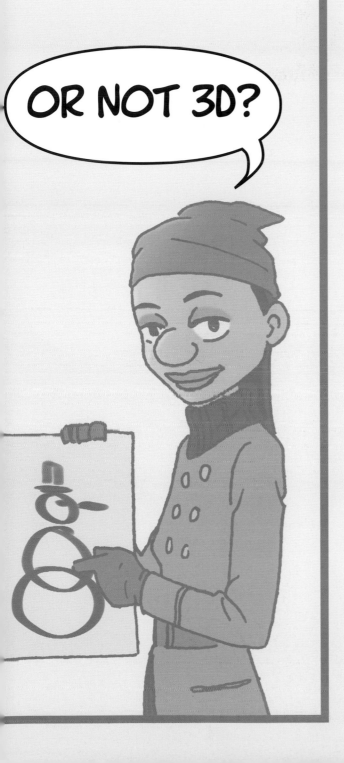

CHAPTER 7

THE NEXT BIG THING?........................124
SKETCHING IN 3D126
CREATING SOLID BACKGROUNDS.............128
REALISTIC CHARACTERS.....................130

THE NEXT BIG THING?

THERE'S A BODY OF OPINION THAT CLAIMS ANIMATED CARTOONS FOLLOWED NATURALLY FROM THE COMIC BOOK...

THE ANIMATORS JUST ADDED A FEW THOUSAND MORE PANELS AND PUT THEM ALL ON CELLULOID!

CERTAINLY, THERE'S A STRONG CONNECTION BETWEEN THE TWO.

AND IT'S HARDLY SURPRISING THAT COMIC CHARACTERS HAVE BEEN SO SUCCESSFUL IN ANIMATED CARTOONS.

(ALTHOUGH THEIR LIVE-ACTION VERSIONS HAVEN'T ALWAYS BEEN SO GOOD).

WHAT'S LESS CERTAIN IS THE CONNECTION BETWEEN COMPUTER-GENERATED IMAGERY IN THE MOVIES, CGI ANIMATED CARTOONS, AND 3D COMICS.

IT'S SOMETHING OF A CHICKEN AND EGG SITUATION, DECIDING WHICH CAME FIRST,

BUT IT'S ALMOST CERTAINLY TRUE THAT ALL WERE INEVITABLE, GIVEN THE ADVANCES IN COMPUTER TECHNOLOGY OVER THE PAST TWENTY YEARS OR SO.

THE ADVANTAGE OF A 3D COMIC OVER A CGI TV SERIES— SUCH AS THE LATEST *TRANSFORMERS* OR *CAPTAIN SCARLET*—

IS THAT FOR A COMIC, YOU DON'T NEED A COUPLE OF SUPERCOMPUTERS TO DO THE PROCESSING.

SOME POPULAR SOFTWARE PACKAGES FOR CREATING 3D IMAGERY ARE *POSER, BRYCE,* AND *CINEMA 4D.* ALL WILL WORK WITH MAC AND PC, AND THEY WON'T BREAK THE BANK.

POSER DOES EXACTLY WHAT IT SOUNDS LIKE IT SHOULD. IT'S USED FOR DESIGNING AND POSING FIGURES FOR 3D ARTWORK.

THE SOFTWARE COMES COMPLETE WITH BOTH MALE AND FEMALE FIGURES THAT ARE FULLY ARTICULATED AND POSABLE.

THEY ALSO COME WITH PHOTO-REALISTIC TEXTURES AND MORPH SETS, SO SKIN AND CLOTHING WILL LOOK CORRECT IN DIFFERENT POSITIONS. THERE ARE EVEN SOME CHILDREN TO MAKE UP THE FAMILY.

ASIDE FROM THE SKIN AND CLOTHING TEXTURING, YOU CAN POSITION LIGHTING AND VARY ITS INTENSITY TO MATCH THAT OF YOUR BACKGROUND.

AND YOU CAN DOWNLOAD SUCH ITEMS AS CLOTHING, WEAPONRY (ANCIENT, MODERN, AND FANTASTIC), AND HAIR MODELS FROM A VARIETY OF WEB SITES.

THESE ARE EFFECTIVELY COPYRIGHT FREE—BUT YOU STILL HAVE TO PAY TO USE THE MODEL—BUYING THE LICENSE, IN A WAY.

UNLIKE BRYCE OR POSER, CINEMA 4D DOES NOT SPECIALIZE IN ONE PARTICULAR FIELD OF MODELING.

INSTEAD, IT IS A GENERAL 3D MODELING APPLICATION THAT CAN BE USED TO CREATE ANYTHING YOU CAN THINK OF.

IT TAKES A BIT MORE TIME AND EFFORT TO GET TO KNOW ALL OF ITS FUNCTIONS, BUT IT'S A HUGELY POWERFUL PROGRAM THAT REWARDS THE HARD WORK YOU PUT INTO IT.

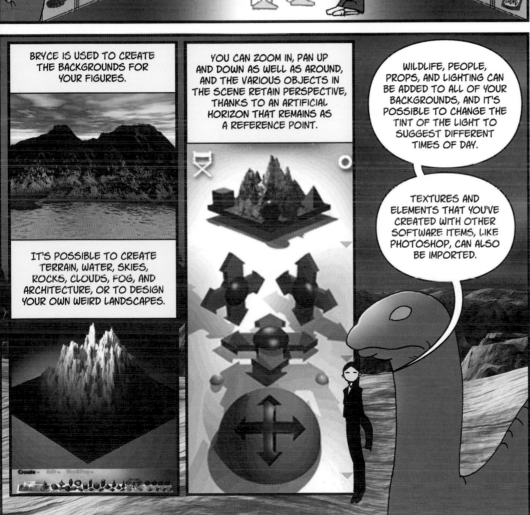

BRYCE IS USED TO CREATE THE BACKGROUNDS FOR YOUR FIGURES.

IT'S POSSIBLE TO CREATE TERRAIN, WATER, SKIES, ROCKS, CLOUDS, FOG, AND ARCHITECTURE, OR TO DESIGN YOUR OWN WEIRD LANDSCAPES.

YOU CAN ZOOM IN, PAN UP AND DOWN AS WELL AS AROUND, AND THE VARIOUS OBJECTS IN THE SCENE RETAIN PERSPECTIVE, THANKS TO AN ARTIFICIAL HORIZON THAT REMAINS AS A REFERENCE POINT.

WILDLIFE, PEOPLE, PROPS, AND LIGHTING CAN BE ADDED TO ALL OF YOUR BACKGROUNDS, AND IT'S POSSIBLE TO CHANGE THE TINT OF THE LIGHT TO SUGGEST DIFFERENT TIMES OF DAY.

TEXTURES AND ELEMENTS THAT YOU'VE CREATED WITH OTHER SOFTWARE ITEMS, LIKE PHOTOSHOP, CAN ALSO BE IMPORTED.

SKETCHING IN 3D

GOING THROUGH THE PRELIMINARY STAGES OF 3D ARTWORK ISN'T QUITE THE SAME AS PREPARING ROUGH SKETCHES FOR HAND-DRAWN WORK.

YOU STILL NEED TO TRY SOME IDEAS OUT ON PAPER FIRST TO GET THE DESIGN CLEAR IN YOU HEAD, BUT YOU ALSO NEED TO THINK ABOUT HOW THE MODEL WILL BE CONSTRUCTED.

WITH 3D SOFTWARE, YOU'LL BE ASSEMBLING THE MODEL OUT OF SHAPES SUCH AS SPHERES, CUBES, CONES, AND CYLINDERS THAT ARE ALL KNOWN AS PRIMITIVES.

YOU NEED TO IMAGINE HOW THE MODEL CAN BE BROKEN DOWN INTO THESE BASIC SHAPES. IT TAKES A BIT OF PRACTICE, BUT YOU'LL SOON GET THE HANG OF IT.

THE OTHER GOOD THING ABOUT WORKING WITH THE COMPUTER, OF COURSE, IS THAT IT'S EASY TO UNDO STEPS IF SOMETHING GOES WRONG.

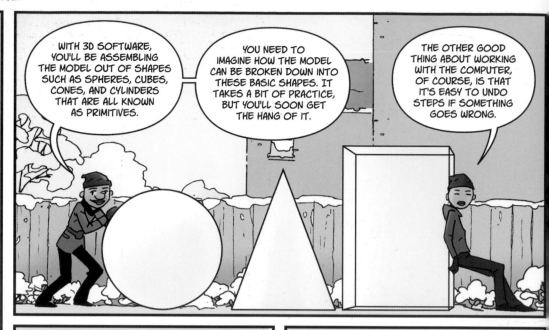

THE PRIMITIVE SHAPES ARE THE BUILDING BLOCKS OF 3D DESIGN.

THEY CAN BE SCALED, SKEWED, STRETCHED, AND OTHERWISE MANIPULATED TO MAKE ANY SHAPE.

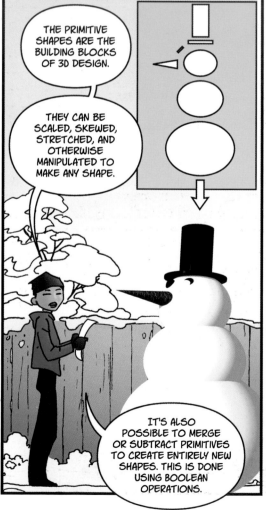

IT'S ALSO POSSIBLE TO MERGE OR SUBTRACT PRIMITIVES TO CREATE ENTIRELY NEW SHAPES. THIS IS DONE USING BOOLEAN OPERATIONS.

SOUNDS COMPLICATED, BUT IT BOILS DOWN TO THREE SIMPLE THINGS.

WHEN SHAPES MERGE, THEY CAN EITHER: COMBINE FULLY TO FORM ONE LARGE NEW SHAPE;

ONE CAN SUBTRACT FROM THE OTHER, REMOVING THE PORTION WHERE THE SHAPES INTERSECT;

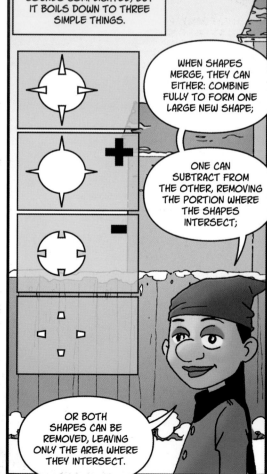

OR BOTH SHAPES CAN BE REMOVED, LEAVING ONLY THE AREA WHERE THEY INTERSECT.

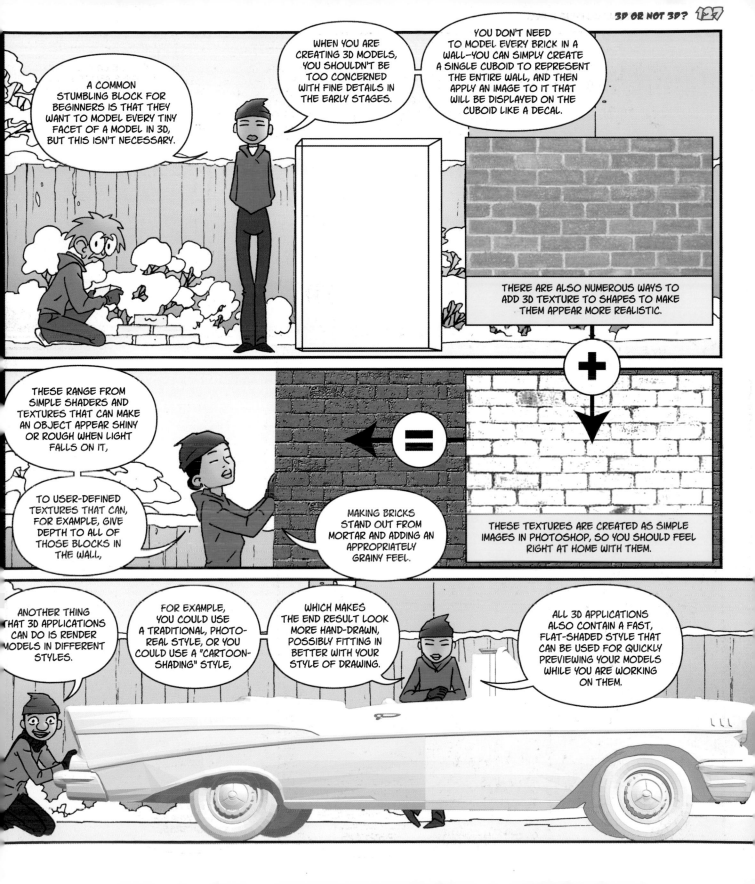

CREATING SOLID BACKGROUNDS

THERE ARE MANY WAYS TO CREATE A BACKGROUND FOR YOUR PICTURES, BUT THE BASIC STARTING POINT IS DECIDING WHAT SORT OF BACKGROUND YOU ARE LOOKING FOR.

IF YOU'RE CREATING A 3D LANDSCAPE TO POSITION YOUR CHARACTERS IN, THEN YOU SHOULD BEGIN WITH A SPECIALIZED PIECE OF LANDSCAPE SOFTWARE, SUCH AS *BRYCE* OR *VUE*.

THESE PACKAGES ARE VERY EASY TO USE, AND YOU CAN CREATE A USABLE, RANDOM LANDSCAPE WITH A FEW CLICKS OF THE MOUSE.

IT TAKES A LITTLE LONGER TO CUSTOMIZE THE LANDSCAPE IF YOU HAD SOMETHING SPECIFIC IN MIND, BUT IT'S STILL A QUICK PROCESS.

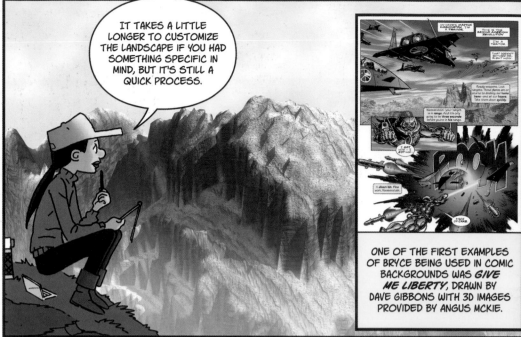

ONE OF THE FIRST EXAMPLES OF BRYCE BEING USED IN COMIC BACKGROUNDS WAS *GIVE ME LIBERTY*, DRAWN BY DAVE GIBBONS WITH 3D IMAGES PROVIDED BY ANGUS MCKIE.

IF YOU WANT A CITY SCENE, THEN YOU NEED TO DO A BIT MORE WORK. IN THIS CASE, IT'S WORTH GETTING HOLD OF A PIECE OF MORE GENERAL 3D SOFTWARE, SUCH AS CINEMA 4D OR *LIGHTWAVE*.

IF YOU'RE JUST AFTER A SIMPLE BACKGROUND, PRESETS OF DIFFERENT TYPES OF SKY AND WATER ARE USUALLY INCLUDED IN THE 3D PACKAGE.

THERE ARE ALSO CLOUD EFFECTS THAT CAN BE ADDED–ALSO IN 3D–THAT CAN LINK THE BACKGROUND IMAGE WITH YOUR FOREGROUND CHARACTERS.

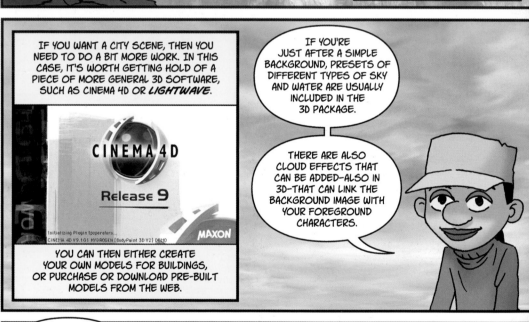

CINEMA 4D

Release 9

Initializing Plugin tpoperators...
CINEMA 4D V9.1 G1 HYDROGEN (BodyPaint 3D Y2) DEMO

MAXON

YOU CAN THEN EITHER CREATE YOUR OWN MODELS FOR BUILDINGS, OR PURCHASE OR DOWNLOAD PRE-BUILT MODELS FROM THE WEB.

FOR VIEWS OF OUTER SPACE, CHECK OUT THE *NASA* WEBSITE.

NEW HIGH-RESOLUTION IMAGES ARE REGULARLY POSTED, AND THERE'S AN ARCHIVE OF OLDER ONES. ALL OF THE NASA IMAGES ARE FREE FOR PERSONAL USE.

FOR THE EXTERIOR OF BUILDINGS, *IMAGE MAPS* (2D IMAGES THAT CAN BE ATTACHED TO 3D SHAPES) ARE AVAILABLE.

USING A LARGE IMAGE MAP WITH VISUAL VARIATIONS (THEY CAN BE MINUTE, AS LONG AS THEY'RE THERE) HELPS TO REDUCE THIS.

THE THING TO AVOID HERE IS HAVING A SMALL PATTERN THAT OBVIOUSLY REPEATS ACROSS THE BUILDING'S SURFACE.

DON'T FORGET THAT MODELS CAN EASILY BE REPURPOSED. BY CHANGING A BRICK TEXTURE TO STONE BLOCKS, THE CHARACTER OF A BUILDING CAN BE COMPLETELY CHANGED—ENOUGH TO USE IT IN THE BACKGROUND OF A DIFFERENT PANEL, OR A DIFFERENT COMIC.

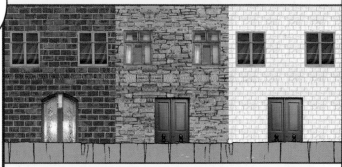

A "STREET" OF INDIVIDUAL BUILDINGS CAN EASILY BE REORDERED TO MAKE A NEW STREET, OR DOORS AND WINDOWS MOVED AROUND TO CREATE NEW BUILDINGS.

AN IMPORTANT POINT IF YOU'RE CREATING YOUR OWN MODELS OF BUILDINGS FOR A STREET SCENE, OR JUST BUILDING INTERIORS, IS THAT EVERY TIME YOU CREATE GROUPS- SUCH AS WINDOW FRAMES—GIVE THEM NAMES.

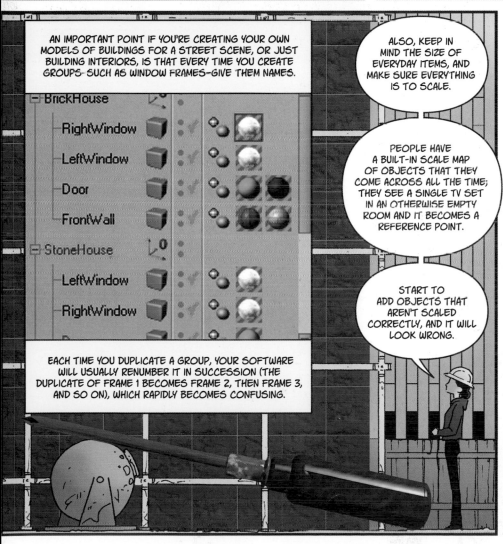

- BrickHouse
 - RightWindow
 - LeftWindow
 - Door
 - FrontWall
- StoneHouse
 - LeftWindow
 - RightWindow

EACH TIME YOU DUPLICATE A GROUP, YOUR SOFTWARE WILL USUALLY RENUMBER IT IN SUCCESSION (THE DUPLICATE OF FRAME 1 BECOMES FRAME 2, THEN FRAME 3, AND SO ON), WHICH RAPIDLY BECOMES CONFUSING.

ALSO, KEEP IN MIND THE SIZE OF EVERYDAY ITEMS, AND MAKE SURE EVERYTHING IS TO SCALE.

PEOPLE HAVE A BUILT-IN SCALE MAP OF OBJECTS THAT THEY COME ACROSS ALL THE TIME; THEY SEE A SINGLE TV SET IN AN OTHERWISE EMPTY ROOM AND IT BECOMES A REFERENCE POINT.

START TO ADD OBJECTS THAT AREN'T SCALED CORRECTLY, AND IT WILL LOOK WRONG.

IT'S ALSO POSSIBLE TO LOOK AT YOUR SCENE FROM DIFFERENT ANGLES OR UNDER DIFFERENT LIGHTING CONDITIONS—FROM EACH CORNER OF A ROOM, FOR INSTANCE, OR AN 180° ROTATION FROM THE CENTER OF THE SCENE.

ONE OF THE BEAUTIES OF USING 3D MODELS IS THAT ONCE THE MODEL IS CREATED, IT CAN BE USED MULTIPLE TIMES FROM MULTIPLE ANGLES WITHOUT HAVING TO REDRAW THE SCENE.

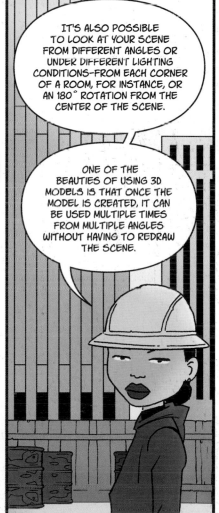

REALISTIC CHARACTERS

GETTING YOUR CHARACTERS TO LOOK REALISTIC IS HALF THE BATTLE WITH 3D.

ALTHOUGH POSER'S FIGURES WILL GIVE YOU A REASONABLE FACSIMILE OF A HUMAN, THE FACIAL FEATURES CAN BE QUITE BASIC AND UNREMARKABLE. HOWEVER, IT'S POSSIBLE TO ADD EXTRA DETAIL THAT WILL BRING EACH OF YOUR CHARACTERS TO LIFE.

THE TWO MAIN WAYS OF ADDING DETAIL TO A FIGURE ARE BY PAINTING THEM ON, OR BY USING A PHOTOGRAPH.

THE PHOTOGRAPH SHOULD EITHER BE A 300 PPI SCAN OF A HIGH-QUALITY ORIGINAL, OR ONE TAKEN BY A DIGITAL CAMERA. AGAIN, SET THE RESOLUTION TO 300 PPI, AS YOU WANT TO KEEP AS MUCH DETAIL AS POSSIBLE.

SAY CHEESE...

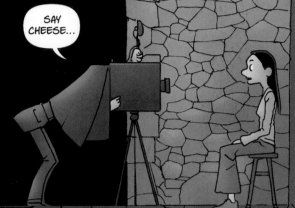

TO INCORPORATE THE NEW TEXTURE, YOU CAN USE THE "UV MAPPING" FUNCTION OF POSER'S FACE ROOM. THIS ONLY WORKS FOR FACES, BUT IT CAN GIVE REALISTIC RESULTS.

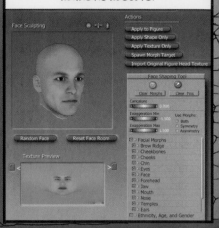

YOU NEED TWO SHOTS OF THE PERSON THAT YOU WANT TO MODEL, ONE STRAIGHT ON, AND ONE PROFILE.

THESE ARE THEN MAPPED ONTO THE 3D HEAD MODEL THAT YOU ARE USING. POSER WILL TRY TO DO THIS AUTOMATICALLY, BUT YOU CAN TWEAK IT LATER IF NECESSARY.

THE RESULT OF THE TWO PHOTOS AND THE 3D MODEL IS A SINGLE UV MAP (UV IS JUST THE COORDINATE SYSTEM, LIKE THE X AND Y OF 2D GRAPHS). BASICALLY, THIS MAP IS THE FLATTENED "SKIN" THAT IS WRAPPED AROUND THE HEAD.

THIS SKIN CAN BE TAKEN INTO AN IMAGE-EDITING APPLICATION, SUCH AS PHOTOSHOP, PAINTED ON, AND THEN BROUGHT BACK INTO POSER AND APPLIED TO THE MODEL.

IF THE SOURCE PHOTOS THAT YOU'RE USING AREN'T GREAT, THEN FIXING THEM TO THE FACE CAN BE A FRUSTRATING VENTURE.

ONE WAY AROUND THIS (AND THE ONLY WAY IN POSER OF CREATING UV MAPS FOR OBJECTS OTHER THAN THE HEAD) IS TO USE A SEPARATE APPLICATION, SUCH AS *UVMAPPER*.

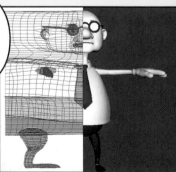

TO USE THIS, MODELS MUST BE EXPORTED FROM POSER AS *WAVEFRONT* OBJ FILES. THESE FILES CAN THEN BE OPENED WITH UVMAPPER, AND THEIR UV MAPS CREATED AT THE CLICK OF A BUTTON.

IN UVMAPPER, YOU CAN ALSO SEPARATE ALL THE BODY PARTS INTO GROUPS, WHICH MAKES IT EASIER TO SELECT INDIVIDUAL PARTS IN PHOTOSHOP.

THE BODY PARTS WILL LOOK DISTORTED, BECAUSE THEY ARE FLATTENED, 2D REPRESENTATIONS OF 3D IMAGES. ONCE YOU'VE IMPORTED YOUR UV MAP INTO PHOTOSHOP, DELETE THE BODY PARTS YOU WON'T NEED.

IF YOU'RE USING A SCANNED-IN IMAGE OR PHOTOGRAPH, OPEN THE FILE AND SELECT WHICHEVER FEATURE YOU WANT TO COPY WITH THE LASSO TOOL.

COPY, AND THEN PASTE THE SELECTION ONTO A NEW LAYER IN YOUR UV MAP FILE. REDUCE THE OPACITY OF THE LAYER SO THAT YOU CAN SEE THE UV MAP THROUGH IT, AND THEN POSITION IT CORRECTLY OVER THE MAP.

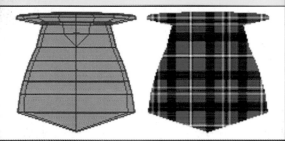

ONCE THE SCALE AND POSITION MATCH AS CLOSELY AS POSSIBLE, RESET THE OPACITY OF THE LAYER TO 100%, FLATTEN THE IMAGE, THEN SAVE IT AND APPLY IT TO YOUR MODEL.

ANOTHER METHOD OF ADDING PHOTO-REALISTIC DETAILING TO BODY PARTS IS TO USE THE TEXTURE SOURCE EDITOR IN BRYCE. EYES, EYELASHES, AND LIPS CAN ALL HAVE TEXTURE, LIGHT, AND SKIN TONE APPLIED-VARYING IT ACCORDING TO THE POSITION ON THE BODY.

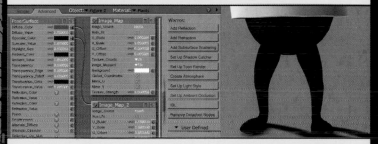

PHOTOSHOP CAN ALSO BE USED TO CREATE THE FINAL TOUCHES-EITHER ON THE UV MAP, OR ON THE FINAL IMAGE ITSELF IF IT'S ONLY GOING TO BE STATIC.

WITH PRACTICE, YOU CAN CREATE FIGURES AS REALISTIC AS YOU WANT-IT'S ALL A MATTER OF HOW MUCH TIME YOU HAVE, AND HOW MUCH DETAIL YOU ACTUALLY NEED.

...AND BE DAZZLED!

CHAPTER 8

WEB COMICS .134

FLASH!. .136

SELF-PUBLISHING .138

PROMOTION AND MARKETING. 140

THE INTERNET FOR SALES AND PROMOTION. . .142

BASIC NETWORKING .144

PITCHING TO A PUBLISHER.146

WEB COMICS

SO, YOU'VE COMPLETED YOUR MAGNUM OPUS. WHAT ARE YOU GOING TO DO WITH IT NOW? WHERE AND HOW DO YOU PUBLISH IT?

ONE OF THE QUICKEST AND EASIEST PLACES TO PUBLISH HAS TO BE THE INTERNET.

MOST E-MAIL ACCOUNTS HAVE A FEW MEGABYTES OF FREE WEB SPACE ALLOTTED TO THEM. YOU MIGHT AS WELL USE IT.

FIRST, YOU NEED TO DECIDE HOW YOU'RE GOING TO DISPLAY YOUR WORK. DO YOU PUBLISH IT A PAGE AT A TIME, OR JUST A SINGLE PANEL AT A TIME?

OBVIOUSLY THAT WILL DEPEND ON HOW YOU DESIGNED THE ORIGINAL PAGES.

IF YOU'VE CREATED A DYNAMIC PAGE WITH PANELS AND DIALOGUE OVERLAPPING EACH OTHER, THERE'S NO WAY YOU'RE GOING TO BREAK IT UP INTO INDIVIDUAL PANELS WITHOUT LOSING THE ORIGINAL EFFECT.

SHOULD IT FIT THE SCREEN –SCALING TO FIT DIFFERENT SCREEN RESOLUTIONS?

OR SHOULD THE READER SCROLL TO SEE IT, IN WHICH CASE, SHOULD IT RUN HORIZONTALLY OR VERTICALLY?

TO RUN THE STORY A PANEL AT A TIME, YOU NEED TO DESIGN IT SPECIFICALLY FOR THAT PURPOSE.

ON THE DARK HORSE WEB SITE, *IAN EDGINTON* AND *D'ISRAELI* –FOLLOWING THEIR SUCCESSFUL *SCARLET TRACES* SERIES–

HAVE ADAPTED H. G. WELLS' ORIGINAL *WAR OF THE WORLDS* NOVEL INTO A WEB COMIC, WITH SEVERAL NEW PAGES EACH WEEK.

HERGÉ'S *TINTIN* BOOKS ALWAYS USED TO HAVE A MINI-CLIFFHANGER AT THE BOTTOM OF EACH DOUBLE-PAGE SPREAD TO ENCOURAGE READERS TO TURN OVER AND KEEP READING.

IF YOU'RE GOING TO PUBLISH A PAGE OF YOUR STORY EACH TIME, YOU MIGHT WANT TO CONSIDER SOMETHING SIMILAR TO ENCOURAGE PEOPLE TO COME BACK FOR THE NEXT EPISODE.

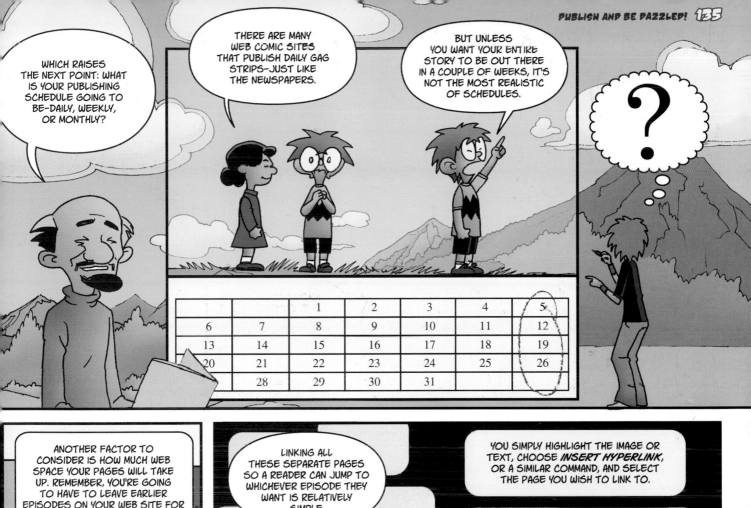
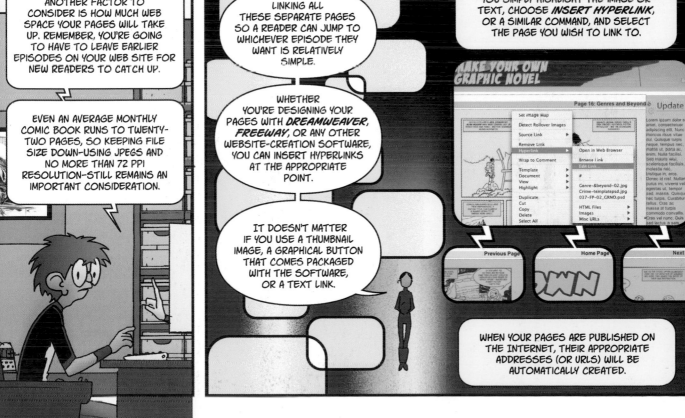

FLASH!

ADOBE *FLASH* HAS BEEN AROUND FOR SOME TIME, AND IS USED FOR CREATING FRONT ENDS, AND ADDING MOVIES, ANIMATION, AND SOUNDS TO WEB SITES.

ITS BIG ATTRACTION IS THAT IT CREATES THESE EFFECTS, BUT KEEPS FILE SIZE DOWN.

WHEN IT FIRST BECAME AVAILABLE, IT WAS COMMON PRACTICE FOR WEB DESIGNERS TO USE JUST ABOUT EVERY TOOL THERE WAS—DANCING TEXT, ANIMATED CARTOONS, AND A CHORUS OF NOISES— BELLS, WHISTLES, AND THE KITCHEN SINK.

THIS GAVE FLASH SOMETHING OF A BAD REPUTATION, BUT IT'S SETTLED DOWN NOW THAT FLASH HAS BECOME MORE MAINSTREAM, AND OVERDOING IT IS CONSIDERED AMATEURISH.

FLASH USES A TIMELINE TO ORGANIZE MATERIAL THAT SHOULD CHANGE INTERMITTENTLY. YOU HAVE FULL CONTROL OVER THIS TIMELINE, SO YOU CAN LET IT RUN AS A SLIDESHOW, OR HAVE BUTTONS FOR THE VIEWER TO CLICK WHEN THEY'RE READY TO MOVE ON.

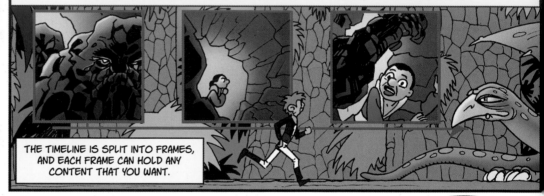

THE TIMELINE IS SPLIT INTO FRAMES, AND EACH FRAME CAN HOLD ANY CONTENT THAT YOU WANT.

IN ITS SIMPLEST FORM, A COMIC CREATED IN FLASH WOULD HAVE A SEPARATE PAGE ON EACH FRAME, AND BUTTONS FOR THE USER TO NAVIGATE BETWEEN PAGES.

THERE'S NO REAL ANIMATION INVOLVED, AND IT WOULD LOOK NO DIFFERENT FROM GOING FROM WEB PAGE TO WEB PAGE.

BOOM!

BOOM!

BOOM!

HOWEVER, FLASH CAN EASILY BE USED TO CREATE FADES, TRANSITIONS, AND OTHER ANIMATIONS BY USING THE SIMPLE TOOLS PROVIDED.

THE TIMELINE IN FLASH CAN HAVE MULTIPLE LAYERS, SO A PAGE ON ONE LAYER CAN BE FADING OUT AS THE PAGE ON ANOTHER LAYER FADES IN.

ALTERNATIVELY, YOU CAN REALLY BRING YOUR PAGES ALIVE AND ANIMATE CERTAIN ELEMENTS OF THE COMIC WHILE THE VIEWER IS READING IT.

THE REAL POWER OF FLASH COMES WITH ITS BUILT-IN SCRIPTING LANGUAGE: *ACTIONSCRIPT*.

WITH THIS, YOU CAN CREATE ALMOST ANYTHING YOU CAN THINK OF...

...AS LONG AS YOUR CODING SKILLS ARE UP TO IT.

IT'S A FAIRLY SIMPLE MATTER, THOUGH, TO SET UP FLASH TO DYNAMICALLY LOAD IMAGES FROM YOUR WEB SITE SO THAT YOU DON'T HAVE TO CREATE ENTIRELY NEW WEB PAGES EVERY TIME YOU WANT TO UPLOAD A NEW PIECE OF YOUR COMIC.

YOU COULD ALSO ADD SOUNDS, OR INTERACTIVITY TO YOUR COMIC.

INSTEAD OF A DRAWN "BANG!" EFFECT WHEN A BOMB EXPLODES, THE VIEWER COULD CLICK ON THE BOMB TO SEE AN ANIMATED EFFECT (EVEN IF IT'S JUST THE WORD "BANG" EXPLODING) ACCOMPANIED BY A REAL SOUND.

LOADING...

ONE THING TO REMEMBER IF YOU DO USE SOUNDS, THOUGH, IS THAT THEY CAN ADD QUITE SUBSTANTIALLY TO THE SIZE OF YOUR FLASH FILE, MEANING LONG DOWNLOADS FOR VIEWERS WITH SLOW CONNECTION SPEEDS.

WHEN YOU FINALLY COME TO SAVE YOUR FLASH MOVIE FOR THE INTERNET, YOU CAN EITHER ADD IT STRAIGHT INTO YOUR PAGE IN DREAMWEAVER OR SIMILAR SOFTWARE, OR USE FLASH'S *PUBLISH* COMMAND TO AUTOMATICALLY CREATE AN HTML PAGE WITH THE MOVIE EMBEDDED IN IT, READY TO BE UPLOADED TO YOUR WEB SITE.

TICK TOCK TICK TOCK TICK TOCK TICK

THE ADVANTAGE OF THIS METHOD IS THAT THE PAGE CONTAINS CODE–SO THAT IF THE VIEWER'S WEB BROWSER DOESN'T HAVE THE FLASH PLAYER BUILT-IN, SHE IS PROMPTED TO VISIT THE MACROMEDIA WEB SITE AND DOWNLOAD IT.

TOCK
TICK
TOCK
TICK

BOOOM

SELF-PUBLISHING

ANOTHER OPTION IS SELF-PUBLISHING.

THIS IS NOT TO BE CONFUSED WITH SO-CALLED *VANITY PUBLISHING*, WHERE A COMPANY OFFERS TO PUBLISH YOUR WORK—JUST SO LONG AS YOU PAY FOR IT TO BE DONE.

GOLDEN RULE: NEVER PAY SOMEONE ELSE TO PUBLISH YOUR WORK!

HAVING SAID THAT, SELF-PUBLISHING IS STILL COMING OUT OF YOUR POCKET.

IF YOU CAN'T AFFORD TO LOSE THAT MONEY, EITHER PUBLISH ON THE WEB, OR TRY TO GET SOMEONE ELSE TO PAY FOR IT.

FIRST OFF, YOU'RE GOING TO NEED TO FIND A PRINTER. THEY'RE PROBABLY GOING TO BE THE MOST EXPENSIVE PART OF THE ENTERPRISE, SO LOOK AROUND.

TAKE AN EXAMPLE OF THE KIND OF THING THAT YOU WANT TO MAKE TO SEVERAL PRINTERS, AND ASK HOW MUCH THEY'D CHARGE TO PRINT IT.

REMEMBER, BLACK-AND-WHITE PRINTING IS GOING TO BE A WHOLE LOT CHEAPER THAN COLOR.

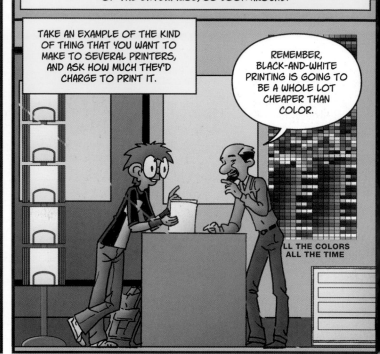

...LL THE COLORS ALL THE TIME

ASK HOW THEY'D LIKE THE ORIGINAL MATERIAL DELIVERED.

IT GOES WITHOUT SAYING THAT YOU DON'T WANT TO HAND OVER 50 FOUR-COLOR ORIGINALS AT TWICE THE FINAL PRINTED SIZE TO A PRINTER, EVEN IF THEY WOULD ACCEPT THEM.

THEY'LL WANT THEM ON A DISC IN AN APPROPRIATE FORMAT: USUALLY A TIFF, PDF, OR A POSTSCRIPT FILE.

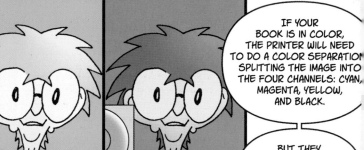

IF YOUR BOOK IS IN COLOR, THE PRINTER WILL NEED TO DO A COLOR SEPARATION SPLITTING THE IMAGE INTO THE FOUR CHANNELS: CYAN, MAGENTA, YELLOW, AND BLACK.

BUT THEY SHOULD BE ABLE TO TELL YOU EVERYTHING THEY'LL NEED FROM YOU IN ORDER TO DO THIS.

ONCE YOU'VE HAD YOUR BOOK PRINTED AND DELIVERED, YOU NEED TO SELL IT.

THANKFULLY, COMICS ARE IN THE ALMOST UNIQUE POSITION OF HAVING SPECIAL OUTLETS (THERE ARE ALSO A FEW SPECIALIZED SF, HORROR, AND FANTASY BOOKSHOPS), AND MANY TOWNS NOWADAYS HAVE THEIR OWN COMIC SHOP.

Roll-up! Roll-up!
LOS BROS
author
signing today

EVEN LARGE CHAIN STORES WILL SOMETIMES STOCK YOUR WORK IF YOU'RE A LOCAL AUTHOR, THOUGH IT'S LIKELY TO ONLY BE STOCKED IN THAT ONE STORE, NOT THROUGHOUT THE CHAIN.

Fantasy Graphic Novels

Local Author Kevin Siegel

MANY COMIC STORES ALSO SELL THROUGH MAIL ORDER, AND OVER THE INTERNET.

BY STARTING WITH YOUR LOCAL COMIC STORE AND THEN CONTACTING OTHERS, YOU CAN PERSUADE MORE STORES TO STOCK YOUR BOOK.

NEARLY ALL STORES WILL STOCK ON SALE OR RETURN (SOR), MEANING THAT THEY CAN GIVE YOU BACK THE STOCK THAT DIDN'T SELL. THEY'LL ALL WANT A PROPER DISCOUNT, TOO—ANYTHING UP TO 60%—SO YOU SHOULD ALLOW FOR THAT IN YOUR COVER PRICE. YOU WANT TO AT LEAST GET YOUR PRINTING COSTS BACK!

THEN THERE'S SELLING THROUGH INTERNET SITES, LIKE AMAZON AND EBAY.

BUT IF YOU WANT TO SET UP AN ON-LINE STORE WITH THEM, YOU MAY FIND THAT THERE ARE HIDDEN CHARGES, SUCH AS MONTHLY SUBSCRIPTIONS TO KEEP YOUR ITEM VISIBLE ON THE SITE.

YOU MAY BE LUCKY ENOUGH TO FIND A DISTRIBUTOR –A COMPANY OR INDIVIDUAL WHO'LL GET YOUR BOOK INTO STORES COUNTRYWIDE.

IF YOU'RE ONLY TRYING TO SELL A FEW COPIES, YOU WON'T HAVE TO PAY ANYTHING OTHER THAN A SMALL FEE FOR EACH SALE.

THERE ARE SMALL DISTRIBUTORS WHO DEAL PRIMARILY WITH THE SO-CALLED SMALL PRESS: SMALL PUBLISHERS WITHOUT THE RESOURCES OF THE BIG COMPANIES. AGAIN, YOU'LL HAVE TO ARRANGE DISCOUNTS, AND BE AWARE THAT SUCH BUSINESSES ALSO HAVE A HABIT OF GOING BROKE WITHOUT WARNING.

PROMOTION AND MARKETING

ONCE YOU HAVE YOUR BOOK READY TO SELL, HOW DO YOU LET PEOPLE KNOW ABOUT IT? A PUBLISHER WILL TAKE CARE OF ALL THE PROMOTIONAL DETAILS; BUT IF YOU'RE SELF-PUBLISHING, IT'S UP TO YOU. SO, HOW DO YOU GO ABOUT IT?

OBVIOUSLY, YOU NEED TO LET PEOPLE KNOW WHAT YOUR BOOK IS ABOUT, WHEN IT'S AVAILABLE, WHERE IT CAN BE BOUGHT, AND HOW MUCH IT WILL COST.

THERE ARE TWO FUNDAMENTAL METHODS FOR GETTING ALL OF THE PROMOTION AND ADVERTISING DONE: *PUBLIC RELATIONS (PR)*, AND *MARKETING*. THE DIFFERENCE BETWEEN THE TWO IS DOWN TO MONEY.

BASICALLY, MARKETING IS ALL ABOUT SPENDING MONEY, WHICH IS FINE IF YOU HAVE IT.

WITH A BUDGET YOU CAN BUY ADVERTISING SPACE IN EVERYTHING FROM MAGAZINES AND NEWSPAPERS TO WEB SITES.

THE COSTS CAN VARY WIDELY, DEPENDING ON HOW BIG AN ADVERTISEMENT YOU WANT TO PLACE, AND WHERE YOU WANT TO PUT IT.

THE ADVANTAGE IS TOTAL CONTROL. YOU DECIDE WHEN AND WHERE THE AD APPEARS AND EXACTLY WHAT IT SAYS.

BUT WHAT IF YOU DON'T HAVE ENOUGH MONEY TO DO THIS?

THAT'S WHERE MARKETING'S POORER COUSIN, PR, COMES IN.

PR IS ESSENTIALLY ALL ABOUT GETTING THE MESSAGE OUT THERE AND HOPING THAT AS MANY PEOPLE AS POSSIBLE WILL SPREAD THE WORD.

YUMI

THE DISADVANTAGE IS THAT IT'S ENTIRELY DOWN TO YOU TO GET THE BALL ROLLING. YOU CAN HIRE A PR SPECIALIST— BUT, AGAIN, IT TAKES MONEY.

THE CHEAPEST AND MOST OBVIOUS ANSWER TO SPREADING THE NEWS IS TO USE THE INTERNET AND E-MAIL.

WE'LL LOOK AT USING THE INTERNET AS A PROMOTIONAL TOOL SHORTLY, BUT CREATING A LIST OF ADDRESSES FOR E-MAIL SHOTS IS MORE DIRECT.

YOU CAN SEND OUT PROMOTIONAL MATERIAL STRAIGHT TO THOSE YOU FEEL ARE MOST LIKELY TO BE INTERESTED.

YOU CAN ALSO ASK THOSE YOU E-MAIL TO PASS ON THE INFORMATION TO THEIR FRIENDS. THIS IS KNOWN AS "VIRAL MARKETING"—ESSENTIALLY, ELECTRONIC WORD OF MOUTH.

GETTING PEOPLE TO TALK ABOUT YOUR BOOK (IN A GOOD WAY, HOPEFULLY!), AND GENERATING INTEREST QUICKLY AND CHEAPLY—

THE FASTEST WAY TO DO THAT IS TO OFFER SOMETHING FOR NOTHING.

COMPETITIONS ARE ALWAYS A GOOD IDEA. OFFER 10 COPIES OF YOUR BOOK TO THE FIRST 10 CORRECT ANSWERS TO A QUIZ. THIS CAN BE DONE WITH EITHER A PRINT OR ONLINE PUBLICATION.

WHAT IS THE NAME OF THE WERESPARROW IN ISSUE 6 OF "LOS BROS?"

YOU'LL ALSO NEED TO CREATE A PRESS RELEASE THAT TELLS EDITORS AND REPORTERS EVERYTHING THEY NEED TO KNOW ABOUT YOUR BOOK.

OFTEN IT'S GOOD TO TRY TO MAKE THIS TOPICAL AND RELEVANT TO THE SPECIFIC EDITOR. FOR EXAMPLE, IF YOU ARE SENDING IT TO YOUR REGIONAL PAPER, PLAY UP THE ANGLE THAT YOU ARE A LOCAL AUTHOR/ARTIST.

The Fisherman's Times

IT'S MILLER TIME!

Jonathan Miller on his new graphic novel and fly-fishing as a source of inspiration.

ALSO, TRY TO THINK LATERALLY BY APPROACHING NON-COMICS PUBLICATIONS—IF YOUR GRAPHIC NOVEL FEATURES A LOT OF FLY-FISHING, SEND A COPY TO THE FISHERMAN'S TIMES.

QUIRKY AND UNUSUAL PRESS RELEASES ARE FAR MORE LIKELY TO GENERATE A STORY THAN A BORING, "HERE'S MY BOOK, CAN YOU REVIEW IT PLEASE?"

SIMPLE FLYERS AND POSTERS ARE ALSO A GOOD WAY OF SPREADING THE WORD, BUT MAKE SURE IT'S OK TO DISTRIBUTE THEM—YOU DON'T WANT TO ANGER SHOPS BY DUMPING 1,000 LEAFLETS ON THEM!

IF YOU HAVE THE BUDGET, T-SHIRTS, BADGES, AND STICKERS ARE OTHER GOOD WAYS OF CREATING A "BUZZ" ABOUT YOUR BOOK.

CREATING YOUR OWN PROMOTIONAL MATERIAL ISN'T DIFFICULT; PRODUCTS SUCH AS MICROSOFT *PUBLISHER* COME WITH A WHOLE COLLECTION OF PRE-LOADED TEMPLATES THAT CAN BE MODIFIED TO SUIT.

REVENGE of the weresparrow

A Miller Siegel production

IF YOU WANT TO CREATE YOUR OWN MATERIAL FROM SCRATCH, THE INDUSTRY-STANDARD PROGRAMS ARE *INDESIGN* AND *QUARKXPRESS*, BUT YOU CAN ALSO USE PHOTOSHOP OR WORD TO CREATE SIMPLE LAYOUTS.

WHEN DECIDING ON A COVER PRICE, YOU'LL NEED TO FACTOR IN THE COST OF ALL YOUR MARKETING AND THOSE FREE REVIEW COPIES YOU'LL BE SENDING OUT TO BOTH PRINT AND WEB MAGAZINES (AND COMPETITION COPIES, TOO).

Printing Costs
+
Marketing Budget
÷
the number of issues available (excluding promotional and competition copies)
+
a sum to cover distributor's and retailer's percentages
+
Profit

= cover price

IF, FOR EXAMPLE, A PRINT RUN OF 500 COSTS $1,000, AND YOU'RE PUTTING ASIDE 100 COPIES FOR PROMOTIONAL PURPOSES, THE REMAINING BOOKS WILL HAVE TO BE PRICED AT $2.50—JUST TO GET YOUR MONEY BACK.

AND DON'T JUST STICK TO MAGAZINES OR WEB SITES: YOU WANT TO REACH THE WIDEST AUDIENCE POSSIBLE.

THINK BIG!

KEEP UP WITH WORLD AND LOCAL NEWS AND SEE IF THERE IS ANYTHING RELEVANT THAT YOU CAN LINK YOUR GRAPHIC NOVEL TO, THEN CREATE AN INTERESTING NEWS STORY FOR LOCAL RADIO AND TELEVISION STATIONS.

THE INTERNET FOR SALES AND PROMOTION

YOU CAN, OF COURSE, SELL YOUR GRAPHIC NOVEL FROM YOUR OWN WEB SITE, OR AT LEAST USE THE SITE AS AN ADVERTISING TOOL. EITHER WAY, FIRST YOU NEED TO ATTRACT BUYERS' ATTENTION.

A WELL-DESIGNED WEB SITE IS HALF THE BATTLE: ONE THAT LOOKS SMART, PROFESSIONAL, AND WELL THOUGHT-OUT.

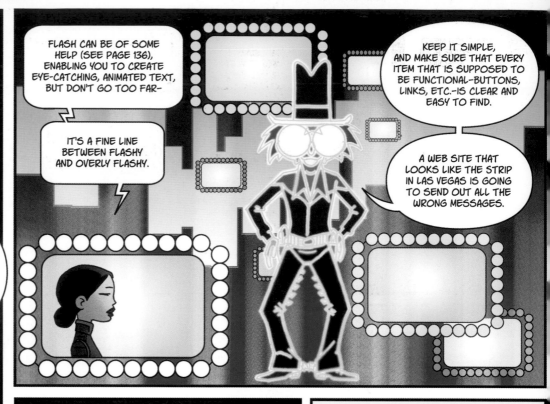

FLASH CAN BE OF SOME HELP (SEE PAGE 136), ENABLING YOU TO CREATE EYE-CATCHING, ANIMATED TEXT, BUT DON'T GO TOO FAR—

IT'S A FINE LINE BETWEEN FLASHY AND OVERLY FLASHY.

KEEP IT SIMPLE, AND MAKE SURE THAT EVERY ITEM THAT IS SUPPOSED TO BE FUNCTIONAL—BUTTONS, LINKS, ETC.—IS CLEAR AND EASY TO FIND.

A WEB SITE THAT LOOKS LIKE THE STRIP IN LAS VEGAS IS GOING TO SEND OUT ALL THE WRONG MESSAGES.

A MAIN INDEX PAGE IS BEST, WITH ALL THE OTHER PAGES OF YOUR SITE CLEARLY MARKED, AND LINKED.

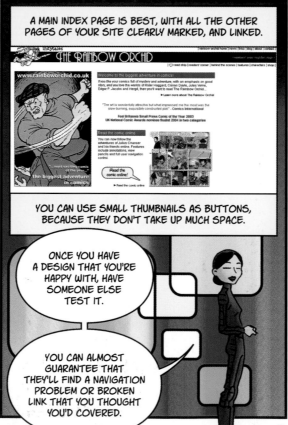

YOU CAN USE SMALL THUMBNAILS AS BUTTONS, BECAUSE THEY DON'T TAKE UP MUCH SPACE.

ONCE YOU HAVE A DESIGN THAT YOU'RE HAPPY WITH, HAVE SOMEONE ELSE TEST IT.

YOU CAN ALMOST GUARANTEE THAT THEY'LL FIND A NAVIGATION PROBLEM OR BROKEN LINK THAT YOU THOUGHT YOU'D COVERED.

ONCE YOUR POTENTIAL CUSTOMERS HAVE NAVIGATED TO YOUR SALES PAGE, THEY SHOULD GET A CONCISE AND OVERALL SENSE OF WHAT YOU'RE SELLING.

A SMALL IMAGE OF THE COVER, A PRÉCIS OF THE PLOT—NOT ENOUGH TO GIVE ANYTHING AWAY, JUST TO WHET THEIR APPETITE—THE PAGE COUNT, AND PRICE.

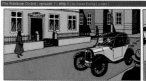

IT'S ALSO A GOOD IDEA TO HAVE A COUPLE OF FULL-PAGE EXAMPLES—ACCESSIBLE BY CLICKING ON THE COVER, FOR INSTANCE—TO GIVE THEM ANOTHER TASTE.

NEXT YOU NEED TO DECIDE HOW YOU'RE GOING TO SELL.

IF YOU'RE GOING TO DO IT SIMPLY THROUGH MAIL ORDER, YOU SHOULD PROVIDE SOMETHING LIKE A PRINTABLE ORDER FORM THAT THEY CAN FILL OUT AND MAIL-ALONG WITH THEIR CHECK.

ON THE OTHER HAND, ORDERING DIRECTLY FROM THE INTERNET IS BECOMING WIDELY ACCEPTED, AND QUITE A FEW BUYERS SEEM TO PREFER IT.

FOR THIS, YOU NEED TO SET UP SOME KIND OF ACCOUNT THROUGH WHICH THEY CAN ORDER FROM YOU USING THEIR CREDIT CARD. *PAYPAL* IS A POPULAR EXAMPLE OF THIS KIND OF ON-LINE COMMERCE.

IF YOU SET UP A BUSINESS ACCOUNT WITH THEM, YOU WILL BE ABLE TO SPECIFY EXACTLY WHAT YOU WANT TO SELL: THE TITLE OF THE COMIC, THE COST, AND SO ON.

ALL TRANSACTIONS GO THROUGH *PAYPAL*, AND THE MONEY CAN THEN BE TRANSFERRED DIRECTLY INTO YOUR BANK ACCOUNT.

$ PAYPAL PASSES ON THE CUSTOMER'S DETAILS TO YOU, AND YOU MAIL THE CUSTOMER YOUR BOOK DIRECTLY.

 THE ONLY DOWNSIDE TO ALL OF THIS IS THAT PAYPAL CHARGES A SMALL COMMISSION FEE, BUT IT'S WORTH IT FOR THE HASSLE IT SAVES YOU, AND THE SECURITY THAT IT OFFERS YOUR CUSTOMERS.

FINALLY, YOU NEED TO GET YOUR WEB SITE LINKED TO AS MANY SITES WITH SIMILAR INTERESTS AS YOU CAN. THAT WAY, INTERESTED PARTIES CAN BE GUIDED YOUR WAY.

IT SHOULD GO WITHOUT SAYING THAT AS A PROFESSIONAL COURTESY, ANY SITE WITH A LINK TO YOURS SHOULD HAVE A RECIPROCAL ONE PLACED ON YOUR OWN SITE.

The "Create Your Own Graphic Novel" web-ring

IT CAN ALSO BE WORTH JOINING A WEB-RING–ESSENTIALLY A CHAIN OF LINKED WEB SITES THAT SHARE A COMMON THEME.

THE UPSIDE OF THIS IS THAT IT OFFERS VISITORS ANOTHER WAY TO REACH YOUR SITE.

THE DOWNSIDE IS THAT SOME WEB-RINGS CAN APPEAR A LITTLE UNPROFESSIONAL, AND YOU MAY NOT WANT TO BE LINKED TO SOME OF THE SITES ON THEM.

BASIC NETWORKING

YOU CAN'T BEAT A LITTLE NETWORKING: GETTING TO KNOW PEOPLE, LETTING THEM GET TO KNOW YOU. YOU CAN'T PRODUCE ANYTHING IN A VACUUM—

AT SOME POINT YOU'RE GOING TO HAVE TO GET OUT THERE AND MINGLE!

THE MOST OBVIOUS PLACE TO DO THIS IS AT A COMICS CONVENTION.

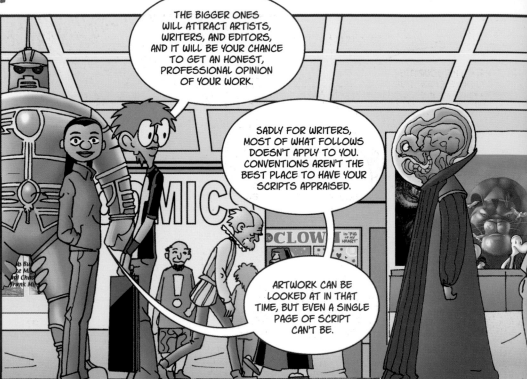

THE BIGGER ONES WILL ATTRACT ARTISTS, WRITERS, AND EDITORS, AND IT WILL BE YOUR CHANCE TO GET AN HONEST, PROFESSIONAL OPINION OF YOUR WORK.

SADLY FOR WRITERS, MOST OF WHAT FOLLOWS DOESN'T APPLY TO YOU. CONVENTIONS AREN'T THE BEST PLACE TO HAVE YOUR SCRIPTS APPRAISED.

ARTWORK CAN BE LOOKED AT IN THAT TIME, BUT EVEN A SINGLE PAGE OF SCRIPT CAN'T BE.

HOWEVER, IF THEY THINK YOU'VE GOT A CHANCE, IT'S TIME TO GET IN LINE WITH ALL THOSE OTHER HOPEFULS WHO ARE AFTER THE SAME JOB AS YOU!

BEFORE YOU EVEN CONSIDER GETTING IN LINE TO TALK WITH AN EDITOR, THOUGH, SEEK OUT THE PROFESSIONAL ARTISTS AT THE CONVENTION.

MOST PROFESSIONAL ARTISTS WILL BE ABLE TO FIND THE TIME TO HAVE A LOOK AT YOUR PORTFOLIO, AND THEY WILL BE FAIR. IF THEY THINK IT'S NOT GOING TO FLY, THEY'LL TELL YOU.

THE WORLD OF COMICS IS A COMPETITIVE BUSINESS, AND THERE ARE A DOZEN ARTISTS FOR ANY ONE JOB (THAT'S TRUE FOR WRITERS, TOO).

SO—

HAVE THE COURTESY TO MAKE SURE YOUR PORTFOLIO IS IN SOME KIND OF ORDER, WITH ARTWORK CLEARLY DISPLAYED AND TIDY. YOU DON'T WANT LOOSE SHEETS FALLING ALL OVER THE FLOOR.

ONLY BRING YOUR LATEST AND BEST MATERIAL. EDITORS WON'T WANT TO SEE HOW YOU'VE DEVELOPED OVER THE PAST FIVE YEARS.

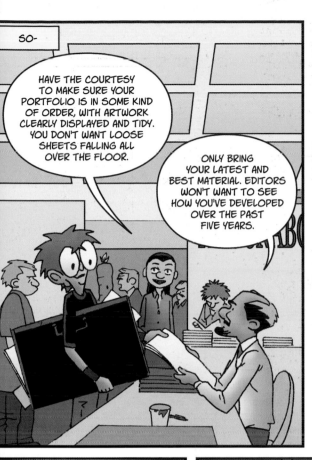

SHOW SEQUENTIAL ARTWORK, NOT ILLUSTRATIONS OR SPLASH PAGES.

EDITORS WANT TO SEE IF YOU CAN TELL A STORY WITHOUT WORDS.

TRY TO HAVE A VARIETY OF STYLES, BECAUSE IT SHOWS THAT YOU ARE FLEXIBLE, AND YOU ARE MORE LIKELY TO GET WORK IF EDITORS ARE LOOKING FOR A PARTICULAR STYLE AND ONE OF YOUR PIECES FITS IT.

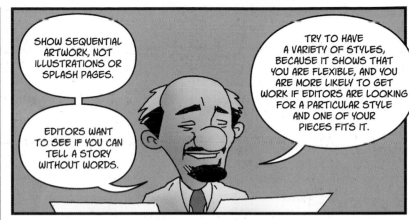

DON'T TRY TO EXPLAIN YOUR WORK OR APOLOGIZE FOR IT.

LET THE ART SPEAK FOR YOU.

IF IT'S GOOD THEY'LL GET IT; IF YOU DON'T THINK IT'S THE BEST, WHY SHOULD THEY?

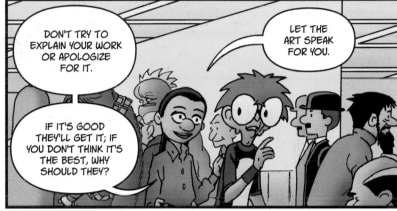

BE PROFESSIONAL—DON'T BE TOO ARROGANT, NOR TOO MODEST, JUST BE YOURSELF.

PAY ATTENTION TO THE ADVICE EDITORS GIVE YOU— THEY WANT TO HELP YOU IMPROVE.

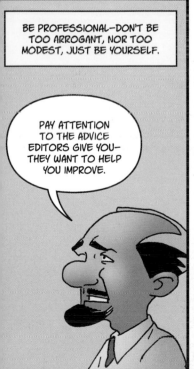

FINALLY, DON'T FEEL TOO BAD IF YOU GET REJECTED.

EDITORS ARE INDIVIDUALS WITH DIFFERENT TASTES, SO JUST BECAUSE IT ISN'T WHAT ONE PERSON IS LOOKING FOR DOESN'T MEAN IT'S THE SAME FOR EVERY COMPANY.

TRY AGAIN AT OTHER CONS, WITH OTHER EDITORS.

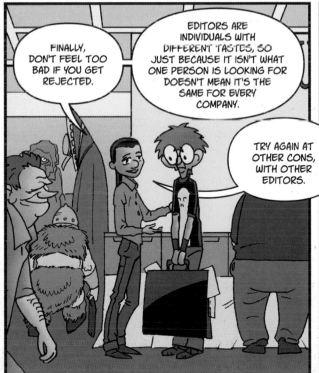

THE IMPORTANT THING IS THAT YOU'VE MADE CONTACT; NOW YOU'RE MORE THAN JUST A NAME.

PITCHING TO A PUBLISHER

WRITERS ARE MOST LIKELY TO BE NOTICED IF THEY APPROACH THE PUBLISHERS DIRECTLY, BUT BEFORE YOU SEND A SINGLE WORD OR EXAMPLE, TAKE A GOOD HARD LOOK AT THE PUBLISHERS' WEB SITES.

ALL OF THEM HAVE A SECTION ON SUBMISSION GUIDELINES THAT WILL TELL YOU EXACTLY WHAT THEY'RE LOOKING FOR.

FIRST, THEY'LL EXPECT YOU TO ENCLOSE AN IDEAS SUBMISSION FORM, SUBMISSION AGREEMENT, OR SOMETHING SIMILAR.

Mexican Brothers, Inc.
Submissions Form

I, Kevin Siegel, hereby agree to the following terms and conditions:

1. Mexican Brothers, Inc are continuously coming up with new ideas for stories and artwork, and these may be similar to the material supplied by you. You agree that you will not claim compensation if Mexican Brothers, Inc publish similar material in future.

2. You swear that you are the sole creator of the material. And that all legal rights

THESE FORMS— DOWNLOADABLE FROM THEIR WEB SITES—ARE DESIGNED TO CLEARLY MARK OUT THE RELATIONSHIP BETWEEN YOU (WHETHER WRITER OR ARTIST) AND THE COMPANY.

THEY'RE A KIND OF PRE-CONTRACT, WHERE YOU ACKNOWLEDGE THAT THE COMPANY HAS NO LIABILITY FOR IDEAS GENERATED IN-HOUSE THAT MAY RESEMBLE ANYTHING YOU SUBMIT.

IT'S NOT A LICENSE FOR THE BIG GUYS TO RIP YOU OFF, BUT TO PROTECT THEM AGAINST LATER CLAIMS.

ANY NEW IDEAS SUBMITTED WITHOUT ONE WILL GET JUNKED WITHOUT BEING SO MUCH AS GLANCED AT.

YOU ALSO NEED TO CHECK IF THE PUBLISHER IS ACTUALLY LOOKING FOR NEW WORK.

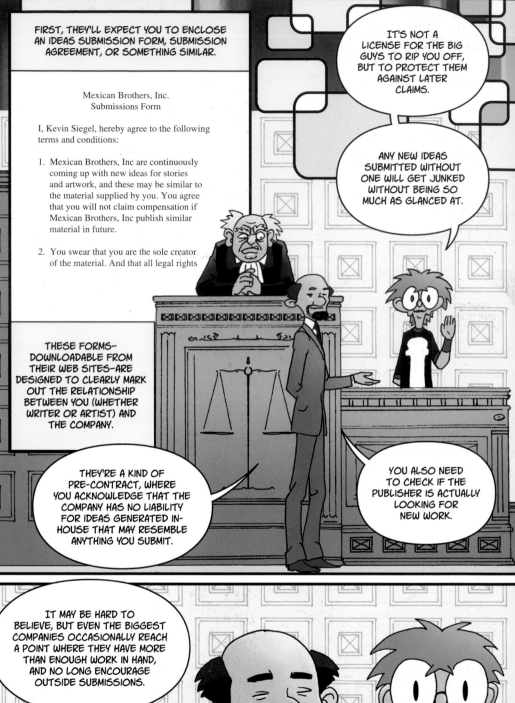

IT MAY BE HARD TO BELIEVE, BUT EVEN THE BIGGEST COMPANIES OCCASIONALLY REACH A POINT WHERE THEY HAVE MORE THAN ENOUGH WORK IN HAND, AND NO LONG ENCOURAGE OUTSIDE SUBMISSIONS.

YOUR FANTASTIC NEW CONCEPT WILL JUST HAVE TO FIND A HOME ELSEWHERE.

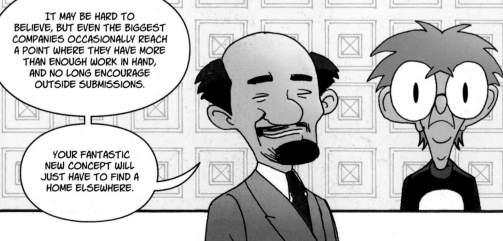

AND FINALLY, YOU'LL WANT TO BE SURE THAT YOU'RE SENDING THEM WHAT THEY WANT TO SEE.

IF THE COMPANY WON'T READ ANY UNSOLICITED SCRIPTS OR SYNOPSES, IT'S KIND OF POINTLESS SENDING THEM.

UNSOLICITED SCRIPTS

IT MAY BE THAT THEY'RE MORE INTERESTED IN YOUR PAST WRITING EXPERIENCE THAN YOUR CURRENT WORK, SO DETAIL IT IN AN INTRODUCTORY LETTER THAT ALSO SAYS WHY YOU WANT TO WRITE FOR THEM.

IF YOU INTEREST THEM, THEY MAY SEND FOR SOME EXAMPLES.

IF THEY'RE PREPARED TO CONSIDER UNSOLICITED WORK, CHECK WHETHER THEY WANT TO SEE JUST A SYNOPSIS, OR BOTH SYNOPSIS AND COMPLETED SCRIPT (ESPECIALLY IF YOU'RE WRITING A ONE-SHOT ISSUE), OR SYNOPSIS AND THE FIRST SEVERAL PAGES OF A PROJECTED SERIES.

WOULD YOU LIKE A SCRIPT TO GO WITH THAT?

IF YOU'RE ALREADY A PUBLISHED WRITER, YOU MIGHT BE ABLE TO GET AWAY WITH THE SYNOPSIS AND EXAMPLES OF PUBLISHED WORK.

FOR A GOOD EXAMPLE OF HOW TO PITCH A SHORT SERIES, ROB WILLIAMS + SIMON FRASER'S *FAMILY*—A MINI-SERIES ORIGINALLY PUBLISHED IN THE BRITISH COMIC *JUDGE DREDD: MEGAZINE* AND COLLECTED INTO ONE VOLUME BY REBELLION IN 2005—PRINTS WRITER ROB WILLIAMS' ORIGINAL PITCH FOR ALL SEVEN EPISODES IN THE BACK.

IT DEMONSTRATES HOW TO PRESENT A LIVELY SYNOPSIS, CLEARLY BROKEN DOWN INTO THE VARIOUS EPISODES...

...PUNCTUATING THE TEXT WITH OCCASIONAL LINES OF DIALOGUE TO GIVE A TRUE FEELING OF HOW THE WRITER SEES THE STORY.

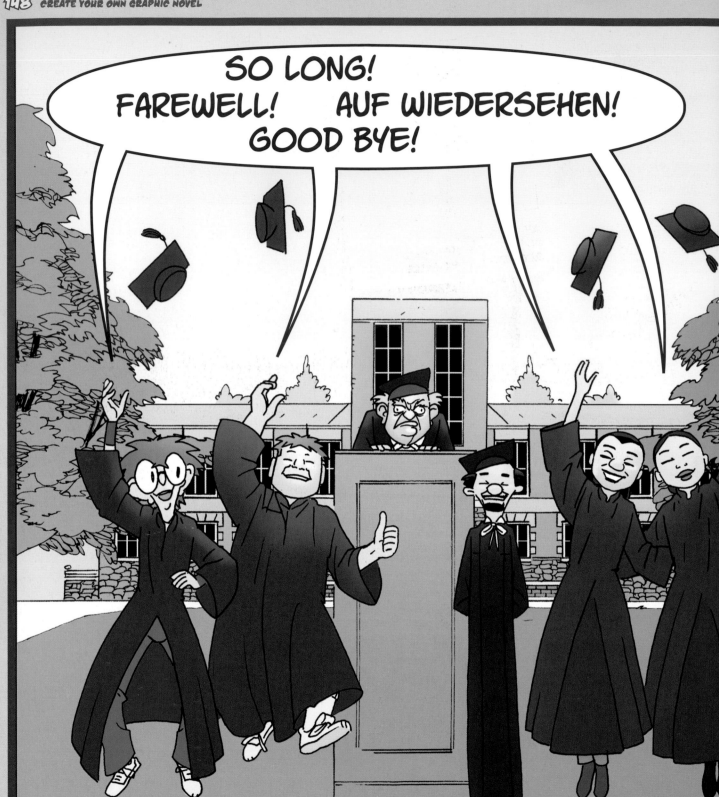

2011: GRADUATED MIT
2015: CREATED LOW-GRAVITY PENCIL
2020: DREW FIRST COMIC IN SPACE

2008-13: DREW ISSUES 1-88 OF LOS BROS
2015: LOS BROS FILM RELEASED BY MIRAMAX
2020: BOUGHT A COMIC STORE IN NANTUCKET

2008-PRESENT: LEAD WRITER ON LOS BROS
2015: LOS BROS FILM RELEASED BY MIRAMAX
2016: DISAPPEARED FROM PUBLIC EYE

2010: FOUNDED GLOBALNOV PUBLISHING
2015: BROKERED LOS BROS FILM DEAL
2020: SOLD GLOBALNOV, BOUGHT PLANET

RESOURCES

BOOKS . 150
ORGANIZATIONS + JOURNALS152
ONLINE RESOURCES. .154

BOOKS

THERE'S AN AWFUL LOT OF READING MATTER AVAILABLE TODAY. GRAPHIC NOVELS, AND THE WHOLE COMICS BUSINESS, ARE NOW JABBING SO HARD AT THE PUBLIC CONSCIOUSNESS THAT PUBLISHERS JUST HAVE TO RESPOND. FROM WILL EISNER'S SEMINAL *COMICS AND SEQUENTIAL ART*—CONSIDERED BY MANY TO BE ONE OF THE MOST IMPORTANT WORKS ON GRAPHIC NOVELS—TO DEZ SKINN'S *COMIX: THE UNDERGROUND REVOLUTION*, THERE ARE BOOKS OUT THERE THAT WILL GIVE YOU EVERYTHING FROM THE HISTORY OF COMICS, TO HOW TO DRAW, WRITE, AND SELL THEM.

MARVEL AND DC HAVE PUBLISHED THEIR OWN GUIDES TO CREATING GRAPHIC NOVELS, AND IT'S WORTH TAKING A LOOK AT THEM, EVEN IF YOU NEVER INTEND TO APPROACH THEM. IF THE GUYS WORKING FOR THE WORLD'S BIGGEST COMICS PUBLISHERS DON'T HAVE A FEW GOOD TIPS, THEN WHO DOES? DARK HORSE HAS ALSO PUBLISHED A GUIDE TO WRITING COMIC BOOKS.

YOU'LL FIND THAT THERE ARE ALSO MANY BOOKS BY WRITERS GIVING THEIR VIEWS ON WRITING, AND ARTISTS GIVING THEIR VIEWS ON COMIC ART. YOU CAN EVEN FIND BOOKS ON COMICS TRADITIONS FROM DIFFERENT GEOGRAPHIES AND CULTURES—SUCH AS A. DOUGLAS' *ARAB COMIC STRIPS*. THERE ARE TITLES AVAILABLE ON SPECIFIC SUBJECTS AND STYLES, TOO—SUCH AS MANGA AND ANIMATION, IF YOU'RE INTERESTED.

AND IT MIGHT NOT BE SUCH A BAD IDEA LOOKING UP SOME OF THE MORE GENERAL WRITING GUIDES THAT ARE AVAILABLE, THOSE THAT TELL YOU SIMPLY HOW TO WRITE IN SPECIFIC GENRES. THEY'LL HELP YOU GET A FEEL FOR GENRE EXPECTATIONS, AND ILLUSTRATE HOW TO COME UP WITH A GOOD STORYLINE BEFORE YOU START WORRYING ABOUT BREAKING IT DOWN INTO A SCRIPT!

ANZOVIN, STEVE + ANZOVIN, RAF.
 3D TOONS.
 BARRON'S EDUCATIONAL SERIES, INC 2005

BURROWS, TOBY + STONE, GRANT.
 COMICS IN AUSTRALIA AND NEW ZEALAND:
 THE COLLECTIONS, THE COLLECTORS, THE CREATORS.
 HAWORTH PRESS INC. U.S. 1994.

CHELSEA, DAVID.
 PERSPECTIVE! FOR COMIC BOOK ARTISTS.
 WATSON-GUPTILL 1997

CHIARELLO, MARK + KLEIN, TODD.
 THE DC COMICS GUIDE TO LETTERING AND
 COLORING COMICS.
 WATSON-GUPTILL 2004

COOPE, KATY.
 HOW TO DRAW MANGA.
 TANGERINE PRESS 2004

DARK HORSE COMICS (VARIOUS CONTRIBUTORS).
 THE ART OF COMIC-BOOK WRITING.
 DARK HORSE COMICS. 2002

DOUGLAS, A. + MALTI-DOULGAS, FEDWA.
 ARAB COMIC STRIPS: POLITICS OF AN EMERGING
 MASS CULTURE (ARAB + ISLAMIC STUDIES).
 INDIANA UNIVERSITY PRESS 1993

EISNER, WILL.
 COMICS AND SEQUENTIAL ART.
 NORTH LIGHT BOOKS 2001
 GRAPHIC STORYTELLING AND VISUAL NARRATIVE.
 NORTH LIGHT BOOKS 2002

FAIGIN, GARY.
 THE ARTIST'S COMPLETE GUIDE TO FACIAL EXPRESSION.
 WATSON-GUPTILL 1990

AINES, LURENE,
 THE WRITER'S GUIDE TO THE BUSINESS OF COMICS.
 WATSON-GUPTILL 1998

GERTLER, NAT.
 PANEL ONE: COMIC BOOK SCRIPTS BY TOP WRITERS.
 ABOUT COMICS 2002
 PANEL TWO: COMIC BOOK SCRIPTS BY TOP WRITERS.
 ABOUT COMICS 2003

GRAVETT, PAUL.
 MANGA: SIXTY YEARS OF JAPANESE COMICS.
 LAURENCE KING PUBLISHING 2004
 GRAPHIC NOVELS: EVERYTHING YOU NEED TO KNOW.
 COLLINS DESIGN 2005

HARTAS, LEO.
 HOW TO DRAW + SELL DIGITAL CARTOONS.
 BARRON'S EDUCATIONAL SERIES, INC 2004

HOGARTH, BURNE
 DYNAMIC ANATOMY. WATSON-GUPTILL 2003
 DYNAMIC FIGURE DRAWING. WATSON-GUPTILL 1996

JANSON, KLAUS.
 THE DC COMICS GUIDE TO PENCILING COMICS.
 WATSON-GUPTILL 2002
 THE DC COMICS GUIDE TO INKING COMICS.
 WATSON-GUPTILL 2003

KUBERT, JOE.
 SUPERHEROES: JOE KUBERT'S
 WONDERFUL WORLD OF COMICS.
 WATSON-GUPTILL 2000

LEE, STAN + BUSCEMA, JOHN.
 HOW TO DRAW COMICS THE "MARVEL" WAY.
 TITAN BOOKS 1986

MARCHANT, STEVE.
 THE COMPUTER CARTOON KIT.
 BARRON'S EDUCATIONAL SERIES, INC, 2006

MCCLOUD, SCOTT.
 UNDERSTANDING COMICS.
 HARPER COLLINS 1994
 REINVENTING COMICS.
 HARPER COLLINS 2000.

MOORE, ALAN.
 WRITING FOR COMICS.
 AVATAR PRESS 2003

O'NEIL, DENNIS.
 THE DC COMICS GUIDE TO WRITING COMICS.
 WATSON-GUPTILL 2001

PILCHER, TIM + BROOKS, BRAD.
 THE ESSENTIAL GUIDE TO WORLD COMICS.
 STERLING/COLLINS + BROWN 2005
 THE COMPLETE CARTOONING COURSE.
 BARRON'S EDUCATIONAL SERIES, INC 2001

ROOT, TOM + KARDON, ANDREW.
 WRITERS ON COMICS SCRIPTWRITING VOL. 2.
 TITAN BOOKS 2004

SALISBURY, MARK.
 ARTISTS ON COMICS ART.
 TITAN BOOKS 2000
 WRITERS ON COMICS SCRIPTWRITING.
 TITAN BOOKS 1999

SKINN, DEZ.
 COMIX: THE UNDERGROUND REVOLUTION.
 THUNDER MOUTH'S PRESS 2004

STARKINGS, RICHARD + ROSHELL, JOHN.
 COMIC BOOK LETTERING: THE "COMICRAFT" WAY.
 ACTIVE IMAGES 2003

WILLIAMSON, J.N.
 HOW TO WRITE TALES OF HORROR,
 FANTASY AND SCIENCE FICTION.
 WRITERS DIGEST BOOKS 1987

WITHROW, STEVEN AND BARBER, JOHN.
 WEBCOMICS
 BARRON'S EDUCATIONAL SERIES, INC 2005

ORGANIZATIONS & JOURNALS

TWO GREAT WAYS OF KEEPING IN TOUCH WITH TRENDS AND NEWS IN COMICS ARE JOURNALS AND ORGANIZATIONS. SOME OF THE MAJOR PUBLICATIONS ARE *COMICS INTERNATIONAL*, *THE COMICS INTERPRETER*, *WIZARD*, AND *THE COMICS JOURNAL*.

COMICS INTERNATIONAL CONTAINS NEWS AND REVIEWS, AS WELL AS A COMPREHENSIVE (AND VERY USEFUL) LISTING OF WORLDWIDE COMICS PUBLISHERS. *THE COMICS INTERPRETER* CONTAINS REVIEWS AND IN-DEPTH ARTICLES ALONGSIDE INTERVIEWS WITH CREATORS IN THE FIELD. *WIZARD* IS THE BIGGEST MAGAZINE IN THE U.S. THAT COVERS ALL OF THE MORE "MAINSTREAM" SUPERHERO NEWS. THEY ALSO RUN THEIR OWN COMICS CONVENTIONS. *THE COMICS JOURNAL* IS THE HEAVYWEIGHT, CONTAINING INDUSTRY NEWS, AS WELL AS PROFESSIONAL INTERVIEWS AND THE OBLIGATORY REVIEWS. IF YOU CAN AFFORD IT, GET ALL OF THEM!

THERE AREN'T THAT MANY ORGANIZATIONS THAT DEAL STRICTLY WITH MEMBERS OF THE COMICS TRADE. THE OLDEST ARE THE BRITISH *COMICS CREATORS GUILD* (WHICH USED TO BE *THE SOCIETY OF STRIP ILLUSTRATORS*) AND *THE GRAPHIC ARTISTS GUILD* OF THE U.S.A. BOTH REQUIRE A CERTAIN DEGREE OF PROFESSIONAL EXPERIENCE FROM ANYONE WANTING TO JOIN, AS DOES *THE NATIONAL CARTOONISTS SOCIETY*.

IN MAINLAND EUROPE THERE IS THE *CENTRO NAZIONALE DEL FUMETTO* (ITALIAN CENTER FOR COMIC ART) THAT, ALTHOUGH BASED IN ITALY, HAS CENTERS IN OTHER EUROPEAN COUNTRIES. THE CENTER MAINTAINS A MASSIVE DATABASE THAT INCLUDES ARCHIVES OF ITALIAN CREATORS AND CHARACTERS, A NATIONAL CONVENTION, AND DAILY NEWS.

FOR BUDDING ARTISTS, THE *JOE KUBERT SCHOOL OF CARTOON AND GRAPHIC ART* IS WORTH LOOKING INTO. KUBERT IS ONE OF THE OLD MASTERS OF COMIC STORYTELLING, AND HAS BEEN WRITING AND DRAWING THEM FOR OVER 50 YEARS. HIS SCHOOL HAS TAUGHT MANY PROFESSIONAL ARTISTS— INCLUDING HIS TWO SONS, ADAM AND ANDY. THE SCHOOL ALSO RUNS A VARIETY OF CORRESPONDENCE COURSES.

FRIENDS OF LULU IS AN ORGANIZATION PROMOTING THE ROLE OF WOMEN AS BOTH CREATORS AND READERS OF COMICS. THE ORGANIZATION RUNS ITS OWN EVENTS, AND THEIR WEB SITE IS A GREAT RESOURCE.

- JOURNALS -

COMICS INTERNATIONAL
QUALITY COMMUNICATIONS LTD. 345 DITCHLING ROAD,
BRIGHTON, BN1 6LL, UK.
WWW.QUALITYCOMMUNICATIONS.CO.UK/CI

THE COMICS INTERPRETER
ABSCESS PRESS (ROBERT YOUNG), 5820 N. MURRAY AVE. D-12,
HANAHAN, SOUTH CAROLINA, 29406, USA
HTTP://TCI.HOMESTEAD.COM/TCINDEX.HTML

THE COMICS JOURNAL
FANTAGRAPHICS BOOKS, 7563 LAKE CITY WAY NE,
SEATTLE, WA98115, USA.
WWW.TJC.COM

WIZARD
WIZARD ENTERTAINMENT, 151 WELLS AVE. CONGERS, NY 10920.
WWW.WIZARDUNIVERSE.COM

- ORGANIZATIONS -

CENTRO NAZIONALE DEL FUMETTO
CP 3242 UFFICIO POSTALE MARSIGLI, 10100 TORINO, ITALY.
WWW.FUMETTI.ORG/CNF

CENTRE NATIONAL DE LA BANDE DESINÈE ET DE L'IMAGE
121, RUE DE BORDEAUX, 16023 ANGOULÉME CEDEX, FRANCE.
WWW.CNBDI.FR

COMICS CREATORS GUILD
22 ST JAMES' MANSIONS, WEST END LANE, LONDON, NW6 2AA, UK.
WWW.COMICSCREATORS.ORG.UK

FRIENDS OF LULU
550 SOUTH FAIR OAKES AVE. #148, PASADENA, CA 91105, USA.
WWW.FRIENDS-LULU.ORG

GRAPHIC ARTISTS GUILD
90 JOHN STREET, SUITE 403, NEW YORK, NY 10038, USA.
WWW.GAG.ORG

JOE KUBERT SCHOOL OF CARTOON AND GRAPHIC ART
37B MYRTLE AVENUE, DOVER, NEW JERSEY 07801, USA
WWW.KUBERTSWORLD.COM

NATIONAL CARTOONISTS SOCIETY
DAVE COVERLY, MEMBERSHIP CHAIR,
PO BOX 8115, ANN ARBOR, MI 48107, USA.
WWW.REUBEN.ORG

- FESTIVALS AND CONVENTIONS -

FINLAND
KEMI (MAY): WWW.KEMI.FI/SARJIS

FRANCE
ANGOULÊME (JANUARY): WWW.BDANGOULEME.COM

ITALY
LUCCA (NOVEMBER): WWW.LUCCACOMICSANDGAMES.COM

NORWAY
RAPTUS INTERNATIONAL COMIC FESTIVAL (OCTOBER):
WWW.RAPTUS.NO

SPAIN
BARCELONA INTERNATIONAL COMIC FESTIVAL (OCTOBER):
WWW.FICOMIC.COM

U.K.
BRIGHTON COMIC EXPO (OCTOBER/NOVEMBER): WWW.COMICEXPO.BIZ
BRISTOL INTERNATIONAL COMIC EXPO (MAY): WWW.COMICEXPO.NET
CAPTION (AUGUST): WWW.CAPTION.ORG

U.S.A.
APE (APRIL): WWW.COMIC-CON.ORG/APE
BIG APPLE CON (SEPTEMBER): WWW.BIGAPPLECON.COM
PHILADELPHIA COMIC CON (AUGUST): WWW.PHILADELPHIACOMIC-CON.COM
SAN DIEGO COMIC CON (JULY): WWW.COMIC-CON.ORG
SPX (SEPTEMBER): WWW.SPXPO.COM
WIZARD WORLD: WWW.WIZARDUNIVERSE.COM/CONVENTIONS
WONDER CON (MARCH): WWW.COMIC-CON.ORG/WC

EVERYONE SEEMS TO HAVE THEIR OWN WEB SITE THESE DAYS. IT MAKES INITIAL CONTACT A LOT QUICKER, AS WELL AS AIDING IN YOUR RESEARCH AND HELPING YOU OUT WHEN YOU FIND YOUR SOFTWARE ISN'T WORKING QUITE THE WAY IT SHOULD.

ALL MAJOR SOFTWARE DEVELOPERS HAVE THEIR OWN SITES. MOST HAVE HELP LINES OF ONE SORT OR ANOTHER, AND MANY ACTUALLY POST TUTORIALS TO GIVE YOU A HAND WITH THEIR PRODUCT. THERE ARE SITES SPECIFICALLY AIMED AT USERS OF POSER AND BRYCE3D, FOR EXAMPLE, WITH TUTORIALS AND LOTS OF ENCOURAGEMENT FOR BOTH BEGINNERS AND THE EXPERIENCED. THE SAME GOES FOR FLASH, WITH BOTH OFFICIAL AND UNOFFICIAL WEB SITES OFFERING SUPPORT AND ASSORTED TIPS AND TRICKS RANGING FROM ACTIONSCRIPT TO ANIMATION.

YOU CAN ALSO FIND SITES THAT HELP WITH COLORING YOUR ARTWORK—AGAIN WITH TUTORIALS. SOME EVEN PROVIDE BLACK-AND-WHITE ARTWORK FOR YOU TO PRACTICE ON (THOUGH IT'S USUALLY UNDER COPYRIGHT—SO DON'T GO POSTING YOUR FINISHED EFFORTS).

THERE ARE ALSO THE INEVITABLE REVIEW SITES—BUT ALSO SITES HOSTED BY QUITE ESTIMABLE INSTITUTIONS (YALE, FOR INSTANCE), THAT RUN IN-DEPTH ARTICLES ON COMICS AND THEIR HISTORY. YOU'LL ALSO FIND RECOMMENDED READING LISTS (MAINLY FOR LIBRARIES, BUT IT GIVES YOU AN IDEA WHERE YOU SHOULD LOOK), MANGA IMPORTERS AND DISTRIBUTORS, AND—EVEN THOUGH MOST COMICS CREATORS NEVER HIRE AN AGENT—A SITE THAT LISTS AGENCIES WILLING TO TAKE YOU ON. AND DON'T FORGET THOSE ALL-IMPORTANT COMICS PUBLISHERS' WEB SITES!

- COMIC RESOURCES -

BOOK LENGTH WORKS ABOUT COMICS:
WWW.COMICSRESEARCH.ORG

COMICLOPEDIA:
WWW.LAMBIEK.NET

EUROPEAN COMICS RESOURCE SITE:
WWW.POEHA.COM/COMICS

REVIEWS SITE:
WWW.THEFOURTHRAIL.COM

WIKIPEDIA - ONLINE ENCYCLOPEDIA:
WWW.WIKIPEDIA.ORG

WRITERSNET: LINKS TO AGENTS, PUBLISHERS ETC.
SPECIFIC TO COMICS FIELD:
WWW.WRITERS.NET

YALE UNIVERSITY LIBRARY SITE-HUGE RESOURCE CATALOG:
WWW.LIBRARY.YALE.EDU/HUMANITIES/MEDIA/COMICS.HTML

- ART HELP -

COLORING TUTORIALS:
WWW.DAVE-CO.COM/GUTTERZOMBIE

MATT BROOKER (D'ISRAELI) SITE, CONTAINS TUTORIALS ON COLORING:
WWW.DISRAELI-DEMON.COM

- PUBLISHERS -

DARK HORSE WEB SITE:
WWW.DARKHORSE.COM

DC COMICS WEB SITE:
WWW.DCCOMICS.COM

MARVEL COMICS WEB SITE:
WWW.MARVELCOMICS.COM

- DISTRIBUTORS -

DIAMOND COMICS SITE - DISTRIBUTORS, REVIEWS AND DIRECT SALES:
WWW.DIAMONDCOMICS.COM

SMALL PRESS COMICS (ONLINE) - SALES, NEWS AND FORUMS:
HTTP://SMALLPRESSCOMICS.COM

TOKYOPOP - COMPREHENSIVE IMPORTER OF MANGA:
WWW.TOKYOPOP.COM/BOOKS/MANGA.PHP

VIZ MEDIA - ANOTHER MAJOR IMPORTER OF MANGA
WWW.VIZ.COM

- ONLINE MAGAZINES -

COMIC BOOK RESOURCES - NEWS AND REVIEWS
WWW.COMICBOOKRESOURCES.COM

NEWSARAMA - DAILY COMIC BOOK NEWS
WWW.NEWSARAMA.COM

SEQUENTIAL TART - COMICS INDUSTRY WEB-ZINE
WWW.SEQUENTIALTART.COM

- SOFTWARE -

ADOBE - FOR PHOTOSHOP, ILLUSTRATOR, FLASH, INDESIGN,
PAGEMAKER, ETC. SALES AND HELP:
WWW.ADOBE.COM

BRYCE 3D SITE:
WWW.PETERSHARPE.COM/TUTORIALS.HTM

FLASH TUTORIALS:
WWW.NEWTUTORIALS.COM
WWW.FLASHKIT.COM/TUTORIALS

POSER TUTORIALS:
HTTP://MEMBERS.TRIPOD.COM/~THE_GREAT_SITE/POSERTUT.HTM

GLOSSARY

ANTI-ALIASING–THE METHOD USED TO CREATE AN ILLUSION OF A SMOOTH EDGE IN BITMAP IMAGES BY BLURRING THE PIXELS AND FOOLING THE HUMAN EYE.

BITMAP–GRAPHICS IMAGES COMPOSED OF SMALL DOTS (SEE PIXELS) THAT DETERMINE RESOLUTION AND LIMIT THE DEGREE OF ENLARGEMENT THE IMAGE WILL TAKE.

BLEED–RUNNING THE COLORS ON A PAGE RIGHT OFF THE PAGE'S EDGE–AN ALTERNATIVE TO THE USUAL WHITE BORDER.

BRIEF–A SHORT, CONCISE DESCRIPTION OF A CHARACTER GIVING ANY RELEVANT DETAILS THE ARTIST MIGHT NEED TO KNOW TO DEVELOP THAT CHARACTER VISUALLY.

CMYK MODE–THE COLORS USED IN FOUR-COLOR PRINTING PROCESS: CYAN, MAGENTA, YELLOW, AND BLACK.

DPI–DOTS PER INCH–THE USUAL TERM USED TO DESCRIBE RESOLUTION. MORE ACCURATELY IT SHOULD BE PIXELS PER INCH–PPI.

FLASH–SOFTWARE USED TO CREATE ANIMATED IMAGES FOR WEBSITES.

FRAMING DEVICE–A VISUAL WAY OF BRACKETING A PERIOD OF TIME–EITHER AN ENTIRE SCENE OR A SINGLE MOMENT. IT CAN BE USED EITHER TO DRAW THE EYE, OR ISOLATE A SCENE FOR SPECIFIC REASONS.

GRAYSCALE–IMAGES THAT HAVE VARYING TONES OF GRAY INSTEAD OF FULL COLOR.

GUTTER–THE GAP BETWEEN PANELS–NORMALLY JUST THE WHITE OF UNPRINTED PAPER.

HTML–HYPERTEXT MARK-UP LANGUAGE–THE CODE USED TO CREATE PAGES FOR THE INTERNET.

HYPERLINKS–LINKS PLACED WITHIN HTML FILES TO ENABLE INTERNET USERS TO NAVIGATE THEIR WAY BETWEEN AND THROUGH WEB SITES.

LEVELS–A TOOL FOR ALTERING THE DEGREES OF BLACK AND WHITE (IN GRAYSCALE) OR COLOR IN IMAGES. CAN BE DONE WITH EITHER THE EYEDROPPER TOOL OR THROUGH A SIMPLE CHART.

LINE ART–BLACK AND WHITE ARTWORK. SHOULD BE SCANNED IN AT HIGHER RESOLUTION THAN GRAYSCALE OR COLOR IMAGES.

PANELS–EACH INDIVIDUAL PICTURE IN A PAGE OF COMIC ART IS A PANEL, USUALLY DELINEATED BY A BLACK OUTLINE AND A GUTTER.

PATH–ANY LINE IN VECTOR SOFTWARE. IT DOESN'T MATTER IF IT'S A STRAIGHT LINE, AN ARC, A COMPLEX CURVE OR CIRCLE.

PDF–PORTABLE DOCUMENT FORMAT. CAN BE OPENED WITH ADOBE ACROBAT OR READER. ONCE SAVED IN THIS MANNER, THE FILE GENERALLY CANNOT BE EDITED–ONLY READ.

PIXEL–THE SMALL DOTS THAT BITMAP IMAGES ARE CONSTRUCTED FROM.

PRIMITIVES–SIMPLE BASIC SHAPES IN 3D SOFTWARE–SPHERES, CONES, CUBES, ETC. THEY ARE THE BUILDING BLOCKS FOR CREATING 3D SCENES.

RENDER–TERM USED FOR THE ACTION WHEN A 3D SKELETON IS TEXTURED, TO GIVE AN IDEA OF WHAT THE FINISHED IMAGE WILL LOOK LIKE.

RESOLUTION–THE DENSITY OF PIXELS IN AN IMAGE. THE HIGHER THE DENSITY, THE BETTER QUALITY THE IMAGE WILL BE–AND THE LARGER THE FILE SIZE.

RGB MODE–RED, GREEN, AND BLUE–THE PRIMARY COLORS THAT MAKE UP NATURAL LIGHT. USED FOR IMAGES VIEWED ON SCREEN–ALSO SMALLER THAN CMYK FILES.

SMALL PRESS–TERM USED FOR NON-PROFESSIONAL PUBLISHERS. IT CAN BE MISLEADING AS MANY ARE QUITE LARGE, AND CAN BE ACCORDED AT LEAST SEMI-PROFESSIONAL STATUS.

TYPOGRAPHY–TERM USED FOR STYLES OF TEXT INCORPORATED INTO ARTWORK–EITHER AS DIALOG, NARRATIVE OR EFFECTS.

VECTOR SOFTWARE–GRAPHICS SOFTWARE BASED ON LINES RATHER THAN DOTS (SEE BITMAP). VECTOR IMAGES DON'T LOSE QUALITY WHEN THEY ARE ENLARGED.

CREDITS

INDEX

A

ARTISTS 75, 87, 94-5, 126-7, 144-5

ARTWORK 52-3, 54-5, 106-7, 112-13

B

BACKGROUND(S) 128-9

BALLOONS/BOXES 34, 37, 40-1, 65, 97, 102, 118-19

BITMAP/VECTOR SOFTWARE 59, 96-7

BLACK + WHITE 20, 21, 24, 54, 94, 96, 97, 138

BRIEFS 77, 88-9, 100-101

C

CAMERAS, DIGITAL 68-9

CHARACTER 42-3, 77, 64-5, 80-1, 88, 100, 101, 130-1

CINEMA 4D (MAXON) 124, 125, 128

CMYK (CYAN, MAGENTA, YELLOW, BLACK) 54, 116-17, 138

COLOR 20, 52, 53, 54-5, 95, 105, 116-17

COMIC BOOKS/COMICS 8, 10, 14-15, 26, 30-1, 51, 134-5, 144

CRIME/ADULT 24-5, 31, 73, 83

CROPPING PICTURES 110-11

CYBER-SQUATTERS 46

D

DIALOGUE 40, 42, 43, 51, 64, 65, 78, 147

DIGITAL CAMERAS 68-9

DIGITAL PAINTBRUSHES 54-55

DIGITIZING ARTWORK 53

DRAWING 52-3, 102-3, 126-27

DREAMWEAVER (ADOBE) 59

DRIVERS 98

E

EDITORS/EDITING 49, 89, 144, 145

E-MAIL 48, 49, 76, 99, 134

F

FANTASY 11, 22-3, 30, 31, 73, 82, 83

FICTION 16, 22, 31, 64, 82

FILE SIZE 55, 97, 135

FLASH (ADOBE) 136-7

FONTS 35, 97, 119

FORMATTING FILES 56, 57, 59, 96, 138

FRAMES/PANELS 34, 36-7

FRAMING DEVICES 110-111

G

GENRE(S) 16-17, 24-5, 26, 27, 28-9

GRAPHIC NOVELS 8, 10, 11, 14, 30-1

GRAPHICS: CARDS 98;
 TABLETS 53, 95;
 TERMS USED FOR 34

H

HARD DRIVE (CAPACITY) 52, 97

HORROR COMICS 20-2, 30, 73, 82

HYPERLINKS 135, 142

I

IDEAS 62-3, 76, 126, 146

IMAGES: BACKGROUND 129;
 CGI (COMPUTER GENERATED IMAGES) 124-5
 COMPRESSED 57;
 DIGITAL 96;
 THREE-D/3D 124;
INTERNET (WORLD WIDE WEB) 29, 46-7, 48, 59, 86, 134-5, 139, 142-3

L

LAYERS 54, 55, 56, 114-15

LAYOUT 51, 58, 102, 108-9

(continued)

LETTERING 35, 37, 118-19

LIBRARIES 68, 86, 87

M

MAC(S) 49, 58, 98-9

MANGA 18, 23, 26-7, 31, 34

MARKETING/PROMOTION 16, 140-1, 142-3

MEMORY, RANDOM ACCESS (RAM) 52

MONITORS 52, 96, 98, 117

MOOD 104-5

MOVIES 20-1, 24, 63, 84-5

N

NARRATIVE 34, 35, 37, 38, 41, 42, 43

NETWORKING 144-5

NOTES/RECORDS, NEED FOR 66-7

NUMBERING PAGES 50, 51, 129

O

ONLINE: COLLABORATING 76-7;
 SEARCHING 46, 47;
 SELLING 143;
 WORKING 48-9

P

PACE 73, 78-9

PANELS 34, 36, 51, 78, 79, 85, 108-9

PCS 49, 98-9

PDF FILES 57, 138

PENCILS 94, 102-3, 113, 120

PHOTOSHOP (ADOBE) 54, 56, 69, 99, 112, 115

PLOTTING STORYLINE 74-5, 79

PRINTERS/PRINTING 30-1, 53, 54, 58-9, 138

PSD FILES 56

PUBLISHERS 15, 16, 17, 46, 47, 58, 140, 144, 146-7

PUBLISHING WORK 58-9, 134-5, 138-9

R

RAM (RANDOM ACCESS MEMORY) 52

READERS/VIEWERS 27, 43, 77, 134, 137

RECORDERS 66, 68

RESEARCH 46, 47, 86-7, 128

RESOLUTION 57, 58, 96, 112, 117, 134

RGB (RED, GREEN, BLUE) 59, 116-17

S

SAVING WORK 52, 56-7, 59, 68

SCANNERS 52, 53, 95, 112-13

SCIENCE FICTION 18-19, 30, 72, 82

SCRIPT(S) 50, 51, 74-5, 102-3, 147

SELF-PUBLISHING 15, 17, 138-9, 140

SELLING ONLINE 139, 142-3

SERVICE PROVIDERS 59

SETTINGS (FOR STORIES) 82-3

SHOTS 34, 84, 85, 105, 111, 125, 129

SKETCHING 67, 76, 126-7

SOFTWARE: BACKGROUNDS 128;

 BITMAPS + VECTORS 59, 96-7;

 CHARACTER 130, 131;

 COLOR 54;

 FOR DRAWING 52-3;

 IMAGES 69;

 ONLINE 49;

 PDF FILES 57;

 THREE-D/3D 124, 125, 128, 130;

 WEB SITES 59;

 WORD PROCESSING 56

SOUND 34, 35, 40, 120, 135, 136-7

SPEECH 34, 35, 37, 40, 42, 65, 102

STORY STRUCTURE 38-9, 72, 74-5, 79,

 STORYLINE 38-9, 42, 72, 89

STYLE(S) 72-3, 92-3, 106-7

SUPERHEROES 18, 19, 21, 30, 83

SYNOPSES 88-9, 147

T

TERMINOLOGY (GRAPHICS) 34-5

TEXT: PRESENTING 50-1;

 SAVING 57;

 WORD PROCESSING 49, 56

THREE-D/3D 124, 125, 128, 130

TIFF (TAGGED IMAGE FILE FORMAT) 56, 58, 138

TV 20, 41, 63, 124

TYPE/TYPOGRAPHY 35, 41, 120-1

V

VIDEO: GAMES 63;

 RECORDERS 68

VIRUSES 99

W

WEB (WORLD WIDE) 46-7, 58-9, 142

WEB COMICS 134-5

WEB SITES 59, 134, 135, 142-3, 146

WEB-RINGS 143

WORD(S): CRUNCHING 50;

 PROCESSING 56

WORKING METHODS 48-9, 74-5, 100, 102

WRITING: BRIEFS 88-9;

 SCRIPTS 74-5

WRITING STYLES 72-3

ACKNOWLEDGMENTS

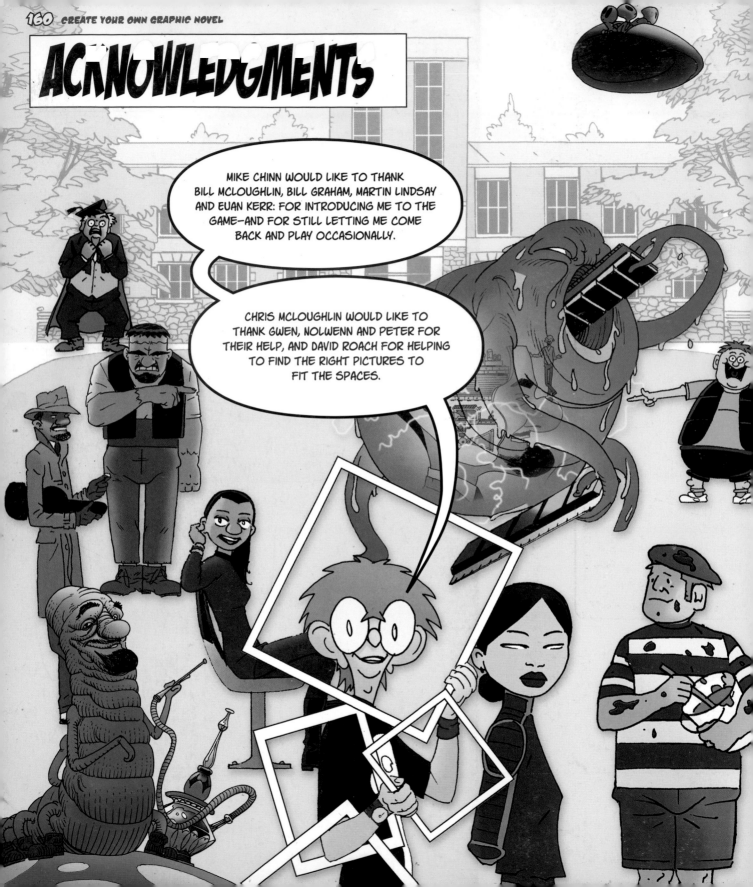

MIKE CHINN WOULD LIKE TO THANK BILL MCLOUGHLIN, BILL GRAHAM, MARTIN LINDSAY AND EUAN KERR: FOR INTRODUCING ME TO THE GAME—AND FOR STILL LETTING ME COME BACK AND PLAY OCCASIONALLY.

CHRIS MCLOUGHLIN WOULD LIKE TO THANK GWEN, NOLWENN AND PETER FOR THEIR HELP, AND DAVID ROACH FOR HELPING TO FIND THE RIGHT PICTURES TO FIT THE SPACES.